MOUNT ROBSON

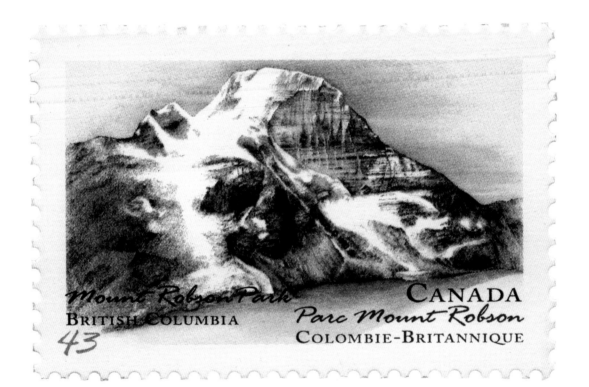

Mount Robson Park
BRITISH COLUMBIA
43
CANADA
Parc Mount Robson
COLOMBIE-BRITANNIQUE

80th Anniversary Stamp, "Mount Robson Park, British Columbia," 43¢, June 30, 1993. © Canada Post Corporation, 1993. Reproduced with permission. (A068003).

MOUNT ROBSON

Spiral Road of Art

JANE LYTTON GOOCH

PREFACE BY ROBERT W. SANDFORD

RMB

Rocky Mountain Books
www.rmbooks.com

Library and Archives Canada Cataloguing in Publication

Gooch, Jane Lytton
 Mount Robson : spiral road of art / Jane Lytton Gooch.

Includes bibliographical references and index.

ISBN 978-1-927330-73-9 (bound).—ISBN 978-1-927330-60-9 (pbk.)

 1. Mount Robson Park (B.C.)—In art. 2. Mount Robson Park (B.C.)—Pictorial works. I. Title.

FC3815.M68G66 2013 971.1'82 C2013-900440-8

Front cover: Lawren S. Harris, *Mount Robson from the South East*, 1929, oil on paperboard, 30.3 x 37.9 cm, Art Gallery of Ontario, The Thomson Collection © Art Gallery of Ontario.

Back cover: Jennifer Annesley, *Mt. Robson, North Face*, 2008, watercolour on paper, 35.6 x 53.3 cm, private collection, photographed by the artist.

Printed in China

Rocky Mountain Books acknowledges the financial support for its publishing program from the Government of Canada through the Canada Book Fund (CBF) and the Canada Council for the Arts, and from the province of British Columbia through the British Columbia Arts Council and the Book Publishing Tax Credit.

 Canadian Heritage / Patrimoine canadien Canada Council for the Arts / Conseil des Arts du Canada BRITISH COLUMBIA ARTS COUNCIL Supported by the Province of British Columbia

 MIX Paper from responsible sources FSC® C016973 This book was produced using FSC®-certified, acid-free paper, processed chlorine free and printed with soya-based inks.

ACKNOWLEDGEMENTS

Writing a book such as this simply would not be possible without the encouragement and help of many people. My family has been steadfast in their moral support along the way. With his enthusiasm for paintings of the Rockies, my husband, Bryan, has also given me much practical help, including proofreading the manuscript. My older son, Arthur, has solved my computer problems, and his younger brother, Robert, has shared my love of hiking in the mountains.

The digitized version of the *Canadian Alpine Journal*, called *Ever Upward*, prepared by Vi Sandford, Nancy Hansen and Ruthie Oltmann to honour the club's centennial, was invaluable in my research. In the early stages of my work, James Swanson's bibliography of the Spiral Road was also very useful, as well as the technical help of Dominique Yupangco of the English Department at the University of British Columbia. The unpublished diary of A.O. Wheeler for 1911 was generously loaned to me by his great-granddaughter Jenny Crompton, and it provided a fascinating insight to the Yellowhead expedition. Mel Heath brought my attention to the plaque he created for the Ralph Forster Hut and put me in touch with Robi Fierz, one of the builders of the hut. Trevor Lloyd Jones clarified the subject of Lawren Harris' drawing *Isolated Peak* as an image of Resplendent Mountain. On hearing about my Robson research, Wendy Bush kindly sent an image of the 1993 Mount Robson Park postage stamp. Roy Andersen confirmed the location of Margaret Lougheed's *Mount Robson and Berg Lake, B.C., Canada*, as well as other works by her in the Parks Canada collection in Banff. He put me in touch with Michael Gair, Collections Specialist with Parks Canada, who

provided biographical information and a digital image. Susan Kennard, Manager, Heritage Programs, gave me permission to publish the image from the Parks Canada files. The reference librarian in Fine Arts, History and Special Collections at the Vancouver Public Library was able to track down Margaret Lougheed's death date. My research in the field while backpacking at Mount Robson was most enjoyable with the help of my Yamnuska guides Tamara Dyckshoorn and Jane Whitney.

Various galleries and museums across Canada were of great assistance in supplying information, archival photographs and images of paintings. My quest for historical photographs of the railway has taken me to the Canada Science and Technology Museum, where Marcia Rak successfully located the desired images in the Canadian National Railways archives. A reproduction of a very early drawing of Mount Robson by George Harlow White was made possible through the efforts of Nathalie Maillet, Alan Walker and Christopher Coutlee of the Toronto Public Library. Photographs by Byron Harmon and lantern slides by Mary Schäffer were provided by the Archives of the Whyte Museum, with the help of D.L. Cameron and Craig Richards. Lena Goon of the Whyte Archives offered valuable assistance in locating letters relating to George Kinney's ascent of Mount Robson. Peter James, a Media Archivist at the University of British Columbia, and Weiyan Yan in the Rare Books and Special Collections department at the University of British Columbia assisted in providing a photograph of A.Y. Jackson sketching near Resplendent, British Columbia. The Royal British Columbia Museum also supplied archival photographs of Mount Robson, with the aid of Kelly-Ann Turkington. Janet Murray of Library and Archives Canada helped me to obtain an image of the 1993 Mount Robson Park postage stamp and referred me to Joy Parks of Canada Post for copyright permission. A reproduction of George Weber's serigraph of Kinney Lake was made possible by Tom Willock and Susan Sax-Willock of Willock and Sax Gallery in Banff, and they put me in touch with George Weber's daughter, Donna Tingley. Kerianne Elvevold and Aimee Woo of Mountain Galleries at the Banff Springs Hotel arranged for photographs by Graham Twomey of two works by Mel Heath, and Alice Law of the Stephen Lowe Gallery provided an image of Cameron Bird's painting of Kinney Lake.

Alison Girling and Lisa Sherlock of the E.J. Pratt Library at Toronto's Victoria University and Nicola Woods at the Royal Ontario Museum were most helpful in providing photographic and watercolour images relating to A.P. Coleman's explorations. My research on Robson drawings and paintings by A.Y. Jackson was greatly assisted by Catherine Sinclair of the Ottawa Art

Gallery, Janine Butler of the McMichael Canadian Collection, Dawn Vernon of the Kamloops Art Gallery and Belma Buljubasic and Raven Amira of the National Gallery of Canada. Julie Levac of the National Gallery of Canada Library and Archives sent an image of the 1915 catalogue of an exhibition sponsored by the Canadian Northern Railway that included works by A.Y. Jackson and Bill Beatty. Mara Meikie and Felicia Cukier, on behalf of The Thomson Collection at the Art Gallery of Ontario, have kindly given me access to several of Lawren Harris' paintings of the Robson area. The National Gallery of Canada has also provided images of drawings by Lawren Harris from its collection. Kim Svendsen of the Vancouver Art Gallery arranged for me to see some drawings and a sketchbook concerning Harris' trips to the Rockies, and Cheryl Siegel showed me the file on Margaret Lougheed. Mary Fus and Chris Cleaveley, owners of a drawing and oil painting by Lawren Harris of the same scene on the Robson Glacier, generously agreed to have these works photographed by Kent Wong.

The holders of copyright were outstanding in their quick responses to my requests for permission to publish. Anna Brennan, representing the estate of Dr. Naomi Jackson Groves, searched her records for any sign of the existence of A.Y. Jackson's nocturnal painting of Mount Robson reproduced in *Jasper National Park*, but to no avail. Margaret Lougheed's daughter, Ruth Buzzard, was pleased to help by giving me copyright permission to publish her mother's painting of Mount Robson, and Stewart Sheppard has always graciously replied to my requests to publish images of works by Lawren Harris. He also looked at the family's collection of photographs to find an image of Harris in the Rockies, dated 1940–41.

Robert Sandford has, once again, magnanimously agreed to write the preface, despite the demands of his busy schedule. I am indebted to Glen Boles for going through his vast collection of photographs and sending me many wonderful images that offer a climber's perspective on Robson and the surrounding mountains. The artists especially, in their enthusiasm for the book and for creating these wonderful images, deserve my special thanks. The support of British Columbia Parks, arranged by Jim Gilliland, Peter Goetz and Wayne Van Velzen, is deeply appreciated. Wayne Van Velzen has generously shared his ideas about balancing recreation with preservation in Mount Robson Provincial Park. Publisher Don Gorman, graphic designer Chyla Cardinal and editor Joe Wilderson of Rocky Mountain Books were enormously helpful throughout the publication process.

Contents

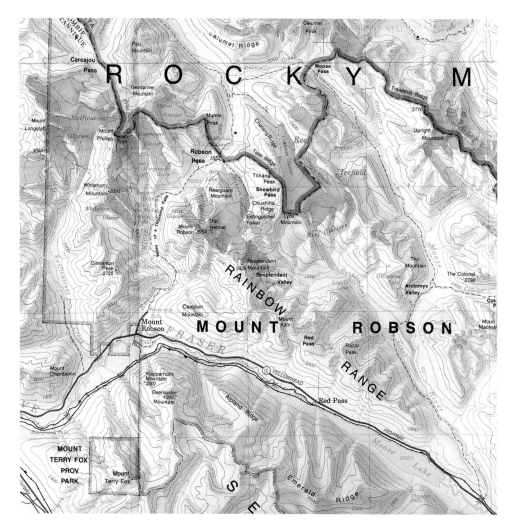

Map based on portion of Jasper National Park, *Atlas of Canada*, MCR 221 (Ottawa: Department of Energy, Mines and Resources, 1985), reproduced with permission. © Department of Natural Resources Canada.

Preface

Mount Robson: Roof of the Rockies

This is Jane Gooch's fourth book celebrating the magnificent legacy of mountain art that we enjoy as Canadians. In this passionate and engaging work, Dr. Gooch demonstrates once again the great extent to which she is drawn to powerful mountain places where the combination of rock, relief, water, weather, snow, ice and sky are most dramatic.

In her three previous books, Dr. Gooch successfully made the steep upward climb necessary to curate and interpret a century of artistic expression aimed at capturing the essence of places like Lake O'Hara, Mount Assiniboine and Bow Lake. The challenge in the present volume was even more difficult, for the distinguishing feature of Mount Robson is that its very scale is so much larger than any of the other grand landscapes in the Rockies upon which Gooch has focused her attention.

Like Mount Assiniboine, and to some extent like Lake O'Hara, the landscape of the Robson region is defined not by a single tall peak but by a massif, which is to say a large mountain mass containing a compact group of peaks usually originating from the same geological forces. In the case of Mount Robson, however, the main peak in the massif is nearly a kilometre higher than most

of the peaks along the Great Divide of the Rocky Mountains. This mountain is so big that it creates its own weather. Moreover, the valley floor beneath the main monolith of Robson is much lower in altitude than many of the main passes to the south, which gives the peak even greater actual and apparent relief and adds significantly to the challenge of accurately representing the scale of it, in either photographs or paintings.

As Dr. Gooch notes, there are features on Mount Robson which, because of its altitude and exposure to prevailing winds and storms, simply do not exist on other mountains in the Canadian Rockies. Hans Schwarz is a mountain guide in Jasper, some sixty miles, or nearly a hundred kilometres, from the monolith that is Robson. He has climbed the peak ten times, and still the very name of the mountain seems to strike a chord of respectful meditation in this man. With each expedition to Robson, Schwarz grew more deeply impressed by the defences of these ramparts. Though there were ledges, later named for Schwarz, the cliff faces in many places were virtually vertical. Ice and rock fall exploded regularly, like rifle shots, often just above the climbers' heads.

Extensive experience proved to Schwarz that there was no easy way to the summit. Day and night the crumbling glacial icecap on the peak pours avalanches down every side, sweeping the mountain from its apex often right to its base with tonnes of deadly ice and jagged rock. Schwarz claims the peril of the summit glacier is so horrendous that he always felt as though he had a five-pound rock in his stomach while he was on the ledges beneath it. This feeling would never go away, even after he got above the hazard, for the knowledge of having to descend through this same danger would be with him constantly until the climb was over and he and his clients were safely down in the trees, where at last they could stop to eat and drink.

But Schwarz was being modest. The summit glacier is only one of many obstacles. Even without the continuing terror of crevassed ice, the climber is constantly exposed to steep walls, falling ice and rock in the couloirs, and finally the alien pillars of rotting hoarfrost that guard the summit. And throughout, there is the problem of the weather. The colossal massif offers great resistance to moisture-laden winds pouring in from the west coast. Even in midsummer, storms regularly plaster the peak with snow. More dangerously, rain falling on the mountain regularly freezes into *verglas*, an often invisible layer of crystal-clear ice that turns every dark rock and ledge into a potential chute down which the climber can be whisked to sudden death. Pondering his own observations on the

conditions climbers could face on the mountain, Schwarz more than once paused to ask why anyone would want to go to such a place.

The answer to that lies beyond the sayability of words. Certainly there are great hazards, but on the summits of the highest mountains there is also an inexplicable glory. And capturing inexplicable glory is one of the great purposes of art.

Not generally being mountaineers of the calibre of a Glen Boles, and thus largely unable to view the Robson landscape from all-encompassing altitudes, it is interesting to see how different artists have addressed the problem of the mountain's overwhelming scale and almost inexpressible natural beauty. Some contemporary painters deal with the challenge of comprehending the mountain's breathtaking relief by compressing it into a wide-angle photographic image and then creating a painting from the photograph. This most often distorts relative perspective, however, robbing the mountain not only of its monumentality and grandeur but of its true scale, which is of course its most astonishing quality.

The paintings Dr. Gooch has selected for this book clearly demonstrate that the most impressive works depicting Mount Robson – which is to say those that leave the greatest lasting impression – may be those that boldly attempt to represent the peak's great scale either by breaking it into elements representative of the larger whole or by focusing on the sweeping upward inclination of stone pointing symbolically ever skyward toward a transcendence that is beyond scale.

During the latter and more metaphysical period of his life, Lawren Stewart Harris observed that "each step of the way up the heights of being is more difficult than the last. The way narrows as we ascend and the abyss on either side grows more terrible. The path of the ages is our greater life and will make heroes or angels of us all." One look at his magnificent abstract rendering of its great massif on the cover of this book and it becomes immediately clear that Harris was referring indirectly if not directly to his experience of Mount Robson.

This is not to suggest, however, that there is only one way to paint this daunting peak. The images in this book demonstrate the wide-ranging sensibilities and techniques which artists over the past century have brought to the challenge of capturing the character and essence of one of North America's most remarkable natural features.

It is also important to note that this book is being published during the centennial celebration

marking the creation of Mount Robson Provincial Park in 1913, a celebration which most fittingly also recognizes how important the larger British Columbia park and protected places system is to the quality of life of all British Columbians. Besides bestowing significant environmental benefits locally, these parks are of such grandeur that they attract visitors from all over the rest of Canada and around the world.

Because of its shared boundaries, Mount Robson Provincial Park has a history inseparable from that of Jasper and the other national parks which are part of Mount Robson's UNESCO Canadian Rocky Mountain Parks World Heritage Site designation. Located a hundred kilometres west of the town of Jasper, Mount Robson is the second-oldest park in British Columbia's system. The monumental peak for which the park is named guards its western entrance. At 3,954 metres, Mount Robson is the highest peak not just in British Columbia but in the entire Canadian Rockies. As the images in this book clearly demonstrate, Robson literally towers over the lesser peaks that surround it. When it is not swathed in cloud, its massif dominates the skyline in a way that only a great mountain can.

Park brochures explain that Mount Robson provides everything from developed, vehicle-accessible camping areas to remote valleys that seldom see a human footprint. What is more important is that Mount Robson Provincial Park also protects the headwaters of the Fraser River, one of the great salmon streams of the West and one of the few major rivers in southern Canada that has not been dammed.

The flora and fauna here are typical of the western slopes of the Rocky Mountains, which means there are trees like cedar and hemlock that grow only in the wetter climate of the West Slope of the Great Divide. The park also exhibits a great deal of vertical diversity. On some trails one can experience three different vegetation zones during a single day hike. Over 180 species of birds have been recorded in the park. All the wildlife that is indigenous to the Rocky Mountains can be found here. Mule and whitetail deer, moose, elk and black bears range through the lower valleys of this 217,000 hectare protected area. Higher-elevation species include the grizzly bear, mountain goat, bighorn sheep and, for the moment at least, the mountain caribou. The provincial parks system in British Columbia is justifiably proud of the fact that wildlife populations are allowed to ebb and flow with minimal intervention by humans.

The timely coincidence of the publication of this book and the centennial of Mount Robson Provincial Park allows our own generation to appreciate that the history of this remarkable mountain encompasses far more than the record of early efforts to climb its principal peak. Others of upwardly mobile aesthetics, besides mountain climbers, also made the supreme effort to reach the mountain in the days before trains and highways, and continue to do so today.

Jane Gooch is a keen and serious mountaineer, but of a different order. Like most of us, she does not have the technical skills to make it to the very summit of the highest mountain in the Canadian Rockies. But this book demonstrates that you don't have to physically climb a mountain in order to understand and appreciate its monumental scale and breathtaking beauty. Everyone who reads this text – and savours the fine art it so knowledgeably presents – will gratefully recognize that Jane Gooch made it to the aesthetic summit of Mount Robson and has returned with a collection of images and stories that will inspire the ages.

Robert William Sandford
Canmore, Alberta
2013

Introduction

Mount Robson's Natural Wonders

Mount Robson's fame as the highest peak in the Canadian Rockies is only the first of its natural wonders. Robson's location on the western edge of the Rocky Mountain chain, near the Fraser River, enhances the dramatic effect of its height. Visitors can see the stunning vertical rise from the valley floor to the peak – all 3000 metres up![1] Such an unobstructed view of the great mountain's south-western face is unforgettable. The eye travels effortlessly up past the thin, dark lines that mark the nearly horizontal sedimentary layers in Robson's vast construction, but each layer is a precipitous cliff that must be overcome in the quest to reach the summit ice cap. About halfway, rock of a lighter colour provides a striking contrast in distinct bands across the face of the mountain. All of these layers were once at the bottom of a shallow sea that was gradually pushed up to an astounding height by terrific geological forces throughout eons of the earth's history. Now glaciers flow from the summit, and great couloirs or gullies cut through the sedimentary layers from peak to valley, creating gigantic avalanche paths. From the Robson valley on a clear day, one can even see the gargoyles

on Robson's summit ridge, the weird snowy shapes sculpted by the wind that guard against the approach of mere mortals who strive to stand on Robson's peak, 3,954 metres above the sea.

The approach from the southwest, from Tête Jaune Cache in British Columbia, offers spectacular views of Mount Robson, especially where the highway crosses the Robson River, a favourite vantage point of artists. Coming from the east, however, from Jasper in Alberta and over the Yellowhead Pass, the traveller's hope of seeing Robson is denied because the peak hides behind the Rainbow Range. A.P. Coleman, a Canadian explorer, doubted the existence of the mountain rumoured to be higher than all others in the Rockies until he reached the Grand Forks (Robson River), and Mount Robson was suddenly revealed in all its majesty.[2] Coleman had been following the old Yellowhead trail that crosses the almost imperceptible Yellowhead Pass and keeps a low profile beside Yellowhead Lake, Moose Lake and the Fraser River. When A.Y. Jackson created his *Vista from Yellowhead*, he was at a higher elevation, probably on Yellowhead Mountain, allowing him to see over the intervening hills and lesser mountains to Mount Robson soaring 529 metres above its closest competitor, Resplendent Mountain.

Mount Robson, a Weather Maker

Mount Robson is so high that the prevailing westerly winds, laden with moisture from the Pacific, are forced up and over the summit, causing cooling and condensation, with the resulting precipitation in the form of rain at lower levels and snow at higher elevations. Clouds moving from the west frequently gather at Robson's peak. In the vicinity of the mountain, distinct climates have developed. The mild, moist Pacific air has produced lush vegetation in the Robson valley leading to Kinney Lake, with large cedar trees and plants found usually in the coastal rainforest, such as moss and devil's club. Higher up in Robson Pass, with cooler and drier conditions, the vegetation is characteristic of alpine tundra where the trees are smaller and little undergrowth manages to survive.[3] Abundant snowfall in all seasons has, over the centuries, produced some spectacular glaciers. Berg Glacier originates on Robson's north face and bends northwest down to the shore of Berg Lake, where enormous blocks of ice can be heard breaking off and splashing into the water, becoming ice

floes as the wind gently pushes them out into the lake. On the east side of the mountain, Robson Glacier is a vast river of ice flowing from the base of the southeastern ridge into an amphitheatre of surrounding peaks before curving to the northeast toward Robson Pass. The ice, now much diminished, once extended as far as the pass, and when A.Y. Jackson and Lawren Harris visited in 1924, Robson Glacier was estimated to be five miles long. The trail from the rainforest near Kinney Lake to the alpine climate of Berg Lake climbs steeply up the Valley of a Thousand Falls where the Robson River drops a total of 600 metres over a series of cliffs into a deep canyon. The last and most spectacular of the great waterfalls as one climbs toward Berg Lake is Emperor Falls, where the water plunges 46 metres, striking the rocks below and sending plumes of spray high into the air. The romantic estimate of a thousand waterfalls in the valley's name is not to be taken literally, but it does suggest that this wondrous place has waterfalls on all sides, not just from Mount Robson but also from Whitehorn Mountain to the west. When Coleman tried unsuccessfully to find a way up the steep sides of the gorge in 1907, he was mystified by so much water that seemed to come out of the sky.[4]

Mount Robson: Inspiration for Artists

Mount Robson is often the focus of attention in a park that is largely unspoiled wilderness. Few people travel through vast tracts of land that support wildlife, including caribou and grizzly bears, and protect the headwaters of the Fraser River. But Mount Robson welcomes thousands of hikers each year, especially on the Berg Lake trail. Among the many visitors are the artists who have observed Robson from all sides, in all different lights and moods. Their vantage points vary considerably, but their paintings offer spectacular views of Robson and the surrounding mountains, glaciers and lakes, from the lower elevations of the Robson valley and Kinney Lake and higher up overlooking Berg Lake, or on the trail to Snowbird Pass with a perspective over the Robson Glacier. Some artists are also experienced mountaineers and have ventured onto Robson Glacier in an attempt to climb Mount Robson. One artist, Glen Boles, has been fortunate to reach the summit on two occasions, each time in perfect weather.

The Mystery of Mount Robson's Name

Although some theories seem more plausible than others, we still do not know who named Mount Robson or, more important, the person who was honoured by having this great mountain named after him.[5] Mount Robson appears to have received its name during the fur trade in the early years of the nineteenth century. One possible explanation is contained in a letter from Henry J. Moberly to A.O. Wheeler, the director of the Alpine Club of Canada. Moberly had settled at Jasper House in the Athabasca valley in 1858,[6] and his recollection is that before the amalgamation of the Hudson's Bay Company and the Northwest Company in 1821, the Norwesters organized hunting and trading parties to work in the field for two years. One such party west of the Rockies had a camp near Mount Robson under the direction of a man named Robson. When the various groups of hunters were ready to journey east again, they met at Robson's camp.[7] The high mountain acting as a landmark for the camp may have been given Robson's name as well.

An even more likely origin of Mount Robson's name is connected to Tête Jaune, the fair-haired Iroquois guide Pierre Hatsination. In 1819 he was sent by Colin Robertson from the Hudson's Bay Company post known as St. Mary's House, on the Peace River at the mouth of the Smoky, to travel with Ignace Giasson up the Smoky and across the Rockies to trade in British Columbia.[8] Tête Jaune may have established a cache near Mount Robson and possibly gave the great mountain the name of Robertson after his boss, a name shortened over time to Robson.[9]

J.M. Thorington, an American mountaineer and historian, offers further support for the idea that Mount Robson was known by its present name during the years of the fur trade. Thorington was shown a diary of George MacDougal's, found by T.C. Young in 1924 among records of the fur trade in Fort St. James. MacDougal's entry for April 25, 1827, describes his location at Tête Jaune Cache near "the meeting of the Grand River – which flows from the base of Mt. Robson – and the Fraser River."[10] The diary was unfortunately lost in a fire, destroying the only written record that has come to light regarding use of the name Mount Robson at the time of the fur trade.

Early Tourists in the Yellowhead Valley

THE OVERLANDERS' JOURNEY TO THE CARIBOO

Lured by the discovery of gold in the Cariboo, the Overlanders came from England and the United States to meet a Canadian contingent in Toronto, and after organizing the larger group into three parties, they set out in 1862 on their arduous journey. William Hind, an accomplished artist, joined one of the parties, and he recorded life on the trail in numerous drawings, monochromatic washes and watercolours. An album of his sketches from this trip, preserved in the National Archives of Canada, is only 8.9 × 15.2 cm, but his detailed pictures add a sense of immediacy to the written accounts of the expedition.[11] Some years prior to travelling with the Overlanders, Hind had spent two or three years teaching drawing at the Toronto Normal School, and his expertise in making quick sketches is certainly evident.[12] A watercolour titled *Leather Pass, Rocky Mountains* (c. 1862), now in Montreal's McCord Museum, shows the Yellowhead Pass, called Leather Pass during the fur trade because the Hudson's Bay Company used this route to transport so many animal skins. Yellowhead Pass marks the beginning of the treacherous Tête Jaune trail, and the Overlanders were the first to record the difficulties of travelling with horses along the path of the fur brigades.[13]

After crossing the summit of Yellowhead Pass, the Overlanders camped at Cow Dung Lake, an early name for Yellowhead Lake. By this time their food supply was running low. After leaving Moose Lake, they came to a shale hill where the trail ascended as high as 900 feet above the Fraser River. The path was too steep for the heavily laden horses, and the men were forced to carry the load up themselves. After passing through a narrow, winding valley with mountains rising sharply on each side, the Overlanders finally reached a much wider valley not far from Tête Jaune Cache, affording them a splendid view of Mount Robson. A member of the group, John M. Sellar, recorded in his diary the sighting of Mount Robson on August 26, 1862, but he gave it a name associated with the weather, not with a person:

> At 4 p.m. we passed Snow or Cloud Cap Mountain which is the highest & finest on the whole Leather Pass. it [*sic*] is 9000 feet above the level of the valley at its base, and the guide told us that out of 29 times that he had passed it he had only seen the top once before.[14]

The next day, the Overlanders, very low on food, reached Tête Jaune, almost a month since leaving Edmonton. The local tribe, the Shuswaps, welcomed the weary travellers and saved them from starvation by trading salmon and berry cakes for items such as clothing, bullets and needles. After leaving Tête Jaune, the Overlanders continued their quest to reach the British Columbia goldfields, some going overland to the Thompson River and some by water down the Fraser to Fort George.

MILTON AND CHEADLE: THE SEARCH FOR A NORTHWEST PASSAGE BY LAND

Just a year later, Dr. William Butler Cheadle and his companion, William Fitzwilliam, Viscount Milton, followed a path similar to the Overlanders' from Fort Edmonton to Tête Jaune. The two explorers from England were hoping to find a northwest passage overland, entirely in British territory, by using a northern pass to cross the Rockies. As well as searching for adventure, they had imperial motives of establishing a transportation route across Canada and opening up the land for settlement.[15] Dr. Cheadle had just finished his medical degree before leaving England, and he was entrusted with the care of the 23-year-old Viscount Milton, who suffered from epilepsy. At Fort Edmonton they invited Eugene Francis O'Beirne to join the expedition. This proved to be a serious mistake because not only was O'Beirne hopeless in his ability to travel in the wilderness, but he also refused to do his share of the work.

Cheadle was fortunate in hiring a guide named Baptiste Supernat and an Assiniboine helper, Louis Battenotte, who had only one arm and took his wife and teenage son along on the trip.[16] Cheadle was a strong leader, physically and mentally, but he was hampered by the ineffectual O'Beirne and the interference of Milton, who was given to strong criticism of decisions made by the guide. The difficult trail through the Yellowhead valley was bound to cause dissension. Cheadle's journal entries for July 10 to 15, 1863, offer a frank account of O'Beirne's inability to keep up, Milton's outbursts and their struggles with swamps, fallen trees and high water. The trail along the shore of Moose Lake was sometimes impassable because of driftwood, forcing them into the water or up the steep cliffs. The ascent of the cliffs proved very difficult for the heavily laden horses. One fell and rolled down twice, and another fell three times before being unpacked. By the time the expedition reached the west end of Moose Lake and good pasture, the horses were ravenous after not eating

very much for two days. Just before coming to the Grand Forks, the travellers were forced to lead the horses along a rocky trail only twelve inches wide on a precipitous cliff 100 feet above the Fraser. On July 14 the party finally arrived at the Grand Fork, where they rested for most of the day, allowing the horses to recuperate. Cheadle recorded the spectacular view of Mount Robson:

> This Grand Fork is the original "Tête Jaune Cache" & it is certainly the finest scene I have ever viewed. To the right Robson Peak, a magnificent mountain, high, rugged, covered with deep snow, the top now clearly seen, although generally covered with clouds.[17]

The next day, they suffered great misfortune when two horses were swept away by the Fraser River. The Assiniboine managed to rescue one, but the other was lost, along with its pack containing some essential personal possessions, including Milton's passport and Cheadle's sextant, matches and revolver. Six weeks after leaving Tête Jaune, the party reached Kamloops. The most strenuous part of their entire journey was following the Thompson River, cutting their way through the underbrush and fallen trees with a single axe.[18] Despite overwhelming obstacles and a chronic shortage of food, the ragged adventurers survived the ordeal and enjoyed some civilized life in Victoria before eventually sailing for England.

When Milton and Cheadle published their popular account of Canadian adventures in 1865, *The Northwest Passage by Land*, Cheadle's straightforward description of Robson in his journal had been embellished to suggest an incredibly high mountain of striking beauty that had seldom been seen because clouds frequently obscured the peak:

> … immediately behind us, a giant among giants, and immeasurably supreme, rose Robson's Peak. This magnificent mountain is of conical form, glacier clothed and rugged. When we first caught sight of it, a shroud of mist partially enveloped the summit, but this presently rolled away and we saw its upper portion dimmed by a necklace of light, feathery clouds, beyond which its pointed apex of ice, glittering in the morning sun, shot up far into the blue heaven above, to a height of probably 10,000 or 15,000 feet. It was a glorious sight, and one which the Shushwaps [sic] of the Cache assured us had rarely been seen by human eyes, the summit being generally hidden by clouds.[19]

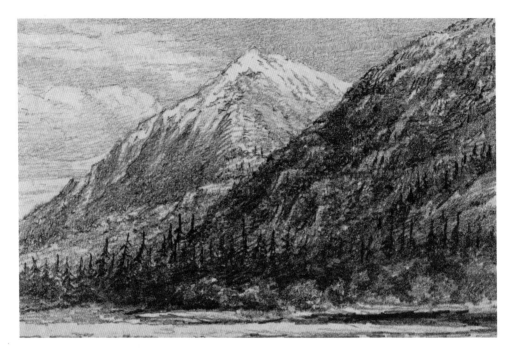

George Harlow White, *Mount Robson, Rocky Mountains*, c. 1876. Pencil, 7.9 x 11.8 cm. Courtesy of Toronto Public Library (JRR 3060).

White, an English landscape painter who settled in Ontario in 1871, travelled west about 1876, when he created this early sketch of Mount Robson.

A.P. Coleman: Explorer, Geologist and Artist

When A.O. Wheeler, the first president of the Alpine Club of Canada, wanted to enhance the prestige of the newly created organization by exploring Mount Robson, he turned, at the first meeting of the club, to his vice-president, A. P. Coleman, a distinguished geologist from the University of Toronto. Since 1884 Coleman had been on six expeditions to Canada's western mountains, and three of them involved searching for the fabled Mounts Brown (9,187 feet) and Hooker (10,847 feet), said by David Douglas, when he crossed Athabasca Pass in 1827, to be at least 16,000 or 17,000 feet high.[20]

Coleman discovered to his disappointment that the mountain giants were much lower than reported. Now Wheeler wanted Coleman and his brother Lucius, also a charter member of the Alpine Club of Canada, to search for Mount Robson, determine its height and, if possible, climb it in honour of Canada's new alpine club.[21] Coleman was naturally skeptical about the truth of Milton and Cheadle's description after his experience with the exaggerated claims for Mounts Hooker and Brown. But he also had some more scientific evidence about Mount Robson's great height in James McEvoy's *Report on the Geology and Natural Resources of the Country Traversed by the Yellow Head Pass*, published in 1900. McEvoy estimated Robson's peak at 13,700 feet with a vertical rise from the valley of more that 10,750 feet.[22] In his report, McEvoy also refers to G.M. Dawson's paper on the Shuswap people for the Royal Society of Canada in 1891 that includes their impressions of Mount Robson:

> The Kamloops Indians affirm that the very highest mountain they know is on the north side of the valley of Tête-Jaune Câche [*sic*], about ten miles from the valley. This is named *Yuh-hai-haś-kun*, from the appearance of a spiral road running up it. No one has ever been known to reach the top, though a former chief of Tsuk-tsuk-kwālk, on the North Thompson, was near the top once when hunting goats. When he realized how high he had climbed he became frightened and returned.[23]

Coleman realized that these descriptions of Robson were based on observations from the Grand Forks of the Fraser, some distance from the base of the mountain. Apart from recording Robson's peak rising so dramatically from the valley, the mountain was almost unknown, judging by the early accounts.[24] Even the Canadian Pacific Railway surveyors who had staked a line from the Miette River west to Tête Jaune in 1876 and 1877 did not leave a record of actually going to the base of Mount Robson.[25] An unexplored mountain reputed to be so high was too much for Coleman to resist, and he prepared to act on Wheeler's suggestion to travel to Robson and try to climb this impressive peak.

COLEMAN THE ARTIST

A.P. Coleman's scientific achievements in geology and glaciology overshadow his significant artistic contribution. If Coleman had not pursued a career in geology, he might well have become a professional artist.[26] His fondness for drawing and painting from an early age developed into a lifelong

habit of taking his sketchbook on his travels, even on expeditions into the alpine wilderness. Before Cornelius Van Horne had given railway passes in 1886 to artists such as John Arthur Fraser and Lucius O'Brien to paint along the recently completed Canadian Pacific Railway line, Coleman had already travelled to the end of the rails in 1884, to Laggan (Lake Louise), and set out with horses to explore farther west in the Columbia River valley in British Columbia. He was the earliest artist to exhibit paintings of the Rockies and Selkirks at the Royal Canadian Academy that were based on first-hand knowledge.[27] In the 1885 show of the Academy in Toronto, Coleman exhibited four watercolours of the alpine landscape, including *Camp in the Selkirks*. The following year, after a second trip to the western mountains, he put *Mount McDonald, Big Bend of the Columbia River* in the annual Academy show.[28] Coleman contributed watercolours consistently to the Academy exhibitions from 1881 to 1888, and he became an associate member on the acceptance of a diploma work in 1903. At the same time, he was a member of the Ontario Society of Artists from 1880 to 1905, exhibiting with them until 1904. In addition, he put paintings in the yearly Toronto Industrial Exhibition, now the Canadian National Exhibition, from 1881–1901. Perhaps the demands of his career as a professor of geology at the University of Toronto caused Coleman to stop exhibiting his watercolours, but he certainly did not stop painting. When he went on the expeditions to Mount Robson, in 1907 and 1908, Coleman sketched extensively, and 23 of these watercolours have been preserved in the large collection of his paintings of Canada and other parts of the world in the Royal Ontario Museum.[29]

Coleman certainly deserves to be recognized for his contribution to the early art of British Columbia. Although his Mount Robson watercolours are too late to be included in Berenice Gilmore's informative history *Artists Overland*[:] *A Visual Record of British Columbia 1793–1886*, his trips of 1884 and 1885 to the Columbia River valley and the Selkirks are worthy of mention for his paintings of this largely unknown wilderness. Gilmore's discussion of the early artists, however, does put Coleman's artistic accomplishments in an interesting context. Most artists before the completion of the Canadian Pacific Railway in 1886 were amateurs who travelled in British Columbia primarily for reasons other than drawing and painting.[30] Military personnel, explorers and surveyors frequently included sketches of the landscape, in pencil and watercolour, as illustrations in their reports. These topographical images tended to be faithful representations, without rearranging the landscape for aesthetic effect, and the colours were accurate.[31] With his knowledge of geology, Coleman had an

extensive understanding of landforms combined with an outstanding ability to draw, and when colour was added to the pencil sketch, the resulting painting was true to nature. He painted what he saw, but the choice of subject and the feeling in his sketches reveal that he goes beyond the topographical image to express his love of the wilderness.

Coleman's specific purpose in travelling to Mount Robson was suggested to him by A.O. Wheeler – exploration of the Robson region and, if possible, a successful mountaineering expedition to reach the summit. In the larger context of Coleman's six previous expeditions to the Rockies, described in his delightful 1911 book *The Canadian Rockies: New and Old Trails*, we can sense his happiness in exploring a landscape largely unknown: "There is the feeling of having made a new discovery, of having caught Nature unawares at her work of creation, as one turns off from a scarcely beaten route into one never trodden at all by the feet of white men ..."[32] His wonder at the enormous geological forces at work in the mountains goes beyond the merely factual when he describes the scene from a mountain top, with an artist's eye for shape and colour:

> How strangely the world has been built, bed after bed of limestone or slate or quartzite, pale grey or pale green or dark red or purple, built into cathedrals or castles, or crumpled like coloured cloths from the rag bag, squeezed together into arches and troughs, into V's and S's and M's 10 miles long and 2 miles high; or else sheets of rock 20,000 feet thick have been sliced into blocks and tilted up to play leapfrog with one another.[33]

Coleman's love of exploration and his fascination with geology are enhanced by his great contentment in the outdoors, free from the constraints of civilization and able to breathe the cool mountain air high on a summit.[34] Life in the wilderness has its bad weather, discomforts and dangers, but the glory of an alpine meadow on a summer's day is more than adequate compensation: "... what could be more inspiring than the flowery meadows above treeline when the warm sun shines in the six weeks of summer!"[35] Coleman's published account of his experiences exploring Mount Robson is based on his notebooks for 1907 and 1908, and the feelings he describes help us to understand how he views the landscape. The sketches of the Robson region are a visual journal, providing images of particularly striking scenes and complementing the precise observations in the notebooks.

Coleman grew up in Canada during the Victorian age, and he developed the skills of drawing and painting that were considered an important part of a young person's education. He took some

lessons from Otto Jacobi, a Prussian master of watercolour painting who had come to Canada for a visit in 1860 and had decided to stay in Toronto because the Canadian landscape appealed to him.[36] Canada was a new country for artists to explore, and the landscape had become a popular subject, evident in the widely circulated *Picturesque Canada*, published in 1882. This volume combined the prose of George Grant, principal of Queen's University, with the images of many artists to show Canadians the great beauty of their own country.[37] Arthur Coleman, a young man of 30, may well have been influenced by this well-known pictorial book, because two years later he went west to the mountains with notebook and sketchbook in hand. He took his portable watercolour box that allowed him to make quick sketches in the field, creating illustrations of the places described in his notebooks. By doing so, he associated himself with the Victorian traveller who painted watercolours as a means to show others what distant and unknown landscapes looked like.[38] When travelling by horseback in the Rockies, Coleman put his notebooks and sketchbooks in a rucksack attached to his saddle. On his return from Mount Robson in 1907, his horse was swept away by the strong current when fording the Athabasca River, and Coleman was forced to swim alongside, holding on to the bridle. His notebooks and sketchbook survived, although somewhat dampened,[39] and they provide a fascinating account of a previously unknown place.

COLEMAN'S EXPEDITION TO ROBSON, 1907: JOURNEY TO THE MOUNTAIN

On August 3 Dr. Coleman set out from Laggan with his brother Lucius, who lived in Morley, a packer named Jack Beder and a third member of the climbing party, Reverend George Kinney, a replacement for Professor L.B. Stewart, a colleague from the University of Toronto who was unable to go. The route from Laggan north to the Yellowhead Trail, while not the shortest way to approach Mount Robson, seemed to have several advantages. Coleman's party could follow trails blazed by earlier climbing expeditions through spectacular mountain scenery, and they would be the first group to travel between the Canadian Pacific Railway and the proposed Grand Trunk Pacific line over Yellowhead Pass. Before railway access, however, a major difficulty in exploring Mount Robson was just getting to the base of the mountain.

The journey north was fraught with difficulties. The summer was very wet and in the mountain passes they encountered snow. When camped near Wilcox Pass during a blizzard, Coleman was astonished to see two snowy figures emerge from the storm, who turned out to be Mary Schäffer, the well known wildflower artist, and her guide, Billy Warren. They had found a wayward horse belonging to Coleman's party, and rather than have the horse follow them back to Laggan, they had kindly returned it. Coleman remarks on the great pleasure of entertaining such a charming woman over lunch beside the campfire. During their conversation, Billy Warren warned Coleman about the great number of fallen trees on the trail ahead, along the Sunwapta River. Coleman's quest to explore Mount Robson must have intrigued Mary Schäffer, because the next

Mary Schäffer, Lantern Slide of A.P. Coleman near Wilcox Pass, 1907. Whyte Museum of the Canadian Rockies (V439/PS-20).

summer she followed in his footsteps, going as far as Tête Jaune Cache. After lunch the Schäffer party continued south on their homeward journey and Coleman went north on uncertain trails with many fallen trees that necessitated much laborious chopping. Progress was slow, and by the time they looked from the plains beside the Athabasca River to the west toward the Miette valley, it was already August 28 and they were two weeks later than expected. Coleman anticipated that the well-travelled Yellowhead Trail would be better. They would not be delayed by chopping through fallen trees and they would not be in any doubt which way to go. He was mistaken, however, because the pack trains taking supplies to the engineers locating the Grand Trunk Pacific line had churned the trail into foul-smelling mud. To make matters worse, after the blissful quiet of their previous days

on the wilderness trails, they now found themselves behind a noisy, slow moving pack train of 21 horses heading west.

The railways were bringing civilization to the Yellowhead valley. Coleman observed no less than three different benchmarks for the elevation of Yellowhead Pass made by survey crews from three separate railways. The Canadian Pacific had staked a line three decades earlier but had decided to locate its railway to the south, over Kicking Horse Pass. Now in the first decade of the twentieth century, two railways, the Grand Trunk Pacific and the Canadian Northern, were planning to lay track west from the Athabasca River and over Yellowhead Pass to Tête Jaune Cache. In just over four years the Grand Trunk Pacific would complete its line to the summit of Yellowhead Pass and establish a raucous railway camp known as Summit City. But, for now, Coleman's party, having been able to pass the noisy pack train, followed the Tête Jaune trail in peace, along the shore of tranquil Yellowhead Lake. Four miles beyond the lake, they reached the Fraser River that led them to the head of Moose Lake, where they camped beside a railway engineer and his packer, soon to be joined by the pack train. All were taking advantage of good grazing for the horses because the next eight or ten miles along the north shore of Moose Lake had a reputation as the worst part of the trail. The ponies had to go up and down the steep slopes, climbing hundreds of feet above the water and descending to a shoreline of steep stones. High or low, the trail offered no relief for the horses and, even worse, there was no pasture.

By the time Coleman was close to the Rainbow Range, and judging from McEvoy's map, only three or four miles from Mount Robson, he still had not seen its white peak soaring over the much lower mountains. He began to suspect he was searching for another Mount Brown, one that would turn out to be much lower than reported. George Kinney and Lucius Coleman followed a stream up to the valley wall in an effort to catch a glimpse of the Rockies' highest peak, but rain clouds only increased the mystery. While they could detect glaciers and summits, they could not be certain they had seen Mount Robson. Their explorations did determine, however, that horses could not approach Robson by that route, and they decided to continue west to the Grand Forks River where, suddenly, Robson appeared:

> Six miles up the valley mighty cliffs rose, crowned by a pyramid of snow, often hidden by clouds, but now and then gleaming above them white against a blue-black sky.[40]

Coleman agreed with McEvoy's calculation that Robson's peak rose more than 10,000 feet above the valley floor, and his suspicion that Milton and Cheadle, 45 years earlier, had exaggerated the height of this great mountain was unfounded. Coleman could see for himself that reports about Robson were true. Now he turned to his next challenge: exploring the highest peak in the Rockies in an attempt to reach the summit.

SETTING FOOT ON THE MOUNTAIN

Coleman's party discovered an old trail leading at least five miles up the Grand Forks valley, but the people responsible for building it were a mystery. Tree trunks had fallen across the trail, victims of a past forest fire, and much chopping was required before the men could lead the horses up the valley and camp beside the Grand Forks River. The next morning, September 11, with supplies for five days, the three climbers followed the river on foot through a British Columbia rainforest of large cedar and hemlock, with moss and ferns underfoot, as well as the dreaded devil's club. After crossing a smaller branch of the Grand Forks that flowed from cliffs on Robson's south side, they reached Kinney Lake, named by Coleman to honour his "indefatigable comrade"[41] who had seen the lake during his explorations of the previous day. Coleman sketched a view of Kinney Lake from a vantage point to the southeast, on the slope of Campion Mountain, looking down on the lake and toward Whitehorn Mountain and the alluvial plain to the northwest. The sun is shining in Coleman's watercolour, but clouds are forming, an omen that the weather is about to change. Now they were almost directly below thousands of feet of steep cliffs, with Robson's peak hidden from view. By walking along the shore of Kinney Lake, they came to a wonderful amphitheatre enclosing the main branch of the Grand Forks River, and at the head of the valley, a glacier reached far below treeline, even sending a tributary down to the river. Coleman's delight in the natural beauty of this spectacular valley reveals his artistic eye:

> The colouring of the amphitheatre was wonderfully rich, with the greys and purples and ruddy browns of the rocks forming the cliffs, and different tones of green on patches of forest and on bare slopes, while the waterfalls that dropped over the cliffs by the dozen made the whole scene alive with motion and music.[42]

His written description is complemented by a *plein air* sketch of White Falls, the last of the high

waterfalls before the river flows across the braided alluvial plain at the head of Kinney Lake. By laboriously climbing over great stone blocks that had fallen from Robson's cliffs, they finally reached the tallest waterfall near the upper end of the valley. Here the river flowed from the northeast in deep canyons, dropping 2,000 feet and creating clouds of spray. The overwhelming volume of water falling from such a height, apparently out of the sky, intrigued the explorers, but without wings they could not scale the tremendous cliffs. Instead, they retreated to Kinney Lake to camp, hoping to ascend the canyon of the smaller eastern branch of the Grand Forks the next day.

Ominous morning clouds brought rain, making the steep rock in the gully of the smaller fork very slippery. Higher up, low cloud and sleet enveloped them, and by the time they decided to camp just below treeline, snow was falling. The next morning, September 14, a foot of snow had covered the end of their sleeping platform, convincing them that it was too late in the season to climb Robson. Coleman found some consolation in their explorations of two valleys below Robson's south and southwest faces and in ascending to 3000 feet, but he realized that they had not even come close to meeting the challenge of climbing to the summit. The two-week delay on the trails taking them north to the Yellowhead valley meant they had missed the favourable weather. Despite his disappointment, Coleman had a vivid memory of Mount Robson seen from the southwest at sunset with a small cloud clinging to the rock below the summit pyramid: "Once on a clear evening we saw this [cloud] rise like a plume of flame against the ruddy alpine glow of the peak, a spectacle to remember."[43] His sketch of this scene is dramatic, with a puff of reddish-grey vapour rising toward the brilliantly coloured ice and snow on Robson's upper slopes, while below the colours have the sombre tones of twilight.

The dejected climbers, with two lame horses and a dwindling food supply, headed east to the Athabasca River, where they were able to buy food from a rancher, Lewis Swift, and one of his neighbours, Ewan Moberly. By the time the party arrived at a settlement on the Edmonton trail called the Big Eddy, Coleman had been travelling for almost two months and he was already late getting back to the University of Toronto for the fall term. In order to reach the railway in Edmonton as soon as possible, he bid farewell to his companions, who had "loyally and good-temperedly borne so many trials and hardships together,"[44] and went ahead at a faster pace with the mail carrier, John Yates. This meeting with Yates was fortuitous because Coleman was able to secure his services as packer the following summer if Coleman wanted to try again to climb Robson.

A.P. COLEMAN, *Mount Robson from Grand Forks River*, n.d. Watercolour over pencil, 14.9 x 22.5 cm. With permission of the Royal Ontario Museum © ROM.

COLEMAN'S SECOND TRIP TO MOUNT ROBSON, 1908

After buying supplies in Edmonton on July 31, Coleman, his brother Lucius and George Kinney set out for John Yates' Hobo Ranch to the west, arriving there on August 4. Coleman hired Adolphus Moberly as guide, and he in turn brought his entire family, which meant that, contrary to Coleman's hope of travelling to Mount Robson as quickly as possible, the colourful cavalcade moved at a leisurely pace. Even Yates' bull terrier Hoodoo joined the expedition, but despite Coleman's concern that the dog would be an impediment, Hoodoo turned out to be a self-sufficient and cheerful companion. The group followed the Grand Trunk Pacific tote road west toward the Yellowhead valley. Along the way Kinney showed his prowess as a sportsman by providing fish, grouse and ducks for the larder.

After the failure the previous season to climb Robson from the south, Coleman's party turned north where the Moose River flowed into the Fraser, with the intention of following the Moose valley until they could approach Mount Robson on its other side, the north flank. The view up the valley tantalized them with glaciers and high peaks, but Adolphus led them to the east, up the other fork of the Moose River, which they followed for ten miles to its headwaters. Adolphus returned to the family camp at the mouth of the Moose but gave the climbers instructions on crossing the Continental Divide and locating the fork of the Smoky River that would lead to Mount Robson. After enduring a severe thunderstorm accompanied by a torrential downpour and darkened sky, the men eventually found the river with blue water that Adolphus had described, and they followed it for two miles, splashing through the submerged grass on the bank until the valley turned to the southwest where they discovered a lake and teepee poles in a camping spot, possibly used by fur traders from the Peace River area travelling to Tête Jaune Cache. The exhausted, hungry men decided to camp before reaching the foot of Mount Robson, even though they had caught intriguing glimpses of the mountain through the clouds. The next day, August 28, Coleman's party could not proceed, because of an ominous snowstorm, a reminder of the reason for their failed attempt the year before. Only George Kinney enthusiastically set out through the snow to explore in the vicinity of Robson, reporting on the lakes and glaciers that lay ahead.

On August 29 the weather improved and the snow was melting, allowing the men to travel about two miles toward Robson Pass and establish their camp one-half mile from the foot of Rearguard Mountain in a grove of trees protected from the Robson Glacier by an enormous rocky knoll, or nunatak. The terminus of the glacier was less than 200 yards away on each side of their camp, and their plan was to follow the glacial road up toward Robson's summit. They named the lake to the north Adolphus after their guide, and the lake to the southwest Berg Lake because of the ice falling from Blue Glacier, now known as Berg Glacier. Coleman was delighted and inspired by the beautiful landscape. To see Mount Robson in the rare moments when the clouds lifted, he just needed to walk 100 yards into the valley and look around the shoulder of Rearguard.

Every morning at 3:30 Coleman checked to see if the weather looked promising for climbing, and for days on end he was greeted with rain in the valley that would be falling as snow higher up on Robson's cliffs. All the men could do was wait. Coleman passed the time drawing the first map

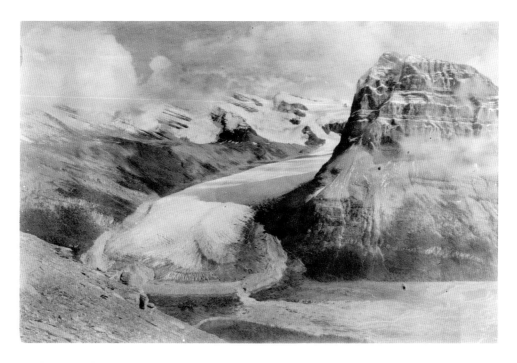

A.P. COLEMAN, Photograph No. 17, *Robson Glacier, c. 1908*. Arthur P. Coleman Collection and Arthur P. Coleman Online Exhibition, Victoria University Library (Toronto) and ROM.

of the area. He also measured the extent of Robson Glacier and observed the unusual drainage of the glacial runoff, some flowing north to Adolphus Lake and the Smoky River, eventually reaching the Mackenzie River and the Arctic Ocean, while some branches of the glacial streams flowed toward Berg Lake and the Grand Forks that joined the Fraser flowing to the Pacific Ocean. The Mount Robson watershed created a geographical anomaly by draining toward two separate river systems in two different provinces. Coleman realized that the provincial boundary between British Columbia and Alberta, determined by the location of the watershed, would involve a difficult decision about how much of Robson Glacier and Mount Robson belonged to each of the provinces. The problem resolved itself in a few years when all of the glacial runoff drained toward Berg Lake, at an elevation 38 feet lower than Alberta's Adolphus Lake.

The morning of August 30 produced good weather for climbing, but unfortunately it was Sunday and Reverend George Kinney preferred not to climb. They spent the day instead exploring along Berg Lake, with the hanging glaciers falling right to the water's edge, and into the top of the valley with the waterfalls that had defeated them the year before. Coleman's explorations on this day produced two sketches. His *Mount Robson from Across Berg Lake* shows the spectacular summit of Robson emerging from thick cloud while, below, Berg Glacier is reflected in the lake. Another watercolour, dated 1908, *Mount Robson from North West*, portrays Robson from near Emperor Falls, the first large waterfall after the river leaves Berg Lake and plunges down to Kinney Lake. From this vantage point, Robson's summit has a pyramidal shape:

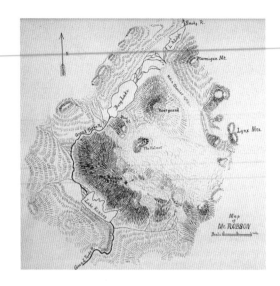

A.P. COLEMAN, Holograph Map, 1908. Arthur P. Coleman Collection and Arthur P. Coleman Online Exhibition, Victoria University Library (Toronto).

> Robson itself, seen from the new angle, had completely changed in shape. Instead of a somewhat irregular, flat-sided dome, it was a daring pyramid in the sky, with filmy clouds sweeping across, casting blue shadows on the pure white of the snow.[45]

After the one fine day, rain, snow and clouds returned to Mount Robson, and the climbers continued to wait. George Kinney passed the time by energetically climbing the lower peaks in the vicinity or hunting for grouse because they were running short of food. Lucius Coleman climbed Ptarmigan Mountain (Titkana Peak), but the clouds prevented him from seeing very much. He also went exploring on Robson Glacier and discovered the skeleton of a lynx among some rocks on the ice two or three miles up toward Mount Robson. The men decided to name the adjacent mountain Lynx in the animal's honour. When the food supply was reduced to just one more week, John Yates

set out with two ponies on September 3 with the intention of making a week's trip to Swift's on the Athabasca River to procure more food, but, fortunately, Adolphus was still camped in the Moose valley and could supply Yates with a large quantity of fresh and dried goat meat. Yates returned in the evening of September 4, just in time to take advantage of a day of good weather.

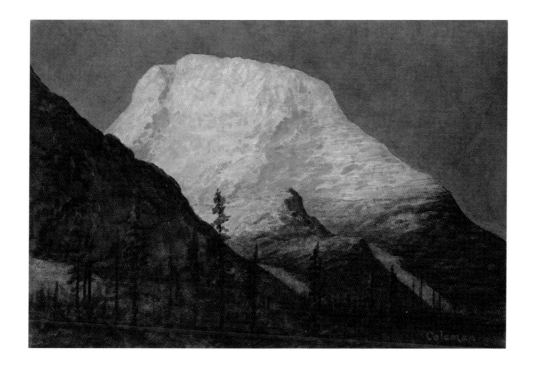

A.P. COLEMAN, *Sunrise on Mount Robson*, n.d. Watercolour over pencil, 67.9 x 99.7 cm. With permission of the Royal Ontario Museum © ROM.

At 3:30 in the morning of September 5, the summit of Robson was free of clouds and the sky was clear. At last the men would be able to climb, and they set out to ascend the Robson Glacier with "the top of Robson … delightfully rosy with the dawn."[46] The sunrise was so wonderful after many days of bad weather that Coleman later painted a large watercolour, *Sunrise on Mount Robson, B.C.,* as seen from near the camp in Robson Pass looking past the dark shoulder of Rearguard Mountain

toward the warm pink and orange north face of Mount Robson above. After two hours winding their way up the glacier's ridges, separated by crevasses, the four men were past Rearguard and could see Robson gleaming white in the morning sunlight.

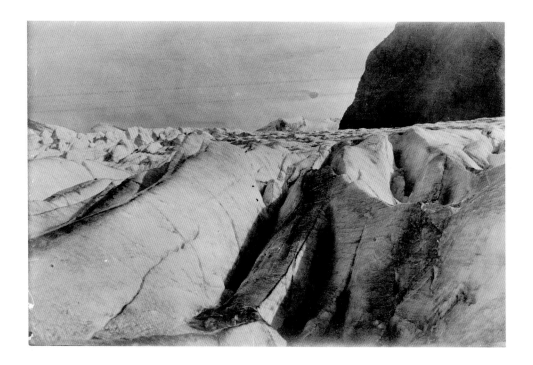

A.P. Coleman, *Photograph of Robson Glacier and not Mount Resplendent from near 9,000 ft. alt.*, c. 1908. Arthur P. Coleman Collection and Arthur P. Coleman Online Exhibition, Victoria University Library (Toronto).

Soon they were level with an enormous black, triangular rock on the southeast side of the glacier, nicknamed Extinguisher Tower because it resembles a candle snuffer. At this point, Robson Glacier bends at right angles toward Mount Robson and drops sharply, creating long crevasses that the climbers had to walk around, doubling the distance they had to travel. By noon they were four miles up the glacier, and the men stopped for lunch as they nervously watched ice blocks falling from

the hanging glaciers on Robson's southeast cliffs. After crossing the avalanche path at a safe distance, the climbers started to ascend a steep slope at 50 degrees or more, consisting of ice and snow and leading to a large dome shape (now known as The Dome).

Arthur Coleman had sprained his knee and was unable to help with the laborious task of cutting steps. His ice axe was given to Yates, and Coleman had to satisfy himself with Yates' homemade alpenstock, a wooden staff with a nail in the end. Coleman, however, immortalized the scene in a watercolour, *Cutting Steps, Robson Glacier*, showing three small figures – his brother Lucius, George Kinney and John Yates, ice axes in hand and joined by a rope – working their way up a steep slope in the midst of great blocks of ice.

By late afternoon the four men had reached an elevation of 10,300 feet. With their estimate of 3,400 feet of challenging snow and ice remaining to reach Robson's

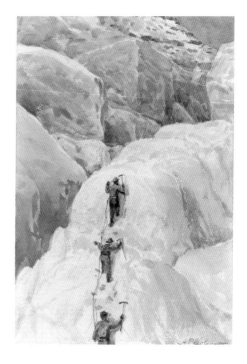

A.P. COLEMAN, *Cutting Steps, Robson Glacier*, 1908? Watercolour on cardboard, 26 x 18 cm. Arthur P. Coleman Collection and Arthur P. Coleman Online Exhibition, Victoria University Library (Toronto).

summit, the men realized they had too little time to accomplish their goal. Yates' feet were completely numb because he did not have proper climbing boots, an added incentive to start their descent. After marvelling over the array of mountains in the Robson amphitheatre, the men began to move slowly down, facing the icy wall and feeling for each toehold. As the angle became less steep, they were able to travel more quickly, finally enjoying a glissade to the main glacier, where they carefully threaded their way around the crevasses on their way to base camp.

After many hours of climbing on the ice, Arthur Coleman began to notice the contradictory

qualities of a glacier. In the early morning's frozen state, the glacier was silent, but with the after-noon thaw, the ice was alive with the musical sounds of running water. The hard, brittle surface of the glacier could support a great weight, but at the same time, the ice was fluid so that the shattered blocks in the icefall gradually moved down the valley, reshaped once more by the pressure of the moving ice into a solid mass. Coleman's fascination with Mount Robson's glaciers would lead to a worldwide study of glaciation throughout the rest of his life:

> I began to collect ice ages, as other persons collect stamps or engravings or old furniture; and the quest of things glacial led me into strange corners of the earth where traces of ancient glaciation had been described and might be studied.[47]

The first attempt to climb Robson came to a sudden halt when the men ran out of daylight hours to reach the peak and descend from the heights. They now realized the necessity of a camp higher up on the glacier if they were going to be successful. On the evening of the next day, September 6, they were ready to try again by filling their packs with blankets and food and balancing their heavy loads on the ridges between the crevasses as they climbed two miles up the Robson Glacier to the last bit of moraine without snow, near Extinguisher Tower. Coleman appears to have carried his watercolours and sketchbook with him because he painted *Camp on Moraine, Mount Robson* with two men, Lucius Coleman and George Kinney, sitting beside a cheerful campfire, a refuge in an austere landscape of ice with the looming challenge of Robson in the background. John Yates had helped to carry the essential gear to the high camp, but his experience cutting steps the day before had cured him of any desire to be a climber, and he returned to base camp before nightfall. In addition to his watercolour sketch of the camp, Coleman provides an evocative description of the scene before them in the evening:

> … looking across toward the pallid face of Mount Robson, on which the moon was shining. About us everything was submerged in darkness by the shadow of the Lynx behind us, so that the moonlit hanging glaciers and the snow dome rose above the dark glacier at our feet like a lovely vision outlined against a nearly black sky sprinkled with stars.[48]

Coleman is a sensitive observer, and his journal and sketchbook combine to create a traveller's ac-count of a wild but beautiful landscape that few people, if any, had seen before.

The clear skies of the evening did not last, and before morning, rain started to fall, increasing to

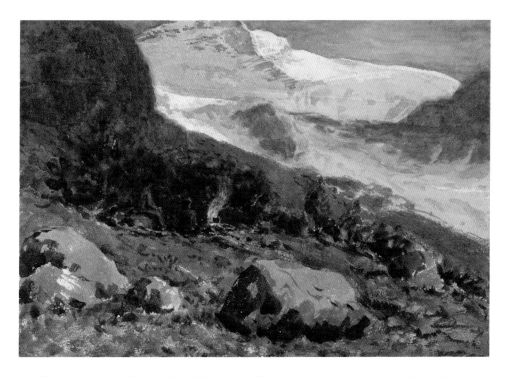

A.P. COLEMAN, *Camp on Moraine, Mount Robson*, n.d. Watercolour over pencil, touches of gouache, 17.8 x 25.4 cm. With permission of the Royal Ontario Museum © ROM.

a deluge during a thunderstorm. The three climbers were forced to return the next morning to their camp in Robson Pass to dry out. Rain continued all day with frost at night, but toward the evening of the next day, the sky cleared and they set out to climb the glacier to their camp on the moraine, where they found the bushes covered in snow. During the night, they endured a snowstorm. Again the men retreated, believing their chance to climb Robson in the 1908 season was gone.

George Kinney, however, had a daring plan to climb Robson on the north side where there was very little snow and no hanging glaciers threatening to launch avalanches of ice. Coleman was not surprised at Kinney's eagerness to try a different route, because throughout the expeditions of 1907 and 1908, Kinney had taken the initiative to explore on his own. When the party first approached

Robson in 1907, Kinney had gone ahead of the others and was the first to see Kinney Lake. In 1908, when bad weather delayed an attempt on Robson's summit, Kinney amused himself by climbing the lesser mountains nearby. Coleman speaks of Kinney's "immense pluck and a well-justified confidence in his powers as a climber,"[49] and despite the foolish and hopeless nature of Kinney's plan, Coleman realized, after having spent several months over two summers with the younger man, that Kinney "was used to working alone and was at his best when depending on himself."[50] Lucius Coleman decided not to accompany Kinney, because the plan did not seem to have any chance of success.

Kinney set out alone to climb Robson's north side at 4 p.m. during a snowstorm.[51] By the time he crossed the river below Berg Lake, daylight was fading, but he managed to climb

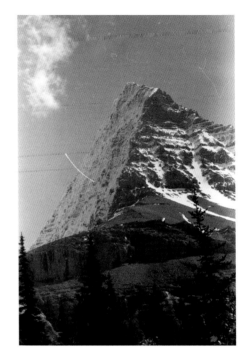

GLEN BOLES, *Looking up at Emperor Ridge and Emperor Face from near the falls, 1987.*

2,000 feet and camp on a shelf in a very cold wind. After a miserable night, he started for the summit. Soft, knee-deep snow covered the shale slopes at the bottom of the cliffs, and when he climbed the chimneys the snow was almost shoulder-deep. Despite being hampered by the snow, Kinney had nearly reached 10,000 feet and the top of the north shoulder by 10:30 a.m., but when he moved around to Robson's west side, he was hit by fierce winds that blew him off his feet three times as he crossed the shale. Kinney persevered in a westward direction for a mile, but finally had to escape from the gale by climbing gullies. When these couloirs became funnels for the blizzard, threatening to sweep him away, Kinney decided, at an elevation of 10,500 feet, that his only choice was to start down the mountain. He was true to his word and returned to his companions in two days, by the

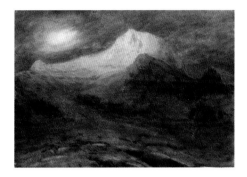

A.P. Coleman, *Mount Robson from Moraine at Dawn: Sun from Northeast*, n.d. Watercolour over pencil, 17.8 x 25.4 cm. With permission of the Royal Ontario Museum © ROM.

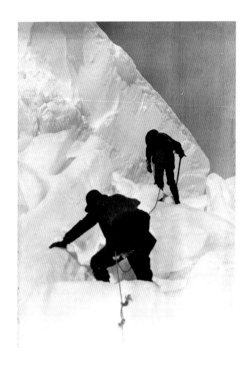

[George Kinney] Photograph No. 26, *Up walls of ice on second party climb of Mt. Robson, 1908.* Arthur P. Coleman Collection and Arthur P. Coleman Online Exhibition, Victoria University Library (Toronto).

evening of September 10. Coleman has high praise for the courage and perseverance of Kinney's solo attempt: "There are few men who would have run the risks alone which Mr. Kinney had braved in his splendid struggle for the top …"[52]

The defeated climbers planned to pack up and head east the next morning, but September 11 dawned without any cloud around Robson's summit. The rare prospect of perfect climbing weather proved irresistible, and once more they carried their packs to the camp high on the moraine beside the Robson Glacier. The sky was clear during the night, with the moon illuminating the entire landscape except for the shadowed glacier directly below. Coleman describes an enchanting vision of Mount Robson at dawn: "… the great snowy peak with its top tinged with heavenly rose, while a low moon hung in the blue-black sky to the west."[53] His watercolour *Mt. Robson from Moraine at Dawn: Sun from Northeast* is the visual counterpart to his journal entry. The viewer looks from the dimly lit glacier in the foreground to the dazzling white summit in the background with the moon above. The

shimmering peak is the goal, but the path over the glacier with all its dangerous crevasses creates a sense of foreboding.

The three men set out at 4:50 a.m. toward the cliffs under the glaciers hanging from Robson's southeast ridge, following closely their previous route and hoping they could cross the avalanche path before the ice blocks started to fall from above. By 7:45 a.m., with Lucius Coleman and George Kinney alternately taking the lead, the climbers started up a 50 degree slope of ice that required step cutting. Eventually, they found themselves surrounded by great "cubes of blue-green ice a hundred feet in diameter, tilted at all angles, propped with smaller blocks, but apparently just ready to topple over."[54] The deep loose snow covering the ice blocks allowed their feet to sink in an alarming manner. Kinney found a way to extricate the group from the ice maze by crossing snow bridges from one ice block to the next, often with threatening abysses on the left and right. Finally, after

The Coleman brothers and George Kinney climbed as high as the bergschrund at the base of the Robson's east arête, seen here in Glen Boles' photograph *Looking over at Mount Robson from the summit of Resplendent Mountain, 1987.*

cutting steps for 1000 feet, they reached the summit of The Dome. Coleman's first-hand experience climbing through the icefall became the subject of a large watercolour painting, *Main Glacier, Mount Robson, B.C.,* one that he undoubtedly painted in a safer place, possibly even at home in Ontario. His vantage point is perhaps below The Dome looking across the icefall with its enormous blocks and towers. The steepness of the slope is apparent in the composition sloping from the top right to the lower left. Even Coleman's signature is on an angle. Light and shadows define the

shapes and colours of the ice, creating a sparkling beauty tempered by the dangerous instability of the ice in the warm sunshine.

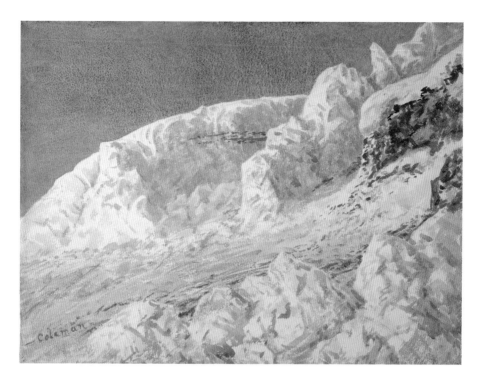

A.P. Coleman, *Main Glacier, Mount Robson, B.C.*, n.d. Watercolour over pencil, 47.6 x 65.4 cm. With permission of the Royal Ontario Museum © ROM.

From the summit of The Dome, the three men climbed, in just a half hour, to the bergschrund at the base of Robson's cliff, an elevation of 11,300 feet. It was now almost 5 p.m. and they had spent 12 hours crossing the glacier and ascending the icefall. With only a few hours of daylight left, they could not hope to reach the peak without spending a night on the mountain, and after Kinney's recent experience, that possibility seemed out of the question. After admiring the spectacular sea of mountains before them, the climbers began a perilous descent, feeling for footholds cut on the way

up and taking great care not to slip and drag everyone down 1,000 feet. Just as they were almost out of danger, two avalanches thundered down just 100 feet in front of them. In order to cross the avalanche path and reach safety, the men unroped and made a dash over the jumble of ice, slipping and tripping over the loose blocks. They finally arrived at their high camp on the moraine by 7:40 p.m., after 15 hours on snow and ice, and they decided to spend the night there to avoid threading their way past the crevasses on the main glacier in the darkness.

The next day, September 13, the three climbers descended to their camp in Robson Pass and helped Yates prepare to leave at once. As they packed, the clouds began to gather behind Mount Robson. The weather and the challenging conditions on Robson had defeated them for a second summer, but they agreed to try again in 1909. Arthur Coleman's work, however, prevented his leaving Ontario until the end of July, and the long journey to Mount Robson meant that climbing could not begin until late August, when the weather was less likely to be favourable. When George Kinney heard that a group of foreign climbers was planning to climb Robson in the summer of 1909, he made hasty plans to set out on his own in June,[55] hoping to claim Robson's first ascent for Canada and the new Alpine Club of Canada.

Mary Schäffer: Artist and Explorer

In August 1908, when the Coleman party was on the way to Mount Robson for the second time, two female explorers, Mary Schäffer and Mollie Adams, accompanied by their packers, Billy Warren and Sid Unwin, travelled on horseback from Swift's ranch on the Athabasca along the Yellowhead Trail as far as Tête Jaune Cache. Their motive was to see Mount Robson. Female tourists in the area were a rarity, and their appearance at Swift's and Tête Jaune caused quite a stir. A year previously, Mary Schäffer had completed her late husband's work by publishing *Alpine Flora of the Canadian Rocky Mountains*, illustrated with her watercolour plates. Now she was free to explore the mountain wilderness as she chose. Perhaps she was inspired to go to Mount Robson as a result of her fortuitous meeting with Arthur Coleman the previous summer during a snowstorm near Wilcox Pass. Her observations of life along the trail, along with her coloured lantern slides and photographs, offer a fascinating glimpse of the Yellowhead valley before the arrival of the railway.[56] During their delightful

visit with the Swift family, Mary Schäffer and Mollie Adams not only admired Mrs. Swift's embroidered buckskin jackets, gloves and moccasins but purchased all that were for sale. Once on the trails along the Miette River and through the Yellowhead valley, Schäffer found that the terrain lived up to its terrible reputation. The trail around Moose Lake was especially bad, alternating up and down between a rocky shoreline and the steep hillside. Although her artistic eye appreciated the beauty of the landscape, Schäffer wished the trail were shorter: "The hills beyond rolled away in soft undulations, but at the time, we were thinking far more of the length of them than of their artistic effect."[57]

Mary Schäffer, Lantern slide of Moose Lake [1908]. Whyte Museum of the Canadian Rockies (V527/PS-1-102).

Mary Schäffer, Lantern slide, *A bit of trail on the Fraser* . [1908]. Whyte Museum of the Canadian Rockies (V527/PS-1-103).

Beyond Moose Lake where the valley narrows, the trail became a dangerous track 200 feet above the Fraser River. At campsites on the north shores of Yellowhead and Moose Lakes, Schäffer was saddened by the burnt timber, evidence of careless campers. When Robson suddenly came into view, Schäffer and her companions were some of the fortunate travellers to see the great mountain without a cloud in the sky: "No doubting the highest peak in the Rockies – she spoke for herself. To our weary, sunburnt eyes she loomed refreshingly up from behind a hill, cold, icy, clean-cut, in a sky unclouded and of intensest blue."[58] Blackened trunks marred the landscape at Robson's base, but at night, with the valley in shadow, the travellers were treated to a wonderful sight as the aurora

constantly changed the colours of the snowfields on Robson's summit. At Tête Jaune Cache, a collection of log cabins, Schäffer discovered to her surprise that an inhabitant called Mr. Reading was also from Philadelphia and that they had mutual friends. The outposts of civilization at both ends of the Yellowhead Trail were certainly enjoyable, but Schäffer concluded her journey by reflecting on the coming of the railway and the loss of the wilderness as she knew it.

George Kinney's Heroic Struggle

Since George Kinney's claim that he stood on Mount Robson's peak on Friday, August 13, 1909, accompanied by his inexperienced companion Curly Phillips, much has been surmised about what may have happened in the storm and cloud near Robson's summit that day. We do know that Kinney's record of his climb, a small bottle containing names and a Canadian flag, was found 50 years later, in 1959, by an American, Leo Slaggie, high on Robson's west face below the Emperor Ridge.[59] This discovery is tangible evidence that Kinney and Phillips did manage to climb at least to this great height on Robson's treacherous cliffs in stormy weather, a feat in itself that inspires awe. In a letter to A.O. Wheeler dated September 23, 1909,[60] Kinney explains that he could not build a cairn at the summit because of deep snow and the lack of any loose rocks on the nearly perpendicular cliffs. Even if he had built a cairn, he says huge cornices, created by winds from the south and west, were liable to topple over, covering any record in snow or sending it thousands of feet down the side of the mountain. Instead, Kinney says, he found a rock outcropping, two feet wide and three or four feet high, with a crack large enough for his bottle, which he secured with a couple of fist-sized rocks. This natural landmark was located on his descent, as Kinney explains, about 1000 feet below the main peak.

Kinney's struggle just to reach the base of Mount Robson shows his indomitable spirit. He could not bear to think that foreign climbers might succeed on a mountain that had captured his heart over the two previous summers, and he felt very strongly that the Alpine Club of Canada should be honoured with the first ascent. Kinney had left Victoria on June 2, travelling first to Calgary and then on to Edmonton, where he intended to outfit his expedition. Money was a problem for Kinney. After borrowing some in Victoria, he could not take advantage of an Alpine Club of Canada grant

for $100 in Calgary, because the grant stipulated that Kinney have a climbing companion, and at the last moment, Kinney's brother was unable to go. Funds that Kinney counted on did not arrive at a bank in Edmonton, and he was forced to borrow $400 from a friend,[61] a large debt simply to climb a mountain. Kinney had telegraphed John Yates to enlist his help, but Yates left a letter in Edmonton saying that a trip to Robson at that time would be foolish in view of a late spring and snow on the mountain passes. Kinney, however, would not be dissuaded. He assembled his own outfit and supplies, and set out for Robson on June 11 with only $2.85 in his pocket, hoping to meet someone who would go with him.

His first companion, an old-timer called Mr. McBride, backed out after only a few days because high water in the rivers made them dangerous to ford. Kinney sold one horse and half of his food to McBride and then continued alone. After losing his main tent, tripod and very nearly his life in the swollen Rocky River, Kinney was faced with flooding in the Athabasca valley so severe that such high water had never before been seen. After one heavy downpour, he found himself stranded on a small island with his horses on another. Fortunately, Kinney was able to reach John Moberly's house, and the next day his luck changed when a 25-year-old guide named Curly Phillips appeared. Kinney was able to persuade Phillips to go on the Robson expedition, a trip both difficult and dangerous, but one that would have a positive outcome in establishing the young guide's career.

The journey to Robson, along the Yellowhead Trail, up the east branch of the Moose River and over Moose Pass had the usual rain, muskeg and fallen timber. One remarkable event near Moose Pass was a bad omen for the entire trip. Kinney, the sportsman who had frequently supplied game for the Coleman expeditions, was unable to shoot a bull caribou at 50 yards with his rifle. Phillips tried with nine bullets, but they all missed because the rifle barrel was cracked. Phillips had, unfortunately, decided to leave his rifle behind, and he knew Kinney's supplies would not be sufficient. Hunger would be yet another hardship, along with Robson's weather, that they would have to overcome.

On July 25, Kinney and Phillips established their base camp at the foot of Mount Robson, below Berg Lake, with a view of the thousands of feet of rock wall they hoped to scale. Over the next 20 days, on five separate occasions, the two men valiantly strived to reach the summit. Three of these climbs took two days, with cold and precarious nights on the mountain between days of extreme

effort. From July 26–29, Kinney and Phillips made two major climbs back to back, reaching an elevation on the second attempt of more than 12,000 feet before the warmer temperatures with the danger of avalanches forced them to descend. Unfortunately they were delayed on their descent on July 29 because Kinney went searching for an easier route on the west shoulder, and they spent another night on the mountain in a snowstorm, with extreme cold and terrible winds. They were lucky they did not freeze.

Over a week of bad weather followed. Climbing was impossible but Phillips made good use of his time by exploring Kinney Lake and finding three ways up the Valley of a Thousand Falls, one of them a game trail that Phillips believed could be used by pack horses. He also took three days to go hunting in the Smoky River area but with little success, except for some fool hens he could shoot with his revolver. Kinney and Phillips then made two more attempts to climb Robson, but each ascent lasted only a day before being defeated by snow at higher elevations. Their fourth climb, on August 9, was followed by three days of stormy weather. By now the total elevation gain for their Robson climbs, not including climbs of lesser peaks during poor weather, was around 23,000 feet. Their food supplies were very low, and Kinney knew they could manage only one more climb of two days' duration.

On August 12, the weather improved, and they reached the top of the west shoulder at 10,500 feet. Dawn on August 13 was clear with a very cold wind. Threatening clouds were building up in the south when they started up the west face, making rapid progress on the hard snow. Robson's summit was shrouded in cloud as they came to the first of the horizontal bands, and snow started to fall when they reached the second band. Kinney realized that a snowstorm would mean total defeat because of the risk of avalanche. By a stroke of good fortune, the snow did not continue, and although enveloped in cloud, the men decided to continue their ascent, veering to the south in the direction of Robson's peak. The mist was a blessing, preventing them from seeing the abyss below as they spent hours on a very steep slope, often more than 60 degrees, where one slip would have been fatal. Their laborious ascent over the cliffs was possible by using the firm snow in the draws between, but every few minutes they needed to rest by distributing their weight on handholds and toeholds, leaning against the wall of snow. Their hair and clothes were frozen by this time, and sleet had cut their faces.

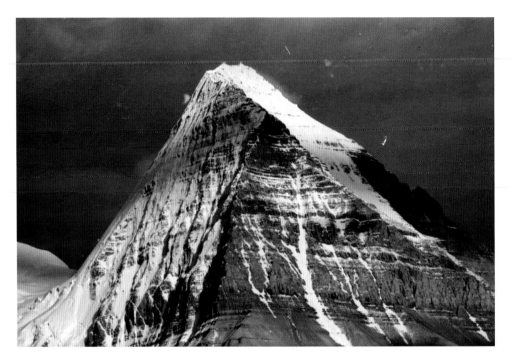

GLEN BOLES, *Telephoto of Emperor Ridge from the meadows east of Mount Whitehorn, 1988.* Kinney and Phillips angled across the snow shown here on the west face (right) toward the summit. Kinney reports that they fought their way through the ice hummocks near the summit.

Two more almost impossible obstacles awaited the intrepid climbers as they angled up the west face toward Robson's summit. The cliffs about 500 feet from the peak had overhanging snow that was so dry they could not find firm footholds. After a desperate struggle up these last cliffs, they discovered Robson's last great trial for them – the gargoyles. Kinney explains how winds from the south and west had driven the snow "out against the wind in fantastic masses of crystal, forming huge cornices all along the crest of the peak."[62] With one last supreme effort, they floundered through the loose snow of the cornices to Robson's summit, where Kinney claims he used his ice axe to make a small hole in the cornice beside his feet and found he could see Berg Lake far below. He concludes, "I was on a needle peak that rose so abruptly that even cornices cannot build out very far

on it."[63] After a brief break in the clouds allowed them to see the valleys below, including the silver thread of the Fraser, the fog rolled in again making photography impossible. Their descent over the three cliffs with the overhanging snow was extremely difficult, but up until now Kinney and Phillips had been blessed with cool temperatures, reducing the risk of avalanche. When they descended to 12,000 feet, they were in the greatest danger of the entire climb because the temperature had risen and the snow was melting. Now the men carefully worked their way around the exposed rock and ice where they could not find secure footholds. The climb down took considerably longer than the ascent on hard snow. Finally, after seven hours of a fearful descent, they were able to unrope and reach their camp on the west shoulder, only stopping now for something to eat before going all the way down to the base camp in the darkness.

No one can deny the tenacity, endurance and courage displayed by Kinney and Phillips. Their supreme effort in climbing a very challenging mountain, without the financial backing of a well-organized expedition and without a professional guide, was simply amazing. Kinney had been a member of the Alpine Club of Canada since its beginning, and he was known for his solo ascent of Mount Stephen on October 21, 1904, carrying 50 pounds of camera equipment, an accomplishment admired by A.O. Wheeler.[64] Curly Phillips, however, did not have any climbing credentials, because he had never before attempted to climb a mountain. Nevertheless, Kinney has the highest praise for his companion in his answer to Wheeler's letter of congratulation, saying that the successful ascent of Robson was due in large part to Phillips. Kinney recommends Phillips to the club, remarking particularly on his speed and caution when climbing.[65]

In the same letter, Kinney responds to Wheeler's request for evidence of their ascent of Robson that could not be challenged by the international climbing community. In addition to the description of the location of his summit record some distance below the snow covered peak and the unfortunate lack of photographs on the cloud-covered summit, even though Kinney says he carried his camera to Robson's peak, he offers witnessed certificates as evidence. One is Phillips' testimonial that he climbed Robson with Kinney, giving the dates of their climbs and the elevations. Another certificate has the signatures of Leopold S. Amery and Geoffrey Hastings, two members of the British party that included Arnold L. Mumm and his Swiss guide Moritz Inderbinen, who were on their way to climb Mount Robson in the summer of 1909 after recently attending the Alpine Club of

Canada's camp at Lake O'Hara as honoured guests. These were the foreigners who Kinney feared would deprive his club of the first ascent of the highest peak in the Rockies. Now on his return, Kinney received their congratulations and asked Amery and Hastings to sign a document attesting to the fact that they had met Kinney and Phillips near Yellowhead Pass claiming to have climbed to Robson's peak. Kinney admits he had hoped for more proof, but feels that what he can offer should satisfy most people.

A letter from A.O. Wheeler to George Kinney the following spring[66] shows that the Alpine Club of Canada deeply appreciated the achievement of Phillips and Kinney, and the executive had voted a $100 gift to recognize their ascent of Robson. Wheeler also suggests that an official account of the climb should be published before the Englishmen, unsuccessful in 1909, tried again in the summer of 1910. Kinney's gracious reply ten days later[67] indicates his gratitude for the generosity and kindness of the club. He also promises an article for the *Canadian Alpine Journal*, which was published soon after in Volume II, number 2 (1910), following the account by Arnold L. Mumm of his 1909 expedition to Robson. Initially Kinney's report of his climb appears to have been accepted by Wheeler and the Alpine Club of Canada. Kinney was appointed an adviser to the club in 1910, and in 1911 Wheeler invited him on the joint scientific expedition to Mount Robson sponsored by the Smithsonian Institution and the Alpine Club of Canada.[68]

British Expedition to Mount Robson, 1909

The British climbers who met Phillips and Kinney near Jasper on August 24 had left the Lake O'Hara Camp on August 8, climbed over Abbot Pass to Lake Louise and caught the train to Calgary and then on to Edmonton, where A.G. Priestly, a friend of Hastings, joined them. John Yates, their packer and guide, was unable to meet them in Edmonton, forcing them to take horse-drawn buggies as far as Wolf Creek, where another packer, James Shand Harvey, agreed to take them to Prairie Creek (Hinton) to meet Yates.[69] Shand, contrary to his appearance as a packer on the edge of the civilized world, was a member of the Scottish aristocracy, and he astonished his companions one night when he informed them he had known one of their masters at Eton.[70] Shand continued with the expedition, with Yates guiding them over the Yellowhead Pass to the Moose valley, where they

spent some time exploring the western branch of the Moose River and climbing the glacier at the head of the valley to gain magnificent views of Mount Robson and the mountains surrounding the Robson Glacier. Their descent at night over the headwall and through the forest below proved to be such a nightmare that they did not return to their camp until 29 hours had elapsed. Mount Robson was proving more challenging than they had imagined. The climbers then followed Yates up the east fork of the Moose River, and by September 5 they had pitched their tents where Kinney and the Coleman brothers had camped a year earlier.

The next morning they climbed up Extinguisher Tower to study the route to Robson's summit. Inderbinen was confident that a successful ascent could be made in nine hours. After leaving a cache of provisions under a rock, they returned to base camp to prepare for a very early start at 1:15 a.m. on September 7. Warm temperatures had softened the snow on Robson Glacier, and the climbers moved slowly, with the guide working very hard to cut steps. They were on top of The Dome by 10:30 and at the bergschrund at the base of Robson's east wall by 11:00, the point reached by Kinney and the Colemans in 1908. Inderbinen showed great skill in crossing the bergschrund without a snow bridge, allowing the others to follow easily. Now they were on a very steep slope, climbing a gully beside a rocky rib. By 2 p.m. they found a narrow opening that would allow them to overcome the overhanging rock and snow and reach the top of the southeastern ridge in about an hour. Now a discussion ensued about whether or not to continue climbing up. Mumm realized that even if they could reach Robson's peak in about three and one-half hours, they would not be able to descend quickly enough to avoid spending the night on the ridge or the wall above the bergschrund. Hastings agreed they should start down immediately, but Amery wanted at least to reach the top of the ridge to see the route to the summit. Mumm and Hastings prevailed, and no sooner had they begun their descent than an avalanche of ice blocks shot through the opening in the rocky belt they had intended to use to gain the crest of the ridge. A second avalanche quickly followed, with ice and rocks falling within a few feet of the climbers. Inderbinen laconically remarked, "We should all have been kilt."[71]

Once safely across the bergschrund, Inderbinen led the descent along the trough between the eastern wall and The Dome in the direction of the col at the head of the Robson Glacier, eventually finding a gentler slope leading down to the glacier. The climbers reached Extinguisher Tower as the

light faded, and then made their way down Robson Glacier in complete darkness and a heavy downpour, arriving in camp after 23 hours. The rain lasted for three days, and by September 11 they had given up on climbing Robson again. Amery and Yates, however, had plans for another adventure. Together with Amery's brother, Captain Amery, who had joined the party on September 6 after travelling almost non-stop from Khartoum in Sudan, they decided to set out from Tête Jaune Cache to canoe down the Fraser, eventually arriving at Ashcroft. Mumm, Hastings and Priestly returned the way they had come, taking advantage of the new Grand Trunk Pacific Railway from Entwhistle to Edmonton.

Mumm Returns to Robson with J.N. Collie, 1910 and 1911

A.L. Mumm organized his second expedition to Robson with the distinguished British climber J. Norman Collie in the summer of 1910. Mumm and Inderbinen again requested John Yates as guide, and Collie brought along his own guide, Fred Stephens.[72] The expedition retraced the route Yates had taken with the Colemans and Kinney in 1908, over Yellowhead Pass and then north along the Moose River. After crossing Moose Pass, they were able to locate the Smoky River to the west. By following the Smoky to its source, they came to Mount Robson, but cloud prevented them from making an attempt on the summit. Instead, they climbed some smaller peaks. Two that Collie named are Mount Mumm (2962 m), after his companion, a well-known member of the Alpine Club, and Mount Phillips (3249 m), to honour Curly Phillips, the novice mountaineer who followed George Kinney up Robson's dangerous cliffs. When the weather did not improve, the expedition headed north to explore the Smoky River valley. The party discovered an easy pass over the Continental Divide into British Columbia, bringing them close to Mount Bess (3216 m), named by Yates after Miss Bessie Gunn, a member of the expedition.[73] On their return to the railhead at Wolf Creek, they found a pass leading from the Smoky River valley to the Stoney River (now known as the Snake) that brought them to the Athabasca River in the vicinity of Jasper. Mumm and Collie were so pleased with their explorations that they again hired Yates and Stephens in 1911 and spent a week near Mount Bess, allowing them to make a first ascent along with Inderbinen and Yates, who proved to be a skilled mountaineer.

Alpine Club of Canada's
Expedition to Mount Robson, 1911

The publicity surrounding the climbing of Mount Robson in the previous four years and the construction of the Grand Trunk Pacific Railway west of Jasper persuaded A.O. Wheeler to propose an expedition to the Robson region in 1911. His specific purpose was not the ascent of Mount Robson but rather to fulfill the club's mandate of opening up new areas for climbing and recreation. He wanted

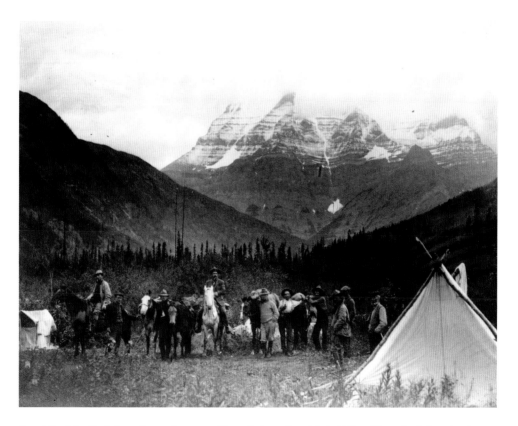

Grand Trunk Pacific Railway Survey Party near Mount Robson, Grand Forks Valley, Alberta [sic], Canada, 1913. Photographer unknown. Canada Science & Technology Museum, CN collection, CN002374.

to explore with the intent of having the annual camp of the Alpine Club of Canada at Robson. A topographical survey was also uppermost in his mind, and he reports in the *Canadian Alpine Journal* that his party climbed 30 mountains ranging in elevation from 7,000 to 11,000 feet.[74] The Grand Trunk Pacific contributed generously to defray the expenses of the expedition, because a survey would help to establish sites for hotels and chalets. The railway also wanted publicity to attract tourists to mountains along the line.

In his letter to A.O. Wheeler dated March 21, 1910, George Kinney says he had been approached by the Montreal office of the Grand Trunk Pacific to contribute photographs and accounts of his climbs on Mount Robson to an illustrated pamphlet on the Yellowhead valley and Mount Robson. The railway had already commissioned George Horne Russell to paint the Rockies and the Skeena River district in 1909, and his Mount Robson canvas, along with others inspired by his trip west, was sent to the International Exposition in Brussels.[75] The Grand Trunk Pacific was following the example of the Canadian Pacific, which had constructed its line through Banff and Lake Louise to the south. The CPR had provided free passes to photographers and artists specifically to obtain advertising material, but this practical purpose, at the same time, created an enduring legacy of mountain images.[76]

Originally, Wheeler had organized a small group from the Alpine Club of Canada, including Austrian climbing guide Conrad Kain, photographer Byron Harmon, Wheeler's assistant George

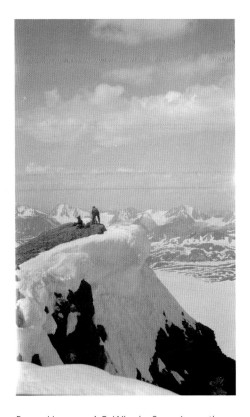

Byron Harmon, *A.O. Wheeler Surveying on the Summit of Lynx Mountain, 1911.* Whyte Museum of the Canadian Rockies (V263/NA-970).

Kinney and outfitter Curly Phillips. When the federal government and the governments of British Columbia and Alberta offered support and money for an expedition that also included a study of natural history, Wheeler readily agreed to increase the scope of his proposed trip. He turned to Canadian scientists, but they were not interested. Dr. Charles Walcott of the Smithsonian Institution, however, enthusiastically endorsed the idea and sent five men to work with Wheeler: N. Hollister, assistant curator of mammals; J.H. Riley, ornithologist; Paul C. Standley, botanist;[77] and big game hunters Charles H. Walcott Jr. and H.H. Blagden. The larger group required more pack horses, so a second outfitter, James Shand Harvey, assisted Phillips. Various levels of government issued permits to obtain specimens of animals and birds in the cause of science. The results of the natural history study were published in Wheeler's long article in the *Canadian Alpine Journal*,[78] with photographs and detailed descriptions of each specimen. The number of specimens in the collection of wild animals, represented by so many photographs, is troubling in view of the present focus on conservation in our provincial and national parks. Wheeler's foresight, however, in organizing an expedition that promoted science, tourism and recreation undoubtedly influenced the decision by the B.C. government to create Mount Robson Provincial Park in 1913.

A year in the life of A.O. Wheeler

Wheeler's 1911 Diary offers a fascinating glimpse of his daily activities, diligently pursuing his occupation as a land surveyor as well as promoting the interests of the Alpine Club of Canada by organizing and leading a two-month expedition to Mount Robson.[79] From his home in Sidney, British Columbia, Wheeler wrote to the Grand Trunk Pacific Railway on January 5, offering to do a topographical survey of the Yellowhead area in return for financial support of his proposed expedition. Near the end of February, the railway replied by accepting his offer and granting him $2,500 as long as he fulfilled certain conditions. Although these conditions are not specified, one of them undoubtedly was the undertaking of a search for possible sites of hotels and chalets that would provide accommodation for tourists travelling on the Grand Trunk Pacific. By the second week in June, Wheeler was on his way to the mountains on the train, stopping overnight in Glacier and then on to Hector, where he spent two days choosing the location for the annual camp that would take place

later in the summer in the O'Hara area. On June 17 he arrived at the clubhouse in Banff, and for the next ten days he organized the Robson trip while Conrad Kain was kept busy building a storehouse underneath the main building and George Kinney helped pack the food and gear. On June 29 the three men took the train to Edmonton, the start of the Yellowhead expedition.

Wheeler's men could travel west from Edmonton much more quickly and easily than earlier explorers because the Grand Trunk Pacific had laid track as far as Fiddle Creek. On the day of departure, July 1, Wheeler was invited to ride in a private railway car attached to a construction train, while the rest of the men and their gear rode in a boxcar. Train travel, however, did have its dangers. When the engine was crossing a bridge over Fiddle Creek, the structure collapsed, causing the engine to crash into the water. Fortunately, the entire train did not leave the tracks, and, apart from the engineer's broken rib, no one was seriously hurt. Curly Phillips arrived with the horses, and the expedition headed west with the pack train toward the Yellowhead Trail. Along the way, railway construction provided constant reminders that civilization was invading the wilderness.

At the junction of the Moose and Fraser Rivers, Wheeler's men arrived, on July 11, at a Grand Trunk Pacific Railway camp called Mile 17, or Moose City, a raucous place of gambling, prostitution, bootleg liquor and thievery. Conrad Kain's clothes were stolen, along with a large amount of food and even the cook's stove, which had to be replaced at double the original cost. Shots were heard in the night, but no one was wounded.[80]

The negative impression of Moose City was soon forgotten when Wheeler discovered, near the railway camp, the Moose river canyon with two beautiful waterfalls that he named Rainbow Falls because they are located in the Rainbow Range. Twelve miles from the railway camp, up the west branch of the Moose River, the men found a small emerald lake enclosed by trees that stretched across the head of the valley, an idyllic spot for a chalet that would give climbers access to many inviting peaks. Situated below the southeast sides of Resplendent and Lynx Mountains, the valley's spectacular scenery is reflected in Wheeler's name for it - Resplendent Valley. On a ridge to the west, he had his first sight of Mount Robson:

> From the crest of the ridge, through an opening in the trees, we saw high in mid-air, out-topping all around, a beautiful, apparently crystalline formation. It showed isolated, sharp and absolutely white against a sky of perfect blue, and seemed to belong to a world other than ours.[81]

Wheeler began his survey on July 15 by making the difficult climb from the Resplendent valley to a ridge on Lynx Mountain, 900 feet below the summit. His brief notes, pencilled into his pocket diary, reveal a strenuous itinerary of climbing mountains day after day, encumbered with photographic equipment and survey instruments. After reaching an elevation providing suitable views of the surrounding landscape, he would spend hours working before he could descend to camp. Most often, Wheeler was assisted by George Kinney and Conrad Kain, both of whom were paid by the Alpine Club of Canada. On the climb to the first photographic station, Lynx Centre, the three men were joined by Byron Harmon. When they ascended to the ridge just after 3 p.m., they were rewarded with a marvellous view of the Robson amphitheatre in brilliant sunshine:

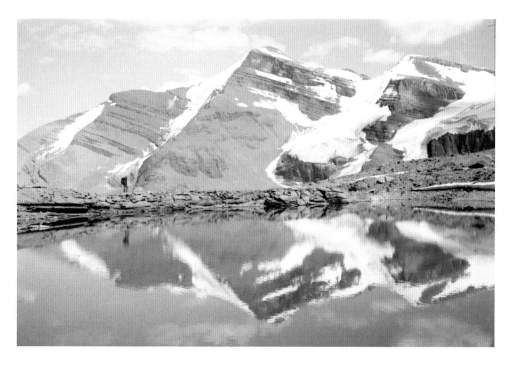

GLEN BOLES, *A small tarn on the west side of the Robson Glacier with Lynx Mountain in the background, 1987.*

It was a glorious day, and the whole wonderful panorama lay before us. So stupendous, so superb, so unexpected was it that we were struck dumb with amazement. Across a wide river of ice where the most minute details of crevasses, icefalls, séracs [and] moraines, [*sic*] were sharply outlined in the thin clear atmosphere rose the great massif of Robson, standing alone and rising supreme above all other peaks. Its northeastern walls, sheer drops of 8,000 feet, were in full view.[82]

The next day, Wheeler and Kain again climbed Lynx Mountain to establish the Reef Glacier Station to the north of Lynx Centre, on a ridge extending from Lynx Mountain and overlooking Snowbird Pass which leads from the Reef snowfield on the east to the Robson Amphitheatre. In the distance beyond Ptarmigan Mountain (Titkana Peak), Wheeler could see Robson Pass, where he looked forward to holding the annual camp as soon as the railway could bring the club members close to Robson's base in the Fraser valley. On the way up the east arête of Lynx, Wheeler almost had a fatal accident when he slipped on the ice. Miraculously he stopped sliding before going over the edge. He was very impressed with Kain's instantaneous response to save him had he not been able to stop by himself. A few days later, when Kain saw a distinctive summit among those surrounding Resplendent valley, one that had a rocky finger rising dramatically from a snow-covered mountain, he exclaimed, "That is my peak!"[83] Wheeler responded by naming it Mount Kain (2880 m) in his honour.

As the expedition progressed from the Resplendent valley on the west branch of the Moose River to the east branch, then north to Moose Pass and over the Continental Divide to follow the Smoky River south to Robson Pass and Berg Lake, Wheeler assiduously continued his topographical survey. Despite the physical demands, minor ailments and usual bouts of inclement weather, Wheeler's diary shows a sense of accomplishment in the survey and the natural history study. The men formed a congenial group, pursuing their own interests but also lending a helping hand when necessary. The naturalists would go in different directions to collect specimens. Byron Harmon took some wonderful photographs, and at times, George Kinney, also an accomplished photographer, would join him. Kain was occasionally allowed to leave a survey station early to go off on his own. On August 10, from a fly camp in Robson Pass, Wheeler and Kinney went to the Robson Glacier to make marks on prominent rocks and measure the ice, while Harmon and Kain went out to photograph

BYRON HARMON, *Camp at Calumet Creek, 1911*. Whyte Museum of the Canadian Rockies (V263/NA71-1148). Carole Harmon, granddaughter of Byron Harmon, has identified the men in this photograph in *Rainbow Mountains: Centennial Exhibition*, a catalogue of Byron Harmon's photographs taken in 1911 during the trip to Mount Robson: (left to right) James Shand-Harvey, George Kinney, Conrad Kain (closest to tree), Curly Phillips, Charles H. Walcott, H.H. Blagden, N. Hollister (back), J.H. Riley and A.O. Wheeler (far right).

Resplendent Mountain, and the two could not resist a first ascent. Two days later, when Wheeler's plans to climb a snow-covered peak to the west were thwarted by the weather, Kain had some free time and he slipped away by himself to climb Whitehorn Mountain.

The ascent of Whitehorn was uneventful, reminding him of scrambling up Mount Stephen.[84] Once on the summit, he could not build his stoneman, or cairn, because the peak was snow covered, so instead he climbed down until he found some rocks to secure a matchbox with his name and the date. Kain's descent was extremely dangerous because he had to cross a glacier in darkness during

BYRON HARMON, *Robson Yellowhead Trip, 1911*. Whyte Museum of the Canadian Rockies (V263/NA-6040). Conrad Kain is seen descending from the summit of Resplendent Mountain.

a thunderstorm. He was grateful for the lightning flashes as he used his ice axe to feel for crevasses. Kain realized a few days later, when he saw his tracks on the glacier, that he had been very lucky to take such a foolish chance and survive. Wheeler, who thought highly of Kain's climbing abilities and believed the guide had reached Whitehorn's summit, felt that the climb would not count as a first ascent in the eyes of the world because of a lack of evidence. Unless the cairn containing the matchbox were found, Kain's word was not sufficient. Fortunately, at the ACC camp in August 1913, a group guided by Walter Schauffelberger discovered the matchbox with Kain's signed note about 20 to 30 feet from the peak.

As the expedition worked its way around Mount Robson, Wheeler realized the aesthetic appeal of this wondrous alpine landscape. He predicted that the Robson Glacier would attract tourists who

GLEN BOLES, *Mount Whitehorn from the flats below Berg Lake, 1987.*

would be able to see the effects of glacial erosion and the amazing scenery under the northeast wall of Robson. The view from the summit of Mumm Peak looking toward Robson's northwest face was so spectacular that Wheeler felt words could not begin to do it justice. When pony trails could be constructed, he envisioned a chalet at Berg Lake that would enable visitors to watch the ice thundering down the glacier and crashing into the lake. Wheeler was fascinated by the Valley of a Thousand Falls, where the river, after flowing out of Berg Lake, goes through a narrow gorge and plunges at a steep angle over a series of cliffs. The most spectacular waterfall, which Wheeler named Emperor Falls, is created when the water strikes a ledge on the way down and shoots dramatically up into the air. Not content with watching Emperor Falls from the side, he explored the gorge with Kinney. Wheeler suggests a more exhilarating – but not advisable – viewing platform can be attained by crossing the river below the waterfall, on a narrow ledge drenched with spray, and looking up:

It is wonderful! You are almost under it and the frantically leaping water can only be described as sheets of spray hurtling through the air as the torrent comes racing down the steep incline.[85]

When Wheeler continued his survey from the peak of Little Grizzly (Cinnamon Peak), a mountain to the southwest of Mount Robson, he was able to see Kinney's route on the west face in his bid for the summit in 1909. As an experienced mountaineer aware of sudden changes in weather and the threat of avalanches, Wheeler recognized at once that Kinney and Phillips had been in considerable danger. He believed that the thick cloud on the day of their final ascent had probably saved their lives by preventing a rapid snowmelt that would have triggered avalanches. Wheeler had first encouraged Arthur Coleman to go to Robson, if possible to capture the peak for

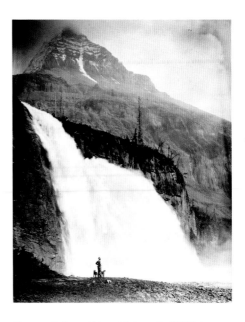

Emperor Falls and Mount Robson [c. 1910]. Image F-02058 courtesy of Royal BC Museum, BC Archives. The man with his two dogs gives a sense of the scale of the waterfall, with Robson's pyramid soaring behind.

the new Canadian alpine club, and although a first ascent would enhance the club's reputation, he certainly did not want a member plunging to his death from Robson's cliffs. He decided that the safest, fastest route to Robson's summit was the one Coleman had attempted on Robson's east side.

When the expedition camp was moved from Berg Lake to a gravel plain near Kinney Lake, the men pitched their tents on a small island on the delta. Wheeler could envisage campgrounds and boating on the lake, even a log chalet as a base for climbing. He hoped that a driving road will soon connect Kinney Lake to the proposed railway hotel at the junction of the Fraser and Grand Forks, similar to the arrangement at Field with Mount Stephen House and the road to Emerald Lake. The railway, however, ran out of money, and not all of Wheeler's dreams were realized. He was certainly

66

right in imagining the popularity of the Mount Robson area, especially Kinney Lake, the Berg Lake trail, Mumm Basin and Snowbird Pass.

After a complete circuit of Mount Robson of more than 85 miles, Wheeler continued his photographic survey when the expedition headed east again and camped a mile beyond Moose Lake. On August 27, after a difficult climb, Wheeler, Kinney and Kain established two survey stations on the summit of Mount Mowat. The next day, they moved their camp to the narrows of Yellowhead Lake. Low cloud and rain delayed the survey until September 1, when the three men ascended to a peak above Yellowhead Lake, probably Yellowhead Mountain. With just one more station located on a rocky bluff above Yellowhead Pass, Wheeler completed his arduous task of surveying Mount Robson and the Yellowhead valley. He was ready on September 3 to place a large post with an inscription in the pass, marking the boundary between British Columbia and Alberta.

In December 1911, from his home in Sidney, British Columbia, Wheeler started a map of the Robson region based on his photographic surveys. The map, apart from a few name changes, is similar to the one we know today. It was published with Wheeler's detailed account of the Yellowhead expedition in the *Canadian Alpine Journal* (1912). Wheeler concludes his extensive report with the conviction that the Robson area has tremendous potential to attract "the scientist, the mountaineer [and] the artist" to an alpine landscape unsurpassed in Canada:

> … the alpine scenic combination of snow-covered mountain, ice-encircled amphitheatre, tumbling glacier, turquoise lake and leaping waterfall beheld at the immediate vicinity of Robson Pass is distinctly unique, and nowhere throughout the whole of Canada's mountain areas can more striking, more impressive or more lasting memories be secured.[86]

ACC Mount Robson Camp, 1913

When Alpine Club of Canada members arrived at Mount Robson for the annual camp, July 28 to August 9, they were welcomed by William W. Foster, on behalf of the British Columbia government, to the new Mount Robson Provincial Park.[87] The Grand Trunk Pacific again offered generous help by transporting members and a half-dozen guests on a special train from Edmonton to the Mount Robson siding. The railway even provided a station agent who stayed for the duration

of the camp to assist the visitors. Once off the train, the mountaineers followed a tote road to the base camp for the first night, before making the 15-mile trek to the Robson Pass camp the next day. The trail up the Valley of a Thousand Falls was now possible for pack horses because the British Columbia government had hired Curly Phillips to build some trestle bridges extending from the cliffs near Emperor Falls. Phillips was also the camp outfitter, along with the Otto brothers, but he is chiefly remembered for his startling announcement in camp one night that he and George Kinney had not quite reached the summit of Mount Robson in 1909. This revelation occurred just after Conrad Kain, William W. Foster and Albert H. MacCarthy returned from their successful climb to Robson's peak. Since then, Kain has been given credit for leading the first official ascent of Robson, and Kinney's efforts have been clouded in controversy.

Conrad Kain's Ascent of Mount Robson

Many mountains in the Robson area were climbed from the main camp, including Resplendent, Lynx, Rearguard, Mumm, Gendarme and Whitehorn, but the focus was on Robson. Wheeler and the Alpine Club executive carefully chose the two climbers to accompany Conrad Kain – the American MacCarthy and the Canadian Foster – and suggested a route similar to earlier attempts by Coleman and Mumm because Kinney's route on the west face appeared far too dangerous. Two years earlier, while assisting with the survey, Kain had had the opportunity to study a possible route on Robson's east side. Now, on July 30, the three men established a high camp at the base of Extinguisher Tower.

At 4:15 the next morning they set out with light packs, intending to reach the summit and descend before nightfall.[88] The sky was clear, and Kain led his companions over the glacier in the half-light of dawn to a wall of ice and snow leading to the summit of The Dome, which they reached by 7:30 a.m. The next challenge was the bergschrund at the base of the east wall that had defeated Coleman in 1908. Kain found a way across by cutting steps down into the bergschrund and up the other side.[89] Now the three climbers were faced with a 2,000-foot precipice of rock covered with a thin coat of ice. Kain heroically cut hundreds of steps up the steep slope while Foster and MacCarthy waited in a bitterly cold wind, straining to keep their feet in the ice steps. Slowly they moved up

GLEN BOLES' photograph *Looking southeast at Resplendent Mountain from above the icefall, 1977* shows members of his party ascending the icefall below The Dome in their successful ascent of Mount Robson by following Kain's route.

the wall, all the time threatened by the danger of avalanches from overhanging snow above. This wall became known as the Kain Face to recognize the guide's supreme effort in leading his companions to the top of the southeast ridge.

The arête, worn to a knife-edge, took them to a small snowfield below the summit pyramid where they found great domes of rock and ice resting on one another, "the exposed portions swept clear by raging storms reveal[ing] clear green ice scintillating in the sunshine."[90] The climb to the summit ridge proved to be a formidable challenge, with snow formations that Kain had never seen on any other mountain. Great walls of snow, some 15–20 metres high, were separated by snow-covered ledges where Kain sank to his hips. Finding a route up these snowy terraces was so difficult that Kain was forced to cut steps up an almost perpendicular couloir. Once above the couloir, conditions improved, and they climbed a steep snow slope, three abreast, to the summit ridge. Foster and MacCarthy followed Kain along the snow-covered ridge to Robson's peak. Kain announced their arrival on the highest summit in the Rockies by saying simply, "Gentlemen, that's so far as I can take you."[91] The time was 5:30 p.m., and they stayed at Robson's summit for only 15 minutes. Foster describes the incredible panorama of eight or nine thousand square miles of alpine landscape as "a sea of mountains, glaciers, snowfields, lakes and waterways, displayed in endless array."[92]

After a difficult ascent of the east face above the bergschrund, Kain and his party reached the east arête. Glen Boles' 1977 photograph shows some of his companions on the arête, heading for The Roof, the upper thousand feet of Robson.

By now the rope and the climbers' clothing were frozen. Kain knew they would have to spend the night on the mountain, but he hoped to climb down far enough to avoid dangerously low temperatures. He descended the first thousand feet below the peak, now known as The Roof, again finding the steep couloir difficult because the steps had been covered by snow. From the shoulder, Kain decided to try going down on the glacier on the south side, but after a short distance they came to a precipice and were forced to climb back up. Now the only possible descent route was an icy trench between the glacier and the rocks, and Foster and MacCarthy waited while Kain cut steps for an hour, trying to keep everyone's spirits up by talking about a campfire in the trees. By 10 p.m., after 17 hours of climbing, they had to stop on a rocky ledge only six and a half feet wide. After

After conquering the summit pyramid, The Roof, Kain led his companions toward the summit. GLEN BOLES' photograph, taken in 1977, shows the cornices on top of Robson, looking northwest, with the summit knob in the upper left.

constructing a small wall for shelter, Foster and MacCarthy secured themselves to the rock and tried to keep their feet warm by putting them into the same rucksack. From their perch, they could see, far below, the campfire of the Alpine Club camp in the Fraser Valley. All three men dreamed of fires and blankets during the long, cold night. In the morning, MacCarthy and Foster were suffering from snow blindness and could only see a short distance, making the descent over thousands of feet of ledges even more treacherous. For ten minutes on the way down the three climbers were in extreme danger as they crossed underneath a hanging glacier. Eventually, they managed to reach the southwest ridge, where they descended to Kinney Lake by 11 a.m. After eating all their remaining food and resting, they climbed the new trail up to the camp in Robson Pass, arriving at 5 p.m.

Around the campfire that night, in the midst of all the acclaim for Kain's party, Phillips made his startling revelation about who could claim the first ascent of Mount Robson. Kain reported Phillips' statements at the end of his account of the climb with Foster and MacCarthy:

> From what Donald Phillips himself said, our ascent was really the first ascent of Mount Robson. Phillips' words are as follows: "We reached, on our ascent (in mist and storm) an ice-dome fifty or sixty feet high, which we took for the peak. The danger was too great to ascend the dome."[93]

Kain goes on, however, to acknowledge the great achievement of Kinney and Phillips in view of the great difficulties just in travelling 200 miles to Mount Robson through the wilderness. Kinney had chosen to ascend on a very dangerous face of the mountain, and his climbing companion was inexperienced. Robson, while a beautiful mountain, is treacherous because of the weather and the frequent avalanches. Years later, when thinking back on his climbs in the Rockies, Kain offered his opinion about Mount Robson:

> … my verdict is that it is long and offers many problems to the leader. No matter from which side the ascent is made, there are dangerous sections, even under the best conditions. He who hires himself out for such a climb earns his pay, and the amateur who can lead to the summit is in my opinion a full-fledged mountaineer.[94]

George Kinney did not attend the 1913 camp at Mount Robson. From the club's beginning, he had been heavily involved in its activities, especially the summer mountaineering camps, but since the expedition of 1911, Kinney appears to have disassociated himself from the Alpine Club of Canada. Perhaps doubts were raised by other climbers about his truthfulness in claiming Robson's first ascent. J.W.A. Hickson and Dr. Longstaff, for example, could not follow Kinney's account of his Robson ascent at the 1910 camp.[95] Kinney always insisted that he and Phillips had reached the true top of Robson. In a letter written in 1938 to the American climber and historian J.M. Thorington shortly after Curly Phillips' death in an avalanche, A.O. Wheeler offers a sympathetic judgment on the controversy surrounding Kinney's claim, by saying that storm and cloud prevented Kinney and Phillips from seeing Robson's summit in much the same way that Parker and Browne could not climb the last 20 feet to Mount McKinley's peak. Wheeler goes on to express his belief that while

Robson's first ascent technically belongs to the professional guide Conrad Kain, the amateurs Kinney and Phillips, who overcame great hardships of hunger and poor weather, should be given credit for actually making the first ascent. Wheeler also says that Phillips' statement and its aftermath almost broke Kinney's heart.[96]

Two more attempts to climb Robson at the 1913 camp were almost successful but in the end were defeated by bad weather. Basil Darling gives a dramatic account of his climb with H.H. Prouty and guide Walter Schauffelberger up the west arête.[97] At 12,000 feet, on a very narrow ridge, they encountered enormous cornices, forcing Schauffelberger to cut steps on either side of the ridge. As they were trying to overcome this challenge the weather suddenly changed, with a fierce wind rolling black clouds up from below and dumping snow. The storm raged around them as they turned back, less than 400 feet from the peak, working their way past the cornices and descending to 11,000 feet where they spent a miserable night in the bitter cold on the crest of the west ridge. At first light, the three men feared they were trapped by the fresh snow covering the rock. After two hours of searching for a way down, Schauffelberger found some ledges on the south side of the ridge that allowed them to descend to the couloir on the southwest face and eventually to safety.

After coming so close to Robson's peak, Darling and Schauffelberger tried again several days later, this time with Kain and MacCarthy.[98] The four men camped at about 8,000 feet near the large couloir on the southwestern side, protected from a thunderstorm by ledges overhead. The next morning the weather was not promising, but despite the guides' concern, Darling and MacCarthy wanted to continue. As the men climbed up beside a 200-foot ice wall extending from the glacier on the southwest side, they were keenly aware of the danger from overhanging ice. Once above the wall, they found themselves in a blizzard with snow waist deep. By 12,000 feet, the peak within range, they emerged from the protection of the west arête and felt the full force of the storm blowing snow from the north. With his clothes like icy armour and one eye frozen shut, Darling found himself in a whiteout:

> … the veil about us was of such an unchanging whiteness and opacity that to our half-blinded vision, the snow underfoot and the enveloping mist became as one, until it was only by feeling with our axes that we could ascertain the angle of the slopes we were ascending.[99]

Incredibly, the four men continued to the base of The Roof, to a crevasse on the south side that Kain and MacCarthy had crossed on their successful ascent. As they rested and ate sandwiches at 12,500 feet, Kain finally decided that the blizzard would make the summit too dangerous. Mac-Carthy, who had followed Kain to Robson's peak in perfect weather, now marvelled at the guide's instinctive sense to find a way down, with all tracks covered by snow and visibility limited to 20 feet. After a 9,000 foot descent in just over eight hours, the four climbers found dry blankets, a fire and cocoa in a hut beside Kinney Lake.

Despite this lack of success on Robson's west side, the Alpine Club of Canada could claim an official first ascent in perfect weather and a complete traverse of this formidable mountain. The railway had played a key role in this accomplishment by providing transportation for club members and their supplies to a station not far from Robson's base. The Grand Trunk Pacific, however, would not enjoy a monopoly on the tourist trade for long, because its rival, the Canadian Northern, had built a parallel line west from Edmonton, and by 1913 this second railway had tracks as far as Lucerne on the south shore of Yellowhead Lake.[100]

Railway Artists: John William Beatty and A.Y. Jackson

The Canadian Northern Railway too wanted to advertise the spectacular alpine landscape along its line through the Yellowhead valley, and commissioned Bill Beatty, a Canadian artist from Toronto, to paint the scenery in the vicinity of the construction camps. Beatty asked the landscape painter A.Y. Jackson to join him on his exploration of the western mountains in the summer of 1914. Almost a century later Beatty's name is almost unknown, while A.Y. Jackson, a member of the Group of Seven, is renowned for capturing the spirit of the Canadian landscape in all its variety. Beatty deserves more recognition, however, because he was the first to realize the potential of sketching in northern Ontario. By 1905 he and other artists who worked for a Toronto design firm, the Grip Company, including J.E.H. MacDonald, Arthur Lismer, Fred Varley, Tom Thomson and Frank Johnston, became interested in taking trips on weekends and holidays to paint the landscape. These excursions, with a focus on Canadian subjects, helped them improve their technique and find inspiration for design work. Beatty's adventurous spirit led him to the northland, and he was the one who

introduced Tom Thomson to this inspiring landscape. Beatty should be given credit as the forerunner of the Group of Seven and their fervent desire to show Canadians their own land. He did not, however, support all of the Group's beliefs and preferred not to become a member.[101]

Beatty had a significant influence on the Group's technique for sketching outdoors. During the time he studied and travelled in Europe, 1906–1909, he adopted the idea of painting on small wooden panels from James Wilson Morrice, a Canadian impressionist painter working in Paris. Morrice had designed a paintbox that could accommodate these small panels. The box was easily portable and could be set up outdoors whenever a subject caught his eye, allowing Morrice to sketch with a sense of immediacy.[102] Beatty brought this very useful idea back to Canada, and members of the Group, especially A.Y. Jackson, copied him. The wooden panels were ideal for the artists' explorations in Canada's wilderness.

Through his role as a teacher at the Ontario College of Art, Beatty influenced the styles of well-known artists. He began to teach painting in 1912 and later took over the summer school of the College, in Port Hope. His career as an instructor lasted almost 30 years.[103] Although elected to the Ontario Society of Artists in 1901, Beatty was better known for his ties to the Royal Canadian Academy, exhibiting with the Academy every year from 1898 to 1941. In 1914, after his trip to the Yellowhead valley, Beatty submitted *Lake Lucerne Canadian Rockies* to the annual show.[104] A *Catalogue of Paintings of Scenes along the line of the Canadian Northern Railway* to accompany the exhibit at the Canadian National Exhibition in 1915 lists 14 works by Beatty, including *Lake Lucerne, B.C., In the Yellowhead Pass at Resplendent, Line of CNR* and *View from CNR Tunnel near Resplendent, B.C.* Nine paintings (Nos. 9–17) are grouped together as views from CNR trains. Beatty appeared to stay close to the railway line when sketching, and he produced a sizable body of work while enjoying CNR hospitality. The Kamloops Art Gallery has in its collection a small undated oil by Beatty, *Old Tote Road, Yellowhead Pass*, that could possibly have been painted during Beatty's 1914 trip to the Rockies.

A.Y. Jackson: "Mountains were not in my line"

In September 1913 when A.Y. Jackson was on the verge of leaving Canada and going to the United States to work, Dr. James MacCallum, a Toronto ophthalmologist, made him an offer that changed

his mind. MacCallum agreed to pay his expenses for a year if he would stay and paint in Canada. In addition, Jackson was given space in the Studio Building, financed by MacCallum and Lawren Harris,[105] a Toronto artist of independent means who strongly believed in bringing talented artists together to stimulate the creation of art that truly reflected the Canadian landscape. Bill Beatty also had a studio in the new building, and when he secured a commission to paint the construction camps along the Canadian Northern line in the summer of 1914, Jackson was delighted to go with him and see the West for the first time.[106]

Jackson, accustomed to hiking as far as 30 or 40 miles in search of good subjects for painting, soon left the older Beatty behind when the two men were halfway up a mountain.[107] To avoid having Jackson climbing mountains alone, a young engineer, frequently Bert Wilson, went along and taught the artist how to survive on a limited diet of bacon, bread, oatmeal and tea and to sleep in the open air without a tent or even blankets. Despite the Spartan existence, Jackson had happy memories of life in the mountains:

JOHN MUNROE, *Photograph of A.Y. Jackson, Resplendent, B.C., 1914*. University of British Columbia Library, Rare Books and Special Collections, Nan Cheney Fonds (BC1849/160).

> We had good times in the mountains, and exciting ones. We took many chances, sliding down snow slopes with only a stick for a brake, climbing over glaciers without ropes, and crossing rivers too swift to wade, by felling trees across them.[108]

The construction camps had their perils, too. By the time Beatty and Jackson arrived, the rail-

way crews were working near Resplendent where the tracks crossed the Fraser River to a steep slope on the south bank. The only place suitable for the camp was on the north side of the river, making it necessary for the men to cross the raging torrent on temporary bridges, such as fallen spruce trees supported by one central pier – not for the faint of heart. Jackson vividly recalls a perilous crossing at night on a single line of planks, his courage bolstered by the light of the cookhouse and the promise of baked pie.

The strenuous outdoor life seemed to suit Jackson perfectly, and he made many sketches of the landscape. In a postcard from Lucerne dated August 27, 1914, Jackson says he had worn out his prospector's boots by frequently climbing as much as eight to nine thousand feet to paint. He also reports that his sketches measure up to his high standard, even though mountains do not appeal to him as much as the Algonquin landscape.[109] Unfortunately, many of these sketches were not developed into larger canvases, because the Canadian Northern ran out of money. Jackson made the fateful decision that mountains were not his favourite subject, and he burned many of his sketches done in the Yellowhead valley:

> Later I came to the conclusion that mountains were not in my line, and I kept throwing the sketches into the furnace until there were none left.[110]

This alarming statement in his autobiography does not mean that none of Jackson's Yellowhead images has survived. A few years elapsed between his trip west and the demise of the railway, time for some works to have escaped the fire. Some oil sketches, graphite drawings and possibly one canvas from 1914 do exist, but they are, sadly, few in number. An intriguing canvas inspired by Jackson's Yellowhead trip is *Evening, Mt. Robson*, exhibited at the Royal Canadian Academy's annual show in 1914, beside *Red Maple*, a painting that became part of the National Gallery's permanent collection.[111] Jackson obviously thought well enough of his Robson painting to put it into the Academy show. This canvas may be the same one mentioned by Naomi Jackson Groves in *A.Y.'s Canada* when she says that her uncle remembered completing a single canvas from his 1914 trip to the Rockies, an oil, 40 × 50 inches, titled *Mount Robson by Moonlight*. Possibly this is the same painting listed as *Night: A View of Mount Robson from Berg Lake* in the *Catalogue of Paintings of Scenes along the line of the Canadian Northern Railway* that accompanied a show at the Canadian National Exhibi-

tion of 1915. In any case, *Mount Robson by Moonlight* hung in the Arts & Letters Club of Toronto while Jackson was serving in the army. When he returned in 1919, he felt that no one had expressed much enthusiasm for the Robson canvas, and he painted over the mountain with a fall landscape of Algoma that eventually found a home in Hart House at the University of Toronto. Jackson was amused to think that the Rockies' highest peak was now invisible under another painting, and he suggested that x-rays could reveal Mount Robson.[112]

At least six sketches on wooden panels have survived, divided among private owners[113] and public collections in the McMichael and Kamloops galleries. The few sketches still in existence show, in Naomi Jackson Groves' opinion, "full-brushed, richly gleaming mountain and cloud effects."[114] Graphite drawings are even more scarce, but, fortunately, some of these fragile images have been preserved in public galleries.[115] The Ottawa Art Gallery has two Jackson drawings dating from 1914, *Mt. Geikie from Yellowhead* and *Mount Robson*. Mount Geikie, not far from the Fraser headwaters, is near the eastern boundary of Robson Provincial Park and can be seen from Yellowhead Mountain. Jackson's drawing of Mount Robson, even though the paper has suffered some damage over the years, is particularly interesting as evidence that the artist hiked up to Berg Lake. Possibly these drawings were among those rescued by Naomi Jackson Groves when in the 1960s she was preparing *A.Y.'s Canada*, a volume of her uncle's drawings reflecting his travels to all parts of Canada.[116] She does include as Plate 70 a drawing titled *Mountains and the Fraser River, at the Yellowhead Pass, British Columbia, 1914*. In her foreword to *A.Y.'s Canada*, Groves describes how drawings, most often graphite on paper, were an integral part of Jackson's artistic process. His normal practice, unless time was short or weather unsuitable, was to paint the oil sketch on a birch panel and do the drawing afterward. The sketch recorded his immediate impressions of light, colour and form. If the subject interested him, Jackson would do a drawing, allowing him to analyze the composition and bring some details into sharper focus. He would make notes about colour and value on the drawing itself. By using a numbering system where 1 represented the lightest value and 10 the darkest, Jackson could remind himself about the varying degrees of light and shadow when he might paint the scene later. He referred to these drawings as his notes, a means to an end, but they are also works of art in themselves, an expression of his feeling for the grand, sweeping rhythms in the landscape.

William Johnstone: Sketching at Mount Robson, 1918

William Johnstone, an artist trained in Scotland, moved to Edmonton in 1912, at the age of 44, and continued his professional career by starting art classes, making a name for himself by painting portraits. In 1921 he served as the first president of the Edmonton Art Club, an organization that would make an enduring contribution to art in Alberta by helping to establish the Edmonton Museum of Art.[117] Johnstone also painted landscapes in his adopted country, and his connection to Mount Robson is through a sketching expedition in 1918 with H.E. Bulyea, who wrote a lively account of their adventures for the *Canadian Alpine Journal*.[118] When the two men discovered that Curly Phillips was unavailable because of war service, they set out on their own on July 31, travelling on the Grand Trunk Pacific. The conductor of the work train advised them where they would be able to cross the Fraser on a logjam, and after establishing their camp on the north side of the river, the next day they followed an old trail west to the Grand Forks River and a view of Mount Robson. There, Bulyea took photographs and Johnstone sketched while they waited for clouds to lift from Robson's peak. They decided to continue their explorations the same day by following the trail to Kinney Lake, enjoying a profusion of edible berries along the way. Here they spent two nights at the site of an old camp before deciding on August 3 to hike to Berg Lake. As they climbed up the Valley of a Thousand Falls, Bulyea was particularly impressed by so many echoing waterfalls sending such a tremendous volume of water plunging over the cliffs. The men hiked along the north side of Berg Lake, hoping to find remnants of an Alpine Club of Canada camp, and to their delight they discovered some cans of food and an old tent, supplies sufficient to make them comfortable. When Bulyea found it necessary to put more wood on the fire during the night, he was rewarded with a truly memorable sight:

> It was a beautiful, clear, starlit night and the great snow-capped peak of Robson, silhouetted against the sky, was a sight I shall never forget; and the great stillness, broken only by the occasional roar of falling ice on rock, filled one with a sort of delicious sense of awe.[119]

They explored the ice cave at the foot of Robson Glacier before returning to their Kinney Lake camp. The next day, August 5, Johnstone sketched at Kinney Lake while Bulyea started to move some of their gear back to the main camp beside the Fraser. Smoke was rising as he approached the Fraser camp, and he arrived just in time to save the tent and their supplies. A smudge fire on their

first night had smouldered for days and had just been ignited by the wind when Bulyea came on the scene. The two explorers had yet another stroke of good luck when they met a cook, Charlie Nelson, who offered to prepare their meals in exchange for staying in their tent. For another week, Bulyea and Johnstone camped beside the logjam, enjoying the fishing and wild berries, as well as their photography and sketching.

A.Y. Jackson Returns to the Rockies, 1924

Since his visit to the Yellowhead valley in 1914, Jackson served as a private in the Canadian army during the First World War, and near the end of the conflict, after recovering from wounds suffered in battle, he worked as an artist for the Canadian War Memorials, painting the shattered landscapes of Vimy and Ypres. In the spring of 1919 he returned to the Studio Building and the companionship of artists who were determined to create paintings portraying the spirit of Canada's North. With MacDonald, Harris and Frank Johnston, Jackson went in the fall to Algoma country in northern Ontario, travelling in a box car on the Algoma Central Railway. On this trip, Jackson did the sketch for the larger canvas *October, Algoma* that was painted over *Mt. Robson by Moonlight*. After one of their Algoma sketching trips, Harris and Jackson took the main line of the Canadian Pacific Railway along the north shore of Lake Superior, where Harris found a stark, austere landscape that appealed to him more than Algoma. They became adept at camping in the northern wilderness, enduring cold nights and days of rain to sketch this immense landscape of long, sweeping lines.[120]

When Harris decided to take his family on a summer holiday in 1924 to Jasper Park Lodge, Jackson went along. The two artists did not linger at this new hotel built by the Canadian National Railways but set out to explore the backcountry during the next two months, making sketches of the landscape that they hoped would lead to canvases the railway might be interested in. After arranging to have their supplies and equipment transported to Maligne Lake by the wardens, Harris and Jackson covered the distance on foot.[121] The artists explored the lake by paddling about 15 miles to the south end, where they camped on the delta created by Coronation Creek. After climbing above treeline to sketch on a number of occasions, they decided they were happiest working at 6,000 or 7,000 feet in the undulating alpine meadows filled with wild flowers and small pools that reflect the

surrounding peaks. For Jackson, the higher elevation solved a major problem encountered in painting mountains lower down, where the trees become a separate focus in the foreground, interfering with the view of the mountains beyond. From above, the vast stretches of forest can more easily be painted as the sweeping lines of a green mat. The highest peaks were also problematic in terms of composition, because in order to avoid a vertical view, the base of the painting had to be widened to provide the appropriate contrast with height. For this reason, Jackson says, they concentrated on the lower mountains to avoid giving the impression that the artist had forced either the foreground or the peak to fit the dimensions of the small wooden panels.[122] In his drawing of Berg Lake, completed sometime on his trip to the Yellowhead in 1914, Jackson solves this difficulty of scale by expanding the foreground to cover the width of two pages in his sketchbook.

The day before leaving Maligne Lake, the two men decided to climb a ridge to the east for a view of the Colin Range, an ascent of about 6,500 feet, at times in heavy showers. As they finally reached the crest of the ridge, the sun suddenly came out, revealing a remarkable symmetry in the mountain shapes beyond, "all running in long diagonal lines to sharp points – a kind of cubist's paradise, with glaciers sprawling lazily in the midst of it."[123] Jackson painted a large canvas of the scene, but, as he had been known to do before, he destroyed the painting because he felt that no one liked it, realizing, to his regret, that it would have been appreciated as a good example of abstraction 25 years later.[124] As the two artists were working on a second sketch from the crest of the ridge, Jackson became aware of a massive black cloud engulfing the landscape behind. They had only managed to descend 600 feet when the cold winds struck, drenching them with rain and hail. Around the fire that night, they reflected on their approach to painting this rugged landscape. Rather than trying to reproduce the mountain panorama in detail, as the camera does, the artist can reveal the architectural shapes and immense rhythms in a style free from the conventions of the pastoral. Jackson comes to the conclusion that mountains in Canada's West offer great opportunities for the artist who can withstand the rigours of outdoor life:

> It is a strenuous life – long hikes, often twenty-five miles in a day, climbing four or five thousand feet in the day's work unless a camp is made at the top of the timber, getting wet or frozen any time – but there is no place where hardships can be so quickly forgotten, or where the artist will find more entrancing motives.[125]

When Jackson and Harris extended their explorations by hiking into the Tonquin valley, the rain was so persistent that they were not able to do very much oil painting. Instead, they made pencil drawings of the panorama of peaks, probably from Tonquin Hill, with each artist doing half the landscape in sections that were appropriate for a mural. Although Sir Henry Thornton of Canadian National Railways later expressed an interest in their project, unfortunately he was not able to see it through.[126] One of Jackson's drawings of the Ramparts, reproduced by his niece in *A.Y.'s Canada*, has the names of the peaks, Bastion, Turret and Geikie, pencilled in at the top, with Moat Lake below.[127] Jackson had been attracted to Mount Geikie in 1914 when he did a graphite drawing from Yellowhead Mountain in Mount Robson Provincial Park.

While Jackson does not include Mount Robson in the list of places he and Harris went to in 1924, both artists produced sketches and drawings of the landscape in Mount Robson Provincial Park. Jackson's pen and ink drawing *Vista from Yellowhead*, 1924, is evidence that he returned to a similar vantage point on Yellowhead Mountain, but instead of looking south to Mount Geikie, he concentrated on the panorama to the west that includes Whitehorn, Robson and Resplendent. His sketch of Robson Glacier called *Five Mile Glacier* was also completed in 1924. It seems likely that on this trip Jackson introduced Harris to the Robson region, a great source of inspiration and a landscape that would be the subject in some of Harris' most famous paintings. Two works by Harris, a graphite drawing of Mount Robson from Berg Lake and an oil sketch titled *Glacier, Mt. Robson District*, are dated c. 1924–1925. Not only were the two artists creating images of the Robson region about the same time, but they both sketched the Robson Glacier, perhaps together.

Although the plan to decorate a Canadian National hotel with a mural of the Ramparts did not materialize, the railway did ask Jackson to contribute to *Jasper National Park*, an elegant pamphlet published in 1927. A large drawing of Jasper Park Lodge, complete with canoes on a lake in the foreground and a panorama of mountains behind, adorns the double page at the beginning and end of the pamphlet. The text, extolling the scenic wonders accessible by visitors, is complemented by 20 pen and ink drawings by J.E.H. MacDonald, Frank Carmichael and A.J. Casson and six colour plates of Jackson paintings, the last showing the moon shining on Mount Robson and Berg Lake.[128] Perhaps the earlier canvas of Robson in the moonlight, completed after his 1914 trip and later painted over, has been reincarnated in the travel brochure. Jackson focuses not just on the landscape but

includes in the foreground a teepee and three figures beside a campfire. Stars twinkle in the night sky and the colours are soft and warm. Jackson does not portray an austere, remote wilderness, but rather a place where one can camp comfortably in the midst of spectacular scenery. Mount Robson is obviously not part of Jasper National Park, but a guest at the lodge could easily travel on regularly scheduled Canadian National trains and hike up the trail through the Valley of a Thousand Falls to Berg Lake. On the centrefold map in the brochure, Mount Robson is shown about 60 miles west of Jasper, in the top left corner, towering above the clouds.

Even though Jackson destroyed sketches and canvases inspired by his 1914 and 1924 trips to the Rockies, he did not completely turn away from painting mountains. Years later, in the fall of 1937, he visited his brother Ernest in Lethbridge, Alberta, and Frederick Cross, a member of the Lethbridge Sketch Club, drove Jackson around the countryside on sketching trips. On these excursions, Jackson solved a major problem in painting mountains when trying to balance the foreground and background. Now he looked for something of particular interest in the foreground and used the mountains as a background,[129] a technique, he explains, that is well suited to painting in Alberta's foothills: "… the foothills of Alberta, with the mountains as a background, afford the artist endless material."[130] In the summer of 1943, Jackson started teaching at the Banff School, and he would return, with the exception of 1948, for six consecutive years. The artist who had claimed the mountains were not in his line was now teaching students how to paint mountains around Banff, starting with Mount Rundle and progressing to Cascade Mountain and the peaks around Sunshine.[131]

Late in his career, at the age of 83, Jackson accepted an invitation from Colonel P.B. Baird to accompany an Alpine Club of Canada expedition to Pangnirtung Pass on Baffin Island. Jackson had been to the eastern Arctic and Baffin Island twice before, with Dr. Frederick Banting in 1927 and with Lawren Harris in 1930. On this latest trip, in 1965, Jackson had an opportunity to sketch mountains while the climbers spent four weeks attempting to scale the peaks in the vicinity. They were successful in making a first ascent of Mount Loki, a mountain shaped like the Matterhorn that required 29 hours of climbing from the high camp to the summit. Jackson's painting of Mount Loki is called *Glacier Lake*, the foreground showing an ice-filled lake at the foot of a great glacier that takes up the middle ground, with flowing lines of ice coming toward the viewer, and the background revealing Mount Loki's pyramid rising out of the glacier.[132] Just over 40 years earlier,

Jackson had sketched a similar scene in *Five Mile Glacier*, with Robson Glacier flowing toward the viewer and Lynx Mountain soaring into the sky in the background. This trip to the Arctic seemed to be the culmination of his experience painting mountains. He did more than 30 sketches on site, and over the following winter worked on many canvases. Mountains certainly came to be part of his line in his eighties.

Arthur Lismer, a member of the Group of Seven along with Harris and Jackson, wrote a foreword to the catalogue of the retrospective exhibit of Jackson's work from 1902 to 1958. Lismer calls his friend and fellow artist a pioneer in the interpretation of the Canadian landscape in its colour, light and form, one who explored the meaning of the northern land with its mountains, forests, lakes and streams and revealed his affection for it. Lismer concludes by praising Jackson's ability to show us the unique qualities of places all over Canada:

> Looking at this exhibition we shall find ourselves seeing this landscape anew, recalling similar experiences and enjoyment under like conditions. Jackson, at times, is yourself made articulate, and that is the mark of a good painter: enticing, revealing, convincing.[133]

Lawren Harris:
His Discovery of Spiritual Wealth in the Mountains

On his first acquaintance with the Rockies in 1924, Harris felt disillusioned. Travel brochures had given him certain preconceived ideas, and he felt that the mountains in reality were sadly lacking.[134] With this initial reaction, Harris might well have painted close to Jasper Park Lodge, where his family was staying during the months of August and September, but fortunately his friend Jackson was a stalwart outdoorsman, willing to share the rigours of camping in the backcountry. As the two artists hiked many miles together in the Maligne, Athabasca and Tonquin valleys, camped in the rain and sketched behind stone shelters to escape the cold winds,[135] Harris discovered a richness of experience in the midst of the soaring peaks that could not be imagined by simply looking at advertising folders. He became entranced with these high places, and from this point in his artistic career the mountains become symbols in his painting, representing the search for spiritual perfection as one ascends toward the heavens. This quest for spirituality was the result of Harris' interest

in theosophy, as he had formally joined the Toronto chapter of the Theosophical Society in 1923. Theosophists believed that mankind, regardless of creed or dogma, must strive to regain an understanding of the spiritual foundation of all existence.[136] To his astonishment, Harris discovered a fellow theosophist living in the Tonquin valley. When Harris and Jackson sought refuge from the rain, they appealed to the warden, Percy Goodair, who was none too eager to accommodate two wet hikers until he realized that he shared an interest in theosophy with Harris. They talked for hours about books on the subject, and after that the two artists were welcome to stay in the warden's cabin as long as they wanted.[137]

Harris and Jackson often worked side by side during their two months exploring the lakes and mountains accessible on foot from Jasper. Harris' large canvas *Maligne Lake, Jasper Park* in the National Gallery of Canada is one of his best-known paintings inspired by his first visit to the Rockies. Less well known is the fact that Jackson also completed a larger canvas, titled *Maligne Lake, Morning* and exhibited in the 1925 Ontario Society of Artists show, but unfortunately he threw it into the furnace in the Studio Building.[138]

Not only did the two artists share adventures and subjects for sketching, they were also members of the Group of Seven, an informal organization created in 1920 that included J.E.H. MacDonald, Arthur Lismer, Fred Varley, Frank Johnson and Franklin Carmichael.[139] The Group was dedicated to the creation of distinctly Canadian art in a new style suited to the portrayal of the rugged wilderness in Canada's North. The idea for this novel approach to landscape painting may have originated some years before, in 1913, when MacDonald and Harris had gone to Buffalo, New York, to see an exhibition of contemporary Scandinavian art. The two Canadians felt an affinity for paintings of the immense, silent wilderness of Scandinavia, created in a style that did not rely on European pastoral conventions. Instead, these Symbolist artists from Scandinavia used simplified shapes and decorative patterns to express a mystical quality in the northern wilderness. MacDonald and Harris realized that Canadian artists could follow the example of the Scandinavians by painting Canada's North in a new way, one that would stimulate an awareness of the spirit of the land.[140] As a whole, the Group stressed the importance of a Canadian school of art, separate from imported traditions and derived from the land itself. They hoped that their art would enable Canadians to see the landscape with greater understanding, instilling a deeper sense of identity. Jackson's art expresses his

strong feelings for the land. He devoted much of his career to painting Canada's wilderness, from Algoma and Lake Superior to the Rockies and the Arctic. While he may have simplified shapes, enhanced and emphasized patterns, his art is still representational, as he sketched the outlines of landscape with unerring accuracy. Harris shared Jackson's sense of nationalism and the importance of conveying the mood of the landscape, but his interest in theosophy led him beyond the particular Canadian landscape to its universal spiritual significance.

Harris' discovery of the Rockies in 1924 had a profound influence on his art for many years. Before coming to the mountains, Harris had spent time painting on the north shore of Lake Superior, a source of inspiration that would continue until 1929 in conjunction with his trips to the Rockies. With his interest in the immense, stark landscapes of Lake Superior, the austere mountain peaks covered with ice and snow were a logical progression in his search for subjects that embodied the feeling of Canada's North, whether it be northern Ontario or the western mountains. His love for this northern country, with its vast, lonely wilderness, is the foundation of his art. He took his inspiration from nature, and by making strenuous journeys to sketch these remote landscapes, he sensed an inherent spiritual quality in the land that seemed to lead him toward a greater knowledge of his own soul.[141] Harris believed that Canada's North was a source of spirituality and that art based on this landscape would be "… more spacious, of a greater living quiet, perhaps of a more certain conviction of eternal values."[142]

Theosophy became a natural extension of his art and provided a philosophical background for Harris in this quest to express the spiritual qualities of the North. He insisted that an artist's work could not be separated from his philosophy.[143] Theosophists believed that the way to restore contact with a universal spirituality was by an ascent through levels of experience, with the visible world at the bottom and the eternal heavens at the top.[144] Mountains suited Harris' purpose perfectly. Climbing above the treeline to the realm of scree and glaciers brought him closer to the divine heavens. His sketches and canvases inspired by the Robson region, particularly the highest summits of Resplendent Mountain and Mount Robson, reveal a move away from the actual landscape toward stylized shapes and elongated summits, taking the eye as high as possible into the sky. Harris was influenced by the beliefs of transcendentalists who viewed the natural world as symbolic of a spiritual presence. The natural landscape represents this duality of the actual and the symbolic, and specific

landscapes lead one from this world to the contemplation of the ideal and mystical. Harris states, in his notebooks of the 1920s, that the actual landscape reflects a world that is more perfect, and the artist must use his creativity to see the eternal beauty behind the outward appearance.[145]

The triangle is a significant geometric symbol in Harris' paintings of the mountains, especially the essential pyramidal shapes of the summits of Robson and Resplendent. The naturally occurring shapes of the peaks are simplified to emphasize the triangle that represented in theosophical thought the "upward rush of devotion."[146] Colours, as well as shapes, are symbolic, with the luminous colours, especially blue, indicating higher levels of spirituality, and white, a union of all colours, representing spiritual truth.[147] Harris sometimes combines the ascending pyramids soaring into the blue sky with bands of white light radiating from the peaks. The natural landscape is altered, as Harris explains, to extend the experience of looking at these majestic mountains to include an awareness of their spiritual qualities:

> Today the artist moves toward purer creative expression, wherein he changes the outward aspect of Nature, alters colours, and, by changing and reshaping forms, intensifies the austerity and beauty of formal relationships, and so creates a somewhat new world from the aspect of the world we commonly see; and thus he comes appreciably nearer a pure work of art and the expression of new spiritual values. The evolution from the love of the outward aspect of Nature and a more or less realistic rendering of her to the sense of the indwelling spirit and a more austere spiritual expression has been a steady, slow and natural growth through much work, much inner eliciting experience.[148]

Harris described this creative process in 1929, at the end of five years spent in the Rockies painting such high mountains as Temple, Lefroy and Mont des Poilus (*Isolation Peak*), as well as Resplendent and Robson. These images are still recognizable, although Harris uses a certain amount of abstraction. He seems more interested in suggesting, through the titles of many of his images, a universal experience of mountains rather than the mountains in particular places.[149] His canvas of Resplendent, for example, is titled *Mountains in Snow, Rocky Mountain Paintings VII*. By the mid-1930s much of Harris' work had become non-representational, although mountain motifs continued to be important in his art. After moving to the United States in 1934 and living there for the next six years, he returned to Vancouver and resumed his visits to the Rockies. Ira Swartz, a Vancouver pia-

nist, remembered joining Harris at Mount Robson Lodge in the summer of 1941, and the two men hiked to Mount Anne-Alice (immediately to the west of Mumm Peak), an expedition that inspired Harris to create a large canvas that is based on the actual appearance of this mountain but also shows some abstraction.[150]

Lawren Harris in the Rockies, 1940-41. Courtesy of Stewart Sheppard.

When Lawren Harris returned to Mount Robson in 1941, he stayed in the valley at Mount Robson Lodge operated by Roy Hargreaves, who also ran the Berg Lake Chalet. Four brothers in the Hargreaves family, Jack, Frank, George and Roy, established homesteads in the Mount Robson valley after the First World War, and although they kept their pack strings separate, they were all involved in guiding, with a focus on Berg Lake. In 1921 the brothers built some log cabins for the Canadian National Railways in Robson Pass, and after operating them for several years, Roy Hargreaves obtained a lease on five acres at Berg Lake, where he constructed a chalet in 1927. Guests could now enjoy comfortable accommodation and home-cooked meals with a spectacular view of Mount Robson and Berg Glacier from the veranda. Lawren Harris may very well have stayed at Berg Lake Chalet when sketching at Mount Robson in the late 1920s.

Mount Robson; Berg Lake Chalet, 1968. Image I-27837, courtesy of Royal BC Museum, BC Archives.

Roy Hargreaves also ran Hargreaves Ranch in the valley, not far from the railway and the Canadian National station.[151] When Roy retired in 1959 he sold the ranch to Alice Wright,[152] a marine biologist who had seen Berg Lake for the first time in 1936 when on vacation in the Rockies. She was captivated by the scenery and readily agreed to return the next year to help the Hargreaves family move their horses from their winter pasture on the Smoky River. Alice Wright came back to the ranch many times and over the years became interested in all details of the Mount Robson climbs, including routes, climbing reports and summit photos. She became so knowledgeable that climbers

Mt. Robson Station, August 1945. Photographer unknown. Canada Science & Technology Museum, CN collection, X-20165.

would consult her before attempting their ascents, calling her the "Mother Confessor of Mount Robson."[153] Mount Anne-Alice, north of Robson, is named after Alice Wright and Anne Chesser, the wife of Chuck Chesser, Roy Hargreaves' partner. The two women decided to climb the mountain in 1939, and not finding a cairn to indicate a previous first ascent, they claimed the peak in their own names. Alice Wright managed the chalet and the ranch for 17 years until she decided not to renew her lease, because park officials insisted she keep her horses in a corral that would have been too far from the chalet to protect them. Berg Lake Chalet was closed and remained empty until 1982 when it became the Hargreaves Shelter, affording campers a comfortable veranda and a warm, dry place to prepare meals and providing an historic connection to all those who have rested there in the past, entranced by one of the world's wonderful views.

Margaret Lougheed: Artist for Parks Canada

A collection of Margaret Lougheed's landscape paintings of the national parks resides in the Banff National Park administration building, and during the "Doors Open Banff" open-house event in August 2010 the public was invited to see them.[154] Included in this collection is *Mount Robson and Berg Lake*, *B.C.*, *Canada*, obviously not a scene from a national park but one accessible by train from Jasper. Before winning the competition in 1930 to become the official artist for the national parks, Margaret Lougheed had received commissions from Canadian National Railways to paint Jasper National Park. Her canvas of Maligne Lake found a home in the Chateau Laurier hotel in Ottawa. The National Gallery of Canada also recognized her work by exhibiting *Indian Paint Brush*, a representation of Vimy Ridge Mountain in Waterton Lakes National Park. From 1930 to 1932, as the artist for the national parks, she sketched in various locations during the summers, often travelling many miles on horseback and even painting from a rowboat. Over the winters at her home in Vancouver, these sketches became the basis for her finished canvases.[155] Margaret Lougheed's work is similar in style to A.Y. Jackson's, with rhythmic shapes, simplified detail and strong colour. Over three decades, from 1925 to 1955, she was a regular contributor to exhibitions of the British Columbia Society of Fine Arts and the annual B.C. Artists shows at the Vancouver Art Gallery.[156]

Artists and Climbers: The Faces of Mount Robson

Artists are inspired by the many faces of Mount Robson. Their paintings from a variety of vantage points reveal Robson's different outlines, shapes and glaciers, and it is possible for the fit hiker, blessed with good weather, to see similar scenes without great danger. Many images of Mount Robson anchor the viewer's perspective in a foreground of lush vegetation of the Robson valley or the alpine meadows of the Hargreaves–Mumm Basin. This is familiar territory for many visitors. Some artists, however, give us a closer look at the austere, inhospitable landscape that confronts climbers attempting to reach Robson's peak. A.P. Coleman painted what he saw from his bivouac high up on Robson Glacier and from his experience climbing the ice wall below The Dome. Lawren Harris tried to capture Robson's various shapes with sketches from different points of the compass,

including his famous view from the southeast across the massive glacier at the head of the Robson amphitheatre. More recently, artists such as Trevor Lloyd Jones, Glenn Payan, Hubert Nanzer and Glen Boles bring a wealth of climbing experience to their paintings of Robson. Anyone looking up at Robson's majestic outline towering against the sky feels a sense of awe in nature's grandeur compared to the insignificance of humanity. For the ordinary person, it is hard to imagine actually trying to scale the precipitous cliffs, exposed to sudden changes in weather and the danger of falling ice blocks, let alone spending a night or two high up on Robson. The climbers' accounts of their attempts to reach Robson's summit increase our awareness of the scale, danger and beauty of this great mountain. Climbers, especially, realize their insignificance when confronted with nature's power in violent thunderstorms, avalanches and clouds that frequently envelop the summit, a silent blanket covering the safe route over the glaciers and ledges.

ROBSON'S SOUTH AND WEST FACES

The rare sight of Mount Robson from the valley near the Visitor Centre with the morning sunshine illuminating the summit is unforgettable. Even though the mountain is several miles away, one can see distinct ridges radiating down from the highest point. Against a clear blue sky, Emperor Ridge, with its overhanging cornices, is visible on the far left, while on the right is the southeast arête extending from the base of the summit pyramid, or Roof. Between these two ridges is the Grand Couloir, a gigantic ravine with a river of ice falling down the southwest side of the mountain for thousands of feet. To its left is the curiously shaped western ridge, appropriately named Wishbone Arête, and to the right of the Grand Couloir is the south-southwest arête, bordering an immense glacier extending from the summit down to the bands of a lighter colour. Incredible as it may seem to the observer on the valley floor, the standard route for mountaineers attempting to ascend to Robson's peak starts from an Alpine Club of Canada hut tucked in just below the lower edge of the glacier and then proceeds up the south-southwest arête to cross the glacier higher up, in an easterly direction, in order to approach The Roof from the southeast ridge. The upper ice fall, where the glacier descends over a cliff, makes the traverse on the ledges below extremely dangerous because of séracs threatening to topple down. One way to circumvent the ice cliffs is to go to the left on the

Schwarz ledges, named after the guide Hans Schwarz, who had an extensive knowledge of Mount Robson in all conditions, based on 12 successful ascents to the summit over 25 years.[157]

Artists painting from a vantage point in the Robson valley portray the majestic presence of Mount Robson, a magnificent background to the valley's wild beauty. Frequently, cloud obscures Robson's features, leading to images that justify Robson's name as the cloud-capped mountain. One of the most delightful places to sketch is beside Carr's pond, close to the Robson River, on property owned by the artist Norene Carr, who settled near the base of Mount Robson in the 1950s.

Climbers' reports collected in *Ever Upward*, the recently digitized *Canadian Alpine Journal*, tell us what the great mountain is really like when one takes on the challenge of climbing to its peak. Mountaineers experience first-hand the great height of Robson's sedimentary layers that appear to the observer far below as thin dark lines running horizontally across Robson's faces. The beauty of glaciers flowing from Robson's summit ridge is tempered by the climbers' constant awareness of the threat of avalanche. Even the exhilaration of standing on the highest point in the Rockies with a magnificent panorama spread out below is shadowed by a concern for a safe descent. Climbers are often defeated by Robson's changeable weather, and some wait years until the conditions are favourable for their attempts on the summit.

At the 1924 Alpine Club of Canada camp, Phyllis Munday, a climber from Vancouver, became the first woman to stand on Robson's peak. With Conrad Kain as guide, Munday set out from a high camp above Kinney Lake with five companions to ascend the south-southwest arête to the ice wall at the upper glacier, where they made a perilous traverse, exposed to an 8,000 foot drop below and the threat of ice blocks falling from above. The great danger of this part of the climb is compensated for higher up, at the base of The Roof, where Munday encountered a strikingly beautiful landscape of ice formed by the wind into the shapes of ocean waves:

> … the huge ice terraces of the final slope appearing like monster breakers on a rough sea. This formation was beautiful in the extreme. Under the graceful folds of each of these "breakers," were fantastic, glistening icicles which shattered the sunlight into every colour of the rainbow.[158]

The metaphor of waves on a stormy sea is certainly fitting given Mount Robson's origins in the ancient seabed. Climbers are often surprised to find near the summit a weird landscape of fantastic shapes wrought by wind and snow.

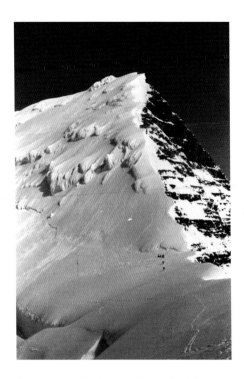

GLEN BOLES, 1977, *Some of [his] party at the base of The Roof*. Notice the ice hummocks; there were many more when [Boles] climbed in 1960.

Sudden changes in weather are potentially fatal for climbers high up on Robson. The death of an experienced mountaineer from New Jersey, Newman D. Waffl, on August 5, 1930,[159] resulted from a dramatic rise in temperature the previous night, followed by a very hot day, causing violent avalanches. The Swiss guides Hans and Henry Fuhrer could only find lightweight articles of clothing on the great fan of snow where all avalanches from the west face fall, and they believed that Waffl, climbing alone, had been swept away from a high elevation on Robson. The peak between Rearguard Mountain and The Helmet was named in Waffl's memory.

Weather was a formidable challenge for Hans Gmoser's successful expedition to Robson's summit in 1957. Sarka Spinkova, a member of the team, reports that after days of rain, they set out from the high camp above Kinney Lake in moonlight on August 10, but soon the cloud in the valley gradually rose and enveloped them in fog, making visibility so poor that they had trouble even seeing each other. When they reached the face of The Roof, they found a barrier of enormous "featherlike snowy curtains," requiring Gmoser to move "like a swimmer trying desperately to make his way through a waterfall."[160] Once they were on the summit ridge, a strong wind blew the mist away, revealing the true summit and giving them a view of Kinney Lake 10,000 feet below. Their descent was hurried because of an approaching thunderstorm that caught them partway down, a terrifying experience described by Spinkova:

GLEN BOLES, 1960, *Icefall from the main glacier on the south side of Robson, above the location of the Forster Hut.* The Schwarz Ledges are to the left of the icefall.

Suddenly the leaden sky began to pour on us tons of hail which bounced off our heads and shoulders and with a sizzling sound rushed down the steep slopes of the ice-falls, forming numerous streams. The streams were so deep that they almost reached our knees and so powerful that it took all the strength we could muster in order not to be swept away. Thunder roared around us, doubled by its echo; bluish and greenish lightning gave us the eerie look of ghosts dancing madly under the open sky. Nevertheless, slowly and taking all possible precautions, we proceeded step by step.[161]

Robson's weather can also be benign, in rare cases giving climbers perfect conditions. In 1960 Glen Boles with Heinz Kahl and two companions successfully climbed to the summit via the south side, using the Hourglass route to ascend the upper icefall. Robert Kruszyna and Charles Fay had such good weather on August 11, 1961, that after leaving the high camp and climbing the south-southwest arête to an elevation of 12,000 feet, they were able to climb directly up the south face. At Robson's summit they were surprised to discover an enormous sérac "… the highest point was located atop a huge sérac at the western end of the summit dome."[162] Could Curly Phillips have been referring to a similar sérac when he claimed, almost a half century earlier, that he and Kinney had not been able to scale the last 50 feet of ice and stand on the very top of Robson?

In 1968 a large avalanche swept down the Grand Couloir, destroying the trees along the trail from the Alpine Club of Canada hut down to Kinney Lake. Even trees on the other side of the lake were blown down in the terrific blast of wind accompanying the avalanche. The hut survived this huge avalanche, but in 1969 another slide, originating in a different place, demolished it. The Alpine Club decided to rebuild, assisted by a generous offer from Ralph Forster to pay for construction.[163] Jo Kato was the project manager, and members from the Edmonton section of the Alpine Club – Charles Lockwood, Ernest Reinhold, John Tewnion, Robi Fierz and Hans Schwarz – helped to build the new hut on the south-southwest ridge, at ap-

MEL HEATH, *Ralph Forster Hut, (Alpine Club of Canada), Mount Robson 1970*, zinc plaque, 24 x 20 cm. Collection of Robi Fierz.

proximately 8200 feet, some 200 feet lower than the old igloo. Their reward on completion of the new hut was a day of perfect weather to climb Robson. Five climbers, with the exception of Schwarz, left at 3:05 a.m. and reached the summit by 9:15, returning to the hut in the early afternoon. On the upper glacier the conditions were so good that they were able to take a direct line to the middle of the summit

ridge. To commemorate the building of the hut, followed by a perfect ascent to Robson's peak, Mel Heath, an artist and friend of Robi Fierz, created a plaque. The artist's drawing of Mount Robson was etched and made into a photo engraving on a zinc plate. The completed plaque was installed over the door of the hut, and each climber received a copy to honour his service to the climbing community.

ROBSON'S FORMIDABLE NORTH FACE AND EMPEROR RIDGE

When looking at Mount Robson from the veranda of Hargreaves Shelter, the highest point – appearing as just a bump on top of the North Face – is 8,000 feet above the glacial lake. Below the peak is a steep snowfield extending down to the col between Mount Robson and The Helmet. This sparkling white cliff is the North Face, a great challenge to climbers with its nearly vertical drop from unstable snow mushrooms above to a treacherous bergschrund below. The North Face is the first to reflect the rising sun on a summer morning. Its striking shape and beauty dominate this perspective on Mount Robson. Avalanches falling down its precipitous cliffs increase the mass of Berg Glacier, which flows down to the water's edge, occasionally launching icebergs into the lake. To the west, beyond a massive rock buttress, is Mist Glacier, falling to the lower edge of Berg Lake, beneath the seemingly vertical cliffs of the Emperor Face, which can also be seen from Emperor Falls. Stretching from the top of the Emperor Face to Robson's summit is Emperor Ridge, the realm of weird shapes known as the gargoyles. On medieval churches, the grotesque stone gargoyles act as water spouts, projecting from the edge of the roof and directing the flow away from the building to the street far below. Robson's gargoyles cling precariously to a knife-edge ridge, sculpted by fierce winds blowing the snow into fantastic shapes. When viewed from the Robson valley or Berg Lake they appear as innocuous bumps, but on Emperor Ridge they can be 50 feet high and so fragile that an ice axe cannot be planted securely. The wonder is what keeps them intact as they bear the brunt of violent storms. These flimsy structures are, paradoxically, an almost insurmountable barrier guarding the final approach to Robson's summit along Emperor Ridge.

One cannot help but be inspired by the magnificence of Robson at such close range. Many artists have painted from a vantage point across Berg Lake, near the shore or higher up, above treeline.

Most often, they paint in the summer or early fall before heavy snow makes travel difficult. Their paintings, however, all differ in their perspective, use of light, and colours. Some artists such as Trevor Lloyd Jones and Hubert Nanzer paint close-ups of the Mist and Berg glaciers in all their gradations of colours and intricate shapes.

The North Face and the adjoining Emperor Face that are an inspiration to many artists are a great challenge for mountaineers. The north and northwest sides of Robson are climbed much less frequently than the South Face. In August 1990, two Slovenian climbers, Bojan Packar and Simona Škarja, successfully ascended the North Face by a new route. From Škarja's account, we gain an insight into her emotions during the climb, beyond simply a factual report. The tremendous physical challenge and constant dangers give her a feeling of reverence for the power of

GLEN BOLES, *The North Face of Robson from Mount Waffl, 1987.*

Mount Robson and the insignificance of human strength. On her descent in rain and fog to the safer, more familiar landscape above Kinney Lake, she has a sense of Robson as a sacred mountain: "Now I understand much better why people who live under mighty mountains choose them to be their holy objects, even deities.[164]

Having started at 3:15 a.m. from the base of the North Face, the two climbers did not reach the summit ridge until 1 p.m. For almost 10 hours they persevered on pitches that seemed to be endless as the climbers became more and more exhausted, their muscles screaming in pain. As the sun rose, the snow became softer and avalanches threatened them: "From somewhere higher up, small pieces

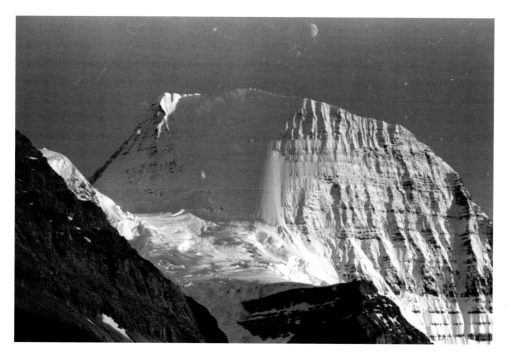

GLEN BOLES, *Robson's North and Emperor Faces 1987*, taken with a telephoto lens from Robson Pass. Notice the evening light on the hummocks near the top.

of ice started to fall and falling stones and pieces of ice kept on humming around my head in a very unfriendly way."[165] Once on the summit ridge, they feared a dangerous change in the weather as heavy clouds gathered, bringing the first whirling snowflakes. Their only concern now was a safe descent. To their amazement, in the snowstorm, they found their way down over avalanche paths and ledges to the upper ice fall on the south side, but one more challenge confronted them, a labyrinth of stony shelves receding down into the mist and encroaching darkness. Relying on instinct and scattered signs of humanity – cairns and a few pieces of rope – they eventually descended to the hut the next morning.

Emperor Ridge, leading along the top of the Emperor Face to Robson's summit, has been climbed even less frequently than the North Face, mainly because of the treacherous gargoyles

along the crest of the ridge. Robert Underhill and Lincoln O'Brien were successful, on August 8, 1930, in ascending from a bivouac at 9000 feet to the crest of Emperor Ridge, but they were turned back by series of "rock gendarmes"[166] covered in snow. These white guardians of the summit were very dangerous because the snow underneath a thin crust would not hold an ice axe, making a belay impossible. Emperor Ridge was still unclimbed when T.M. Spencer and Ron Perla, from Salt Lake City, were successful, on July 19, 1961, in using pitons to climb the overhanging rock covered with ice and gain the crest of the ridge. Thankful for a cloud cap that helped to conceal the fearsome exposure, they were able to thread their way through the ice blocks on the knife-edged ridge, reaching the summit at 7:30 p.m. After spending the night in a crevasse, with a stove, dried food and warm clothing for comfort, they "arose to a fantasy world of wind and snow and weird ice formations."[167] The descent was even more terrifying than the ascent because it involved a traverse on a very steep ice-covered wall, with blocks occasionally falling from the overhanging ice above their heads. After 12 hours, the men reached the col of Little Robson, out of great danger and welcomed by sunshine. Barry Blanchard waited for many years for the right weather to climb Emperor Ridge.[168] One attempt in 1997 was unsuccessful when Steve House, one of his companions, unfortunately dropped a crucial part for their stove. Without the means to melt snow, they were in danger of dehydration. By 2002 Blanchard had been thinking about Emperor Ridge for 12 years. Finally, on October 23, 2002, in the early afternoon, Blanchard and his companions Eric Dumerac and Philippe Pellet reached the ridge at 12,000 feet. They found themselves at the tenth gargoyle, but a kilometre of these treacherous shapes still faced them before they could climb from the top of Wishbone Arête to gain the summit at midnight.

Robson's east side: The Kain Face

The view of Mount Robson's east side from the trail to Snowbird Pass reveals another, equally dramatic panorama. Robson Glacier flows from the west, a gigantic river of ice emanating from an amphitheatre enclosed by The Helmet, Mount Robson, The Dome and Resplendent Mountain. The glacier flows between Rearguard Mountain and Extinguisher Tower before curving to the northeast toward Robson Pass. Between Robson's southeast ridge and Resplendent is the Robson col, a

pass for mountaineers down to the outlet of Kinney Lake. Robson Glacier is much diminished since the Coleman brothers and George Kinney camped near Extinguisher Tower, preparing to climb Robson's east face. Conrad Kain is remembered especially for his great achievement in leading Foster and MacCarthy to Robson's summit by cutting hundreds of steps in this icy east wall.

A.P. Coleman's sketches reveal the beauty of this austere landscape. Like an explorer in an undiscovered land, he recorded what he saw from his primitive camp beside Robson Glacier. Lawren Harris was particularly fascinated by the Robson amphitheatre, creating numerous sketches that became the basis for larger canvases. His famous *Mount Robson* in the McMichael Collection is a view from a high vantage point to the southeast, on Resplendent Mountain looking up to The Dome and Robson's east side, with its elongated summit pyramid soaring into a blue sky. More recently, Glenn

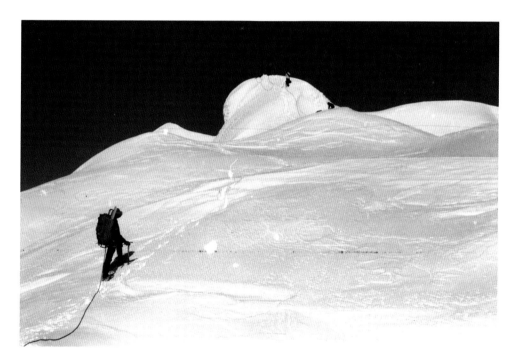

GLEN BOLES, *Approaching the summit, with some of [his] party on the summit, 1977.*

IOI

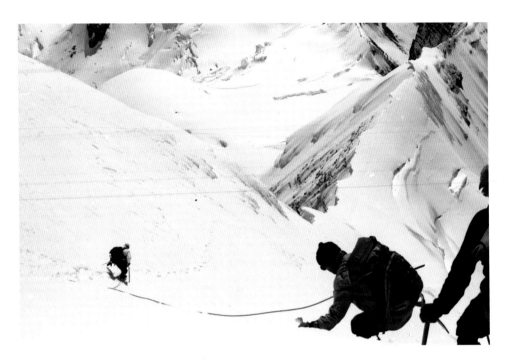

GLEN BOLES, *Starting down from The Roof, with the east arête at the lower right, 1977.*

Payan has painted a mountaineer's perspective of Robson's Kain Face from the peak of Resplendent. Trevor Lloyd Jones, also a climber, ventured onto Robson Glacier to capture an unusual view of Robson's east face from near the base of Rearguard Mountain with Robson's peak towering over-head. Jennifer Annesley's panorama from the hiking trail leading to Snowbird Pass is a dramatic portrayal of the scene looking up the Robson Glacier past Rearguard to Lynx Mountain.

Glen Boles, well known for his photographs, drawings and paintings of the mountains,[169] has climbed for years with a group of friends know as the Grizzly Group. In 1977 they decided to climb Robson by Conrad Kain's original route, and on this occasion they invited their wives and children to set up camp near Robson Pass.[170] A pack train was hired to transport all their gear. The climbers established a high camp below The Dome and near Robson col in an area with so many crevasses that they needed ropes to venture outside the tent. On their ascent of Mount Robson, they

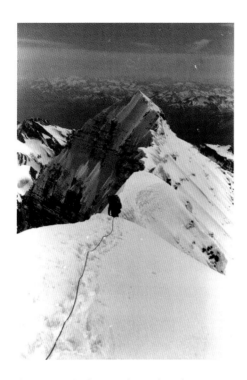

GLEN BOLES, *Looking southeast along the east arête; Leon Kubbernus is standing at the spot where you descend the Kain Face on the left to The Dome, 1977.*

were blessed with good weather and a wonderful view from the peak. Glen Boles and Leon Kubbernus were the last in their group to descend, and Glen photographed Leon on the east arête before they started down the Kain Face. With a belay from Leon, Glen had just stepped off the ridge onto the Kain Face when some large blocks of ice broke off and very nearly hit two members of the climbing party below. Once again, Robson proved to be a magnificent and dangerous mountain.

The spectacular panorama from Robson's peak with mountains below stretching in all directions undoubtedly inspired later expeditions of the Grizzly Group to climb summits in the Robson amphitheatre and to the west in the vicinity of Mount Longstaff. On one of these trips, they established their base camp not far from the western edge of Robson Glacier and close by a geological wonder of Mount Robson Provincial Park: a large number of petrified algal mounds. These huge, round shapes are spread out around the base of Rearguard Mountain's southern face. The mounds once existed in the warm waters of the ocean before they were gradually raised thousands of feet above sea level during the formation of mountain ranges. Not only did they survive intact throughout immense geological change, but they now rest high in the realm of glacial ice. The algal mounds are but one example in the immensity of Robson and the surrounding mountains, glaciers, waterfalls, lakes and meadows, a landscape full of natural beauty and wonder for those who come to explore on foot and on canvas.

GLEN BOLES, *Algal mounds, with Resplendent Mountain in the background, 1988.*

Contemporary Artists Associated with Mount Robson

JENNIFER ANNESLEY

After graduating in 1989 with a Bachelor of Fine Arts degree from the University of Alberta, Jennifer Annesley has worked in Edmonton as a full-time artist. At university she painted mainly in oil and acrylic, but after graduation she decided to challenge the perception of watercolour as a delicate medium by using rich colours to create an impression of strength. She is also intrigued by charcoal, a medium associated with the contrast between light and shadow, but one that can also be

used to produce fine detail. She believes that contrast is the basis of perception, and her art explores opposites, both thematically and formally, in the use of light and shadow and warm and cool colours. During her university years, Jennifer developed an interest in the techniques and ideas of the Old Masters, and since then, historic art and architecture have been a significant source of subject matter, encouraging her to travel extensively. The natural world is also an important subject, one that she enjoys exploring closer to home by backpacking, canoeing and backcountry skiing. For both major subjects, the lengthy artistic process involves, at the outset, careful notes and photographs, as she waits for the transient effects of light to produce strong contrasts that bring architectural or natural spaces into relief, expressing not only shapes but also an atmosphere and sense of time. Jennifer is affiliated with the Canadian Society of Painters in Watercolour and the Canadian Federation of Artists. In 1994 she inaugurated her one-night solo exhibitions that have become a popular annual event. Among numerous awards for her watercolours is the Grand Prize in 2009 from *Canadian Brushstroke Magazine* in the National Landscape Competition for her *Mt. Robson, North Face*.

ROGER D. ARNDT

Inspired by childhood visits to Manning Park in British Columbia, Roger Arndt knew at an early age that he wanted to be an artist. He received formal training at age fourteen as an apprentice to Loren D. Adams, a seascape artist with a studio on Vancouver's Granville Island. Roger painted mainly seascapes until, in his late teens, he discovered the Rocky Mountains. He began to spend several months each year hiking and camping in the vicinity of Lake Louise, the Athabasca River and Jasper, and the natural beauty of mountains, lakes and glaciers became his inspiration for painting. On one trip to the mountains, Roger hired a guide for a week and travelled on horseback up the Moose River and eventually to Berg Lake at the base of Mount Robson, much as the early explorers had done. After a few days hiking near Berg Lake, he completed the circuit by riding down the Valley of a Thousand Falls and past Kinney Lake. More recently, Roger has returned to painting the ocean but with the added interest of Haida totems, a subject he has carefully studied. In his studio in Kelowna, he meticulously prepares his panels by applying layers of oil primer and sanding them by hand to a very smooth finish. After preliminary oil sketches, he progresses to the finished image,

created with the application of many layers of transparent colour that reflect from the white board underneath. This painstaking process, derived from Flemish artists who used it centuries ago, creates the striking effect of luminescence in Roger's paintings.

CAMERON BIRD

Cameron Bird has always enjoyed the outdoors, and his hunting and camping trips give him the opportunity to do numerous sketches as reference material for his oil paintings. He has even worked as a mountain guide on expeditions by pack horse to obtain first-hand experience. His formal training in art, at Emily Carr College of Art and Capilano College, focused on commercial art and professional sign painting. Since then he has been inspired by the works of Illingworth Kerr, Maynard Dixon and Carl Rungius, but especially by Emily Carr and K.C. Smith. Cameron studied with Smith for ten years, learning how to simplify his landscape paintings and use brushstrokes with precision so that none is superfluous. Cameron often paints on location, using rich colours and heavy impasto. Since 1999 he has been a full-time artist and has had numerous solo and group exhibitions. He now lives in the interior of British Columbia with his wife and son.

GLEN BOLES

As a boy growing up in New Brunswick, Glen Boles always took pleasure in the outdoors, sports and drawing, but it was not until 1953, at the age of nineteen, that he moved west to Calgary, not far from the Rockies. When a fellow worker, Heinz Kahl, a Bavarian climber, persuaded him to try rock climbing at Yamnuska in 1957, Glen began a long association with mountains that would expand and deepen over more than 50 years. In his spare time away from his job as a draftsman and planner for the City of Calgary, Glen would eventually make 37 first ascents among climbs to 450 summits in the Rockies alone, not to mention climbing expeditions in other parts of the world. With his close friends in the Grizzly Group, Glen had the opportunity to go into remote alpine areas, establish a base camp and climb the surrounding mountains. In 1987 the group climbed Resplendent Mountain, as well as The Helmet and Mount Waffl, and in August 1992 they spent a week exploring

and climbing to the west of Mount Robson near Mount Longstaff. Glen has had the good fortune to have reached the peak of Mount Robson on two occasions, by the standard route through the Hourglass on Robson's south side early in his climbing career in 1960 and by the Kain Face to the east 17 years later. On his retirement in 1991, Glen's lengthy experience in the mountains became the inspiration for his art: pen and ink drawings and alpine landscapes in acrylic, watercolour and, more recently, oil. In 2005 the Alpine Club of Canada presented Glen with the Summit of Excellence Award for his contribution to Canadian mountaineering as a climber and artist. Glen now lives with his wife in Cochrane, Alberta.

NORENE CARR

Norene Carr was born in Victoria, B.C., and spent her childhood there before moving to the mountains and, shortly after her marriage, to a homestead near the base of Mount Robson. In 1954 Norene and her husband purchased 160 acres in the vicinity of the present Mount Robson Provincial Park Visitor Centre. Although Norene had been particularly interested in drawing and painting since her early teens, the alpine landscape now became a constant source of inspiration. When the Yellowhead Highway was constructed in 1970, they were forced to sell part of their land to the government but were able to take advantage of the new highway by opening a gas station and coffee shop. The demands of raising children and working left little time for her art, but Norene persevered, working late in her kitchen on many nights. She is a self-taught artist and enjoys close ties with the Valemount Arts & Cultural Society and the Jasper Artists Guild, collaborating with other artists on mural projects. She presently lives in a log house beside the Robson River with a spectacular view of Mount Robson. In her Studio of the Spiral Road adjacent to the house, she can now live her dream of painting full time. Over many years, Mount Robson has become part of her soul, and she welcomes other artists to paint beside her pond, with reflections of the great mountain. Norene spends her summers in the Robson valley and works in a winter studio in Victoria. Her long association with Mount Robson makes it fitting that her *North Face, Mt. Robson, Berg Lake* commemorates the 75th anniversary of Mt. Robson Park and hangs on a wall in the Visitor Centre beside the glass doors leading onto the observation deck.

HORACE CHAMPAGNE

Horace Champagne was born in Montreal into an artistic family. His grandfather was the artist Charles-Ernest de Belle (1873–1939), and while Horace began his career in advertising, he decided in 1980 to devote his artistic energy to painting with dry pastels. He studied in Montréal at L'École des beaux arts and in Ottawa at the School of Art, as well as travelling to New England to take workshops from Charles Movalli and to North Salem, New York, to study with Daniel Green. Horace has always enjoyed the outdoors, especially fly fishing in northern Ontario and Québec, and many of his paintings are landscapes ranging from the Atlantic to the Pacific shores, with the Rockies in between. A large number of his mountain paintings show the wonders of Lake O'Hara in Yoho National Park. Inspired by changing lights and colours in the landscape, he likes to paint *en plein air*, trying to capture nature's fleeting beauty. Horace also paints still life and the streets of old Québec from his home and studio on L'Île d'Orléans. The February 2009 *Pastel Journal* includes a wonderful still life by Horace on its cover and an article about his work by Deborah Secor, titled "Joie de Vivre," that reflects the great sense of vitality Horace brings to his painting. In the last few years he has established another studio in a small house in Rose Blanche, on the Newfoundland coast, close to the Atlantic surf with icebergs drifting by.

DAVID DAASE

David Daase was born in Chilliwack, B.C., and grew up in the midst of the coastal mountains. As a boy he enjoyed drawing the natural beauty around him, and his artistic abilities developed at school, where he began oil painting at age thirteen. David was also blessed with musical talents to such an extent that his professional career started as a music teacher. After two years, however, the demand for his paintings was so great that he decided to devote his energies entirely to art. David describes his style as photo-realistic, explaining that precise drawings are combined with an imaginative use of colour, composition and light. Just as the mood of a piece of music is paramount, so too are the feelings expressed by his landscape paintings as he draws the viewer into an experience of these special places. David particularly enjoys painting the mountains of British Columbia and Alberta,

combining the grandeur and power of peaks such as Robson with a tranquility in the midst of nature's beauty. David has started teaching again, but this time he instructs students in oil painting. He now lives in Kelowna with his wife and children.

Mel Heath

Mel Heath was born in Sutherland, Saskatchewan, and attended school there, graduating from City Park Collegiate in 1948. As a boy of ten, Mel was introduced to painting by Salem Hatch, an Ontario artist, and in his teens he started using watercolours under the influence of Robert Hurley, a prairie artist who took him on painting trips. In a long career that began in 1951 and has extended over 60 years, Mel has preferred watercolours for their spontaneity, freshness and challenge, with little room for error. Only recently has he taken up oil painting. When approaching subjects, he looks for contrasts of light and dark and unusual compositions. The natural world is often his inspiration, but his paintings reflect a wide range of topics. Mel's fondness for mountain landscapes developed through trips west on the train with his father, who worked for the railway, and his ensuing interest in climbing is reflected in the plaque he created in 1970 to commemorate the completion of the Ralph Forster Hut on Mount Robson. An important artistic influence later in his career was Andrew Wyeth, who helped him simplify his subjects. Mel was accepted into the Federation of Canadian Artists in 1984, and the same year became a member of the Canadian Society of Painters in Watercolour. He now lives in Edmonton with his wife, Fran, who is also an artist.

Gregg Johnson

Gregg Johnson spent his childhood on the prairies and later attended the University of Alberta, graduating with a Bachelor of Education. After specializing for two more years in fine art education, he taught in several school districts before accepting an appointment as an art teacher at McNally High School in Edmonton, a position he enjoyed for 28 years before taking early retirement in 1994. While teaching art to the students, he was also the sponsor for the hiking club, giving him an opportunity to combine sketching with a love of the outdoors. On retirement, Gregg could devote all

of his time to painting the mountain wilderness and rural Alberta. From landscape and architectural subjects close to home, he later painted on the West Coast and in other parts of Canada and Europe. In the early 1980s Gregg made a transition from oil painting to watercolour, because he felt it gave him more freedom to capture the light and the dramatic character of the western Canadian landscape. A member of the Federation of Canadian Artists and the Society of Western Canadian Artists, Gregg has taken his teaching career in a new direction since leaving the high school, by escorting international art holidays and giving workshops, especially his annual Jasper Watercolour Workshops that he continued to lead for seventeen consecutive years. These workshops, in the spring and fall, combine studio work with *plein air* painting. On one glorious fall day in 2010 Gregg took his students to paint beside Carr's Pond near the foot of Mount Robson.

TREVOR LLOYD JONES

Trevor Lloyd Jones, born in Essex, England, in 1946, spent the years 1965–1971 studying at the Colchester School of Art, Sheffield College of Art & Design and Goldsmith's College, University of London. While teaching at Faringdon School in Oxfordshire during the 1970s, he had a chance to travel, including two summers spent in New York. Now he had an opportunity to see parts of the United States and the Canadian Rockies. In 1980 Trevor decided to emigrate to Canada with his wife, and he was so impressed with Mount Robson that he chose to live nearby, in the Rocky Mountain Trench fifteen kilometres from McBride. He taught art part time for 23 years at McBride Secondary School, from 1981 until early retirement in 2004. During this time he actively pursued his artistic career with annual exhibitions in Prince George and in galleries in British Columbia and Ontario. In 1981 at the Prince George Art Gallery, he had a one-man show of 34 paintings, *Realism and the Robson Valley*. Six paintings from a 1991 exhibition, *Interior Imagery: Landscape Rediscovered*, were displayed at the Mount Robson Provincial Park headquarters. Since 1989 a strong belief in Christianity has influenced his painting, and he is currently a member of Christians in the Visual Arts. After remarrying in 1993, Trevor and his second wife travelled to Australia and New Zealand in 2003 and 2006, allowing him to include images of mountains from the southern hemisphere along with those of the Robson valley and the Rockies in his one-man show in 2006 called *High*

Places & Sacred Mountains. Through his art Trevor seeks to express the spiritual significance of the mountain landscape.

DAVID McEOWN

David McEown's search for beautiful but fragile landscapes as subjects for his watercolours has taken him into the Canadian wilderness and, more recently, to the earth's polar regions. His artistic journeys have made him deeply aware of how quickly some of these landscapes are changing, and his aim through his art is to increase our awareness of the world's natural beauty. As a child growing up in Toronto, David developed his love of the outdoors and painting by visiting his great-grandparents' homestead in northern Ontario. His formal studies at the Ontario College of Art & Design, where he graduated in 1992, were extended with two years of independent work at the Algoma School of Landscape Art in a wilderness area near Lake Superior, a region that also inspired Group of Seven artists. David chose to continue painting in Algoma for several more years, living in a cabin and supporting himself through teaching and guiding. His watercolours in celebration of the wilderness have since taken him to some of Canada's most beautiful places, including the Rockies, the West Coast and the High Arctic. David's love of painting on location allows him to feel connected to the natural world. Since 2005 he has travelled many times to the Arctic and Antarctic, devoting his art to portraying these rapidly changing landscapes. He is a member of the Canadian Society of Painters in Watercolour and received Curry's Da Vinci Award from the society in 2011 for his watercolour *Paradise Bay, Antarctica.*

LINDA McKENNY

Born in Vancouver in 1949, Linda McKenny moved to eastern Canada when she was twelve. After completing high school in Montreal, she spent several years working in New York City before returning to British Columbia in 1974. Her formal art education includes studying with Colin Williams, an alumnus of the Royal Academy, while taking courses in the liberal arts program at Athabasca University. Linda also studied art and design at the University of Calgary. Besides attending

many workshops, she has certification from the Sheffield School of Design. Linda's artistic interests include calligraphy, drawing, oil painting and sculpture. During the 1990s she worked mainly in clay, creating a distinctive line of sculpture and sculptural tiles. In Prince George she has taught art at O'Grady High School and in the continuing education program. She is a member of the Federation of Canadian Artists and the Kamloops Art Gallery, contributing works to juried shows for both organizations. Linda returned to her first love, oil painting, in 2000, finding much inspiration in the landscapes of British Columbia and Alberta. In 2008 she was invited to exhibit some of her landscape paintings at the Agora Gallery in the Chelsea district of New York City, in a show titled *Beyond Borders: Exhibition of Fine Art from Canada*. Linda now lives and works in Kamloops, and she hopes her paintings increase awareness of beautiful landscapes that are being threatened.

DONNA JO MASSIE

When A.O. Wheeler's house in Banff was facing demolition in 2010, Donna Jo Massie combined her love of history and art by asking local artists to join her in creating artistic impressions of this historic building. Donna Jo, born in North Carolina, had studied history at university before teaching in Alabama and Florida. She decided to emigrate to Canada in 1976, settling in the Bow valley and working in environmental education for Kananaskis Country. A decade later she started painting in watercolours and, within two years, made art her full-time profession. Her background as an educator and naturalist became an integral part of her popular weekly watercolour classes for adults in Banff and Canmore. As well as guiding students in numerous workshops in the backcountry and for corporations, she gives courses as an artist-in-residence for the Alberta Foundation for the Arts. Donna Jo has been able to extend her teaching to a much wider audience through a DVD called *Watercolour for Beginners* and her Canadian bestseller *A Rocky Mountain Sketchbook*. From her home in Canmore, she enjoys hiking in the mountains and sketching on location. Donna Jo is a member of the Alberta Society of Artists, Society of Canadian Artists, and Women Artists of the West. For her contribution to art, through teaching and painting, she has been recognized by Canmore with an Artistic Achievement Award and the Honorary Chair of ArtsPeak.

HUBERT NANZER

Hubert Nanzer was born in Switzerland in 1948 and studied at the Academy of Art in Lucerne. After graduation he set out in the early 1970s to explore the world's art and culture, visiting almost 70 countries in three years. While travelling by train along the border of Bolivia and Chile, he saw a mountain that was so beautiful that he felt compelled to get off the train in a small town and climb to the summit, alone and with little equipment. Since then Hubert has grown to understand the great power that mountains have over him. In 1978 he decided to live in Calgary, close to the Rocky Mountains. For twenty years he had a career in graphic design and illustration, until in 1998 he was able to fulfill his dream of painting full time. Hubert has a great empathy for the Rockies, the subject of many of his paintings, and through his art he expresses their strength and beauty. His technique, described by him as "Imax realism," invites the viewer both to see and experience the mountains' grandeur. Hubert now divides his time between Costa Rica, Antigua and Calgary.

GLENN PAYAN

Glenn Payan, born near Vancouver in 1962, continues to live in the Lower Mainland with his wife and four children. Since 1985 he has taught in Coquitlam, specializing in art instruction. Although his father was an artist and a career draftsman, Glenn did not decide to paint seriously until he was almost forty. In his youth he had a passion for rock climbing, and he often liked to sketch the mountains he climbed, particularly his ascent route. It was not until 2001, when on a family vacation, that Glenn decided to paint for his own enjoyment, and he sensed right away that art would become a significant part of his life. His father had an important influence on his technique, but Glenn's whimsical and colourful style is his own. He did spend two years studying with Agata Teodorowicz, a Polish artist. Glenn's subjects are frequently landscapes that may include winding highways and tall buildings and trees against dramatic mountains. He strives to communicate his joy and sense of mystery as he recollects his experiences with particular landscapes. He prefers not to paint from the actual landscape but from his own memories, thus eliminating unnecessary detail and focusing on important elements. The expression of his emotion is also very important, but this has a foundation

in the techniques of lighting, perspective and colour, influenced by the work of A.J. Casson, Emily Carr and Lawren Harris. Glenn is attracted to the effects of changing weather and the magical light of morning and evening in the mountains, but now he experiences them through painting rather than climbing.

CATHERINE ROBERTSON

As a child growing up in West Vancouver, Catherine had the opportunity to explore the British Columbia coast and the inland wilderness from her parents' boat. Her early experiences gave her a great love and respect for the natural world that is most often the subject of her paintings. She is particularly attracted to the alpine landscape. Catherine is mainly self-taught, with a few professional artists acting as mentors, and her works are characterized by dramatic light and brilliant, creative colours. Many of her paintings are in private and corporate collections, including the private collection of the Federation of Canadian Artists. She is a member of Oil Painters of America and the Coloured Pencil Society of America. Catherine has also contributed her art to projects sponsored by the British Columbia Lions Society and the Rotary Club, and she particularly enjoyed painting two life-size bears and an eagle in the Canucks for Kids fundraiser. Recently she was awarded first prize in the environment category at the Semiahmoo Arts Exhibition for her painting of a wood duck swimming in the midst of reflections on a pristine pond. Over the years, she has introduced many people of all ages to the wonderful world of art through her popular classes in painting and drawing. Catherine currently lives in White Rock, B.C.

GEORGE WEBER

George Weber made a significant contribution to Canadian art by introducing the process of fine art serigraphy, or silk screening. Originally trained in Germany as a draftsman and wallpaper designer, he decided to emigrate to Canada in the late 1920s when he feared that German politics were heading in a dangerous direction. Weber found work in Toronto designing wallpaper. There, in the early 1930s, he had the opportunity to study at the Ontario College of Art, taking classes in composition,

colour and, most important, commercial silkscreen techniques. He continued to apply these techniques to the creation of fine art prints when he moved west to Edmonton. In 1948, through lectures at the University of Alberta, Weber introduced serigraphy to Canadians, and in the 1950s he gave classes that were attended by well-known Alberta artists. About the same time, in 1950 and 1951, he was giving workshops at the Edmonton Art Gallery. Weber even imported special paper from Japan and Europe for the benefit of local printmakers. While instructing other artists in serigraphy, he continued to develop his own artistic talents by taking classes in watercolour and life drawing at the University of Alberta and the Banff School, studying with Jack Taylor and Janet Middleton. He founded the Edmonton branch of the Society of Canadian Painter–Etchers and Engravers and belonged to a number of artistic organizations, including the Federation of Canadian Artists and the Society of Canadian Painters in Watercolour. He exhibited his work on numerous occasions, among them the 1957 Western Print Exhibit in Toronto and one-man shows at the Edmonton Art Gallery. Weber's works include preliminary sketches and watercolours as well as serigraphs, and he is represented in the permanent collections of the National Gallery of Canada, Glenbow Museum, Whyte Museum and Art Gallery of Alberta. In 1976 he was honoured by Edmonton's Historical Board for a series of watercolours of historic sites and buildings. To commemorate the centennial of Banff National Park in 1985, Canada Post chose George Weber's serigraph *Moraine Lake*. His subjects cover a wide range, from the Alberta prairies and mountains to the British Columbia interior and coast. His daughter remembers that he had a special fondness for Mount Robson.

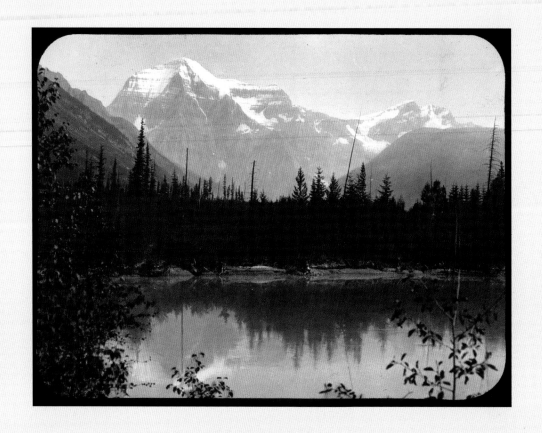

Mary Schäffer

YELLOWHEAD AND ROBSON VALLEYS

The mountains rising far and near were but worthy of the name of hills, leaving Robson a noble massive vision to the pilgrims who had come so far to see her.

—MARY SCHÄFFER, *Old Indian Trails of the Canadian Rockies,* 123.

A. Y. JACKSON

A Vista from Yellowhead, 1924

PEN AND INK WITH WHITE GOUACHE ON ILLUSTRATION BOARD, 26.4 × 34.3 CM
NATIONAL GALLERY OF CANADA

A.Y. Jackson's pen and ink drawing from a high vantage point, probably Yellowhead Mountain, is dated 1924, the year that Jackson and Harris were sketching in the Jasper area. This striking panorama encompasses much of the newly created Mount Robson Provincial Park. In the foreground, the Fraser River, after flowing from its headwaters in the glaciers on the Continental Divide just south of the Ramparts, has started its journey through the Yellowhead valley toward Moose Lake. As the Fraser leaves the 13-kilometre-long lake (in the middle of the drawing), the valley starts to narrow, with high mountains to the northwest obscuring the view of Mount Robson from the Fraser valley until the majestic peak suddenly appears near the confluence of the Robson River and the Fraser. Jackson's high perspective, however, allows him to emphasize the dramatic rise of the distant peaks, with the massive shape of Robson dominating the horizon, flanked by Whitehorn on the left and Resplendent on the right. The composition is carefully designed to provide a contrast for these striking mountains soaring into the sky. The foreground of dark, forested hills has a rolling rhythm, characteristic of Jackson's landscapes. Even the range of lower mountains, with snowfields, suggested through the use of gouache, has a rhythm like waves on a tempestuous sea. Against these undulating lines across the drawing, the sudden vertical shapes of the distant giants dominate the entire landscape, enticing explorers and climbers alike.

\longmapsto 6 ¾' \longrightarrow

A Vista from Yellowhead

A.Y. Jackson

Moose Lake, Mile 25, B.C., 1914

OIL ON BOARD, 21.5 × 26.9 CM
KAMLOOPS ART GALLERY

A.Y. Jackson's signature in the lower right corner of this sketch is an indication that he was pleased with the result, possibly a reason why this painting, completed during Jackson's first visit to the Rockies, has survived. Jackson and another artist from Toronto, William Beatty, had accepted a commission from the Canadian Northern Railway to paint scenes along the rail line that was under construction in the Yellowhead valley. A railway camp existed at Red Pass, or Mile 27, the distance west of Mile 0 at the summit of Yellowhead Pass. Jackson's title for his sketch indicates that his vantage point was two miles east of Red Pass, perhaps on the south side of Moose Lake. His perspective over the water and the three ridges sloping sharply to the lakeshore leads the viewer's eye west to a snow-covered peak on the distant skyline, possibly Mount Kain. The red hues on the ridges above the lake are typical of this area, and the highest of the hills, with its reddish dome, may be the Red Pass that gives its name to the stop on the railway. Jackson captures this scene on a glorious summer morning. The watery reflections, in all their gradations of colour in the landscape, from dark browns, reds and greens to blue sky with white puffs of cloud, take up more than half of the painting. This impressionistic treatment of light on the water, with broad brushstrokes and strong colours, provides an effective foreground for the hills and mountains in the background. The entire painting has a sense of rhythm in the series of coloured reflections, the sloping ridges and even the cumulus clouds that appear to be moving across the sky.

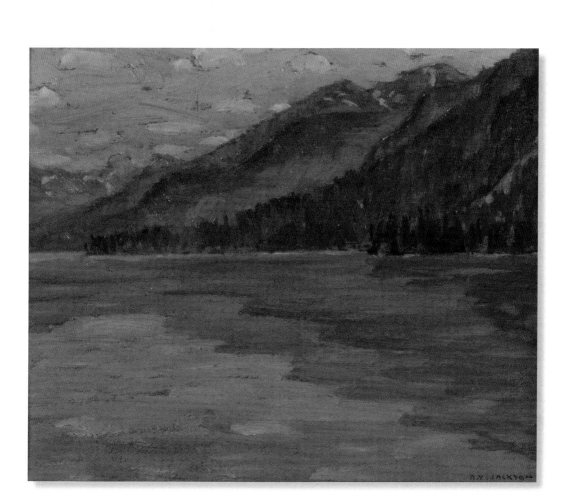

LINDA MCKENNY

Moose Lake, B.C., 2006

OIL ON BOARD, 50.8 × 76.2 CM
PRIVATE COLLECTION

Linda McKenny likes to make annual visits to Moose Lake. She is attracted to the wonderful reflections in this large body of water, stretching 13 kilometres beside the Yellowhead Highway and the tracks of the Canadian National Railways. Her vantage point for this painting is the first bend on the north side of Moose Lake, about a quarter of the way along the lake when travelling west from Jasper and heading toward Mount Robson. She captures the water's various colours, the shades of blue in the sky and the distant mountain range as well as the darker blue-greens of the hills on the left and the mirror image of the golden trees and evergreens on the right. Above the living trees, on the ridge in the middle ground, appear many that have succumbed to a forest fire, but their warm colour is repeated and deepened in the stalks of grass in the foreground. With graceful stems and dried tassels, the grass provides an intriguing contrast to the tracks along the shoreline, inviting the viewer to look past the slender stems and over the beautiful expanse of the lake toward the high mountains to the west. The warmth of summer seems to linger in this peaceful fall landscape.

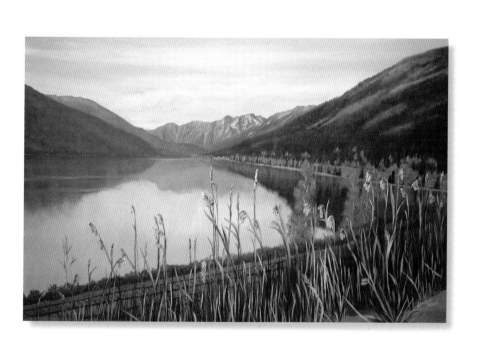

A.Y. Jackson

South of Razor Mountain, B.C. 1914

OIL ON BOARD, 21.7 × 27 CM
KAMLOOPS ART GALLERY

A.Y. Jackson appears to have climbed the slopes above Moose Lake and the railway construction to gain a view of Razor Peak to the north, framed by the vibrant red rock typical of this area. Razor Peak was named by A.O. Wheeler during the Alpine Club of Canada's expedition of 1911 because the strata appear to lie on end like razor blades. In Jackson's painting, three lines in the snow, extending down from the summit of Razor Peak, suggest these sharp edges lined up across the face of the mountain. The dramatic use of colour in the foreground, with deep-red rock interspersed with terraces of green meadow, forms an effective contrast to the snow-covered peak rising behind. The immense, billowing clouds also help to focus our attention on Razor Peak. Afternoon sunshine illuminates the entire scene. Broad brush strokes are used to delineate the shapes in the painting, and through the simplification of form and intensity of colour, Jackson presents an exhilarating wilderness landscape.

A.Y. JACKSON

Mount Robson, Resplendent and Kain, 1914

OIL ON WOOD PANEL, 21.4 × 26.8 CM
GIFT OF MR. S. WALTER STEWART
McMICHAEL CANADIAN ART COLLECTION

A.Y. Jackson's small sketch of the three peaks is sometimes referred to as simply *Mount Robson*. Jackson's vantage point, high on a hillside overlooking a broad valley with a substantial river winding through it, allows him to see the spectacular panorama of Mount Robson to the northwest (on the left), Resplendent Mountain in the centre and Mount Kain to the northeast (on the right). He may well have been on the south side of the Fraser, some distance above the new roadbed and overlooking Resplendent, a construction camp several kilometres west of Red Pass. This outlook would give him a perspective on the three peaks similar to the one in his painting. Jackson is certainly closer to Mount Kain, because this rocky finger seems to be on the same level as the considerably higher peaks of Robson and Resplendent. The morning sunshine illuminates the three summits soaring into the heavens and creates a rhythmic pattern of glorious light on the eastern faces and deep shadows in the steep gullies. Red Pass, the stop along the railway line, takes its name from the striking red colour of the rock north of the Fraser, and Jackson intensifies this red tone of the hills below the glaciated peaks. With vibrant colours and a strong rhythm, he creates an inspiring mountain landscape.

GREGG JOHNSON

Wild Lupines in the Robson Valley, c. 2002

WATERCOLOUR ON PAPER, 55.9 × 76.2 CM
PRIVATE COLLECTION

Gregg Johnson discovered these wild lupines growing near the Fraser River five kilometres west of Mount Robson Provincial Park. The excellent growing conditions in the Robson valley, similar to the West Coast rainforest, have produced a luxuriant bed of lupines in a spectacular range of colours, from red and pink to mauve and blue. The sunshine breaking through the clouds creates this splash of colour surrounded by myriad shades of green. The vertical shapes of the flowers and the trees behind lead the eye to Mount Robson, looming large in the distance. Clouds are resting behind Robson's east side, but for now the sun illuminates the glacier extending from the summit down the south face. The colourful, fragile lupines seem to hold their own against the powerful, austere mountain, with the freshness of new growth set beside the enduring rock.

MEL HEATH

Mount Robson, Summit Clouds, c. 2010

WATERCOLOUR ON PAPER, 38.1 × 55.9 CM
PRIVATE COLLECTION

Mel Heath's image of Mount Robson gives the impression of a majestic peak in the remote wilderness, rising dramatically from the valley floor. The early explorers were astonished to discover this massive mountain, its summit of ice and snow soaring into the sky. Frequently they were denied a glimpse of the Rockies' highest peak because clouds formed around Robson's summit pyramid, as they do in Mel Heath's watercolour. The cloud cover, however, does not diminish Robson's presence. Fresh snow at higher elevations sparkles in the sunshine, and our attention is drawn to the massive proportions of Robson's flanks, including the great buttresses that seem to be lesser peaks. In the centre of the image, on Robson's southwest face, the Grand Couloir falls out of the clouds and extends thousands of feet down toward Kinney Lake, out of sight at the base of Robson's cliffs. Sunshine has broken through the clouds, bringing warmth and colour to the meadow in the foreground and to the lower slopes of Mount Robson and Cinnamon Peak in the middle of the painting. Mel Heath's watercolour captures the feeling of the wild beauty of this alpine landscape.

GLEN BOLES

Mount Robson in the Clouds, 1984

OIL ON CANVAS, 61 × 89 CM
PRIVATE COLLECTION OF JAN OPELIK

This image by Glen Boles portrays Mount Robson as the clouds seem to roll away, revealing the upper part of the mountain in its pristine splendour. Blue sky has replaced the dark clouds that still hang over the cliffs lower down. This dramatic revelation could only have been seen from a mountaineer's vantage point, possibly from Whitehorn Mountain to the west across the valley from Robson. Glen has climbed hundreds of peaks in the Rockies, including Mount Robson twice, and his intimate knowledge of the high alpine landscape with its changeable weather is apparent in this painting. With phenomenal detail, he presents some of the climber's challenges on Mount Robson. We can see the steep northwest face, a partly illuminated bowl on the left where Kinney and Phillips struggled valiantly to ascend the snowy ledges, and Emperor Ridge above with its gargoyles guarding the peak, shaped like an enormous cap of ice and snow. On the south side the summit is protected by a treacherous line of cornices, or snow mushrooms, and a bergschrund near the top of the glacier that marks the standard ascent route. Not only are the precise lines of black rock delineated against snow and ice, but the painting presents an intriguing contrast between mountain and cloud, the eternal and the ephemeral. Wisps of vapour drift across Robson's cliffs and huge puffs of cloud appear to rise from Kinney Lake. Clouds behind Robson emphasize its dramatic silhouette. With a limited number of colours, Glen has created a stunning image of Robson's monumental beauty and strength.

DAVID MCEOWN

Mount Robson, 2004

WATERCOLOUR ON PAPER, 38.1 × 55.9 CM
PRIVATE COLLECTION

Swirling clouds in David McEown's watercolour lift just enough to reveal tantalizing glimpses of Mount Robson's lower buttresses and summit ridges. Painting *en plein air*, David captures the changing weather, as patches of blue sky can be seen above Robson's peak and sunshine breaks through the dark clouds, illuminating the fall foliage and the Robson River winding toward the viewer. The river valley has a freshness, newly washed by a passing shower. Colours here are vibrant with the warmth of autumn leaves and the deep purples of sandbanks and sloping ridges. The domineering presence of Mount Robson is hinted at by the huge triangular rock formation at its base, just emerging from the mist. With sweeping lines of cloud and strong colours, David gives his painting a great sense of energy.

Gregg Johnson

Mount Robson from Carr's Pond, 2010

WATERCOLOUR ON PAPER, 55.9 × 76.2 CM
COLLECTION OF THE ARTIST

Carr's Pond is near the home of the artist Norene Carr, who has been living in the Robson valley since 1954. On a brilliant September day, she invited Gregg Johnson and the participants in his workshop to paint beside her pond. His watercolour, completed *en plein air*, conveys a feeling of vitality on a rare day of sunshine and deep blue sky at Mount Robson. The bright colours of the autumn leaves are doubled in the reflections in the still water, interspersed with long, blue shadows. This striking foreground, full of energy, is a dramatic complement to the commanding presence of Mount Robson, its majestic shape crowned in white. The sunshine on Robson's southwest face brings out an unusual warmth of colour in the cliffs below the snow and ice. Robson endures while the seasons change. This spontaneous watercolour is filled with the happiness and excitement of having discovered Mount Robson on a day of perfect weather.

CATHERINE ROBERTSON

Mt. Robson, Fall Colours, 2011

ACRYLIC ON CANVAS, 20.3 × 25.4 CM
COLLECTION OF THE ARTIST

Catherine Robertson's painting of Mount Robson expresses a sense of exuberance in the midst of nature's grandeur. The vibrant fall foliage with all of its energy seems the appropriate setting for the powerful shape of Robson, its illuminated peak soaring overhead. Catherine's perspective is from the west, looking beyond the darker shapes of the evergreens in the foreground and over the winding river to the colourful trees and bushes catching the sunlight at Robson's base. This blaze of yellows, oranges and reds in the middle of the painting is balanced by the blue tones in the sky and snow above and in the water flowing toward the viewer. A recent snowfall accentuates Robson's ledges and sharp ridges. Catherine's painting has a feeling of immediacy in its celebration of wilderness beauty both enduring and transitory.

LINDA McKENNY

Winter, Mount Robson, 2011

OIL ON CANVAS BOARD, 61 × 91.4 CM
COLLECTION OF THE ARTIST

Linda McKenny portrays Mount Robson on a sparkling winter's day. This painting belongs to a series created from the same location near the highway, but in different seasons. The Robson River flows through this frozen landscape toward the viewer, while in the background Mount Robson soars into a cloudless blue sky beyond the snow-covered shoulder of Cinnamon Peak. Her painting evokes the cold temperature, but one that is softened by the afternoon sunshine, creating warm pools of light on the snowy river bank and on the distant cliffs of Robson, highlighting the glacier flowing from the summit. In sharp contrast is the dark stand of trees casting its long shadows, emphasizing the rosy tones of the sunlit snow and the light-blue water reflecting the sky. Footprints in the snow indicate that other creatures are moving through this radiant winter landscape, one that is not forbidding and empty but with an inviting warmth.

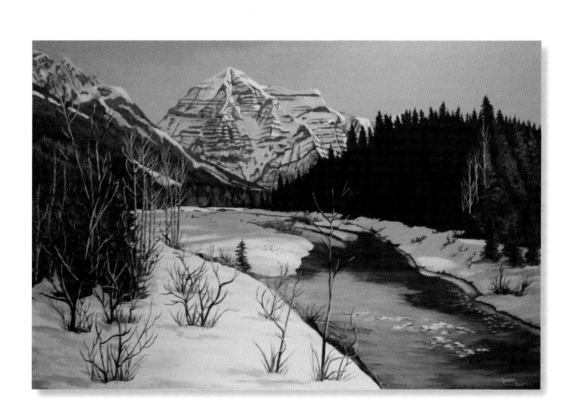

DAVID DAASE

Sunset on Mount Robson, 2006

OIL ON CANVAS, 38.1 × 76.2 CM
PRIVATE COLLECTION

This is a stunning portrait of Mount Robson, revealing the mountain's beauty and danger at the same time. David Daase has caught the fleeting moments of sunset when the south-facing slopes of Cinnamon Peak, on the left, and Mount Robson are a radiant pink. Even the drifting cloud nestled against Robson's lower cliffs has taken on a magical pink tone. Higher up, the sunlight reveals in frightening detail Robson's ridges like knife-edges, their precipitous cliffs too steep for snow to accumulate. Avalanches are a constant hazard, and along the summit ridge mounds of ice are visible, protecting the approach to Robson's peak. The blue shadows of the frozen valley below suggest the penetrating cold, enlivened by the pink reflection in the water tumbling toward the viewer. David has created a truly memorable image of Robson's spectacular shape, towering over us, illuminated by the setting sun.

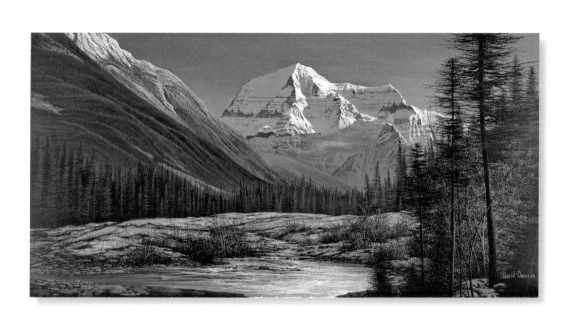

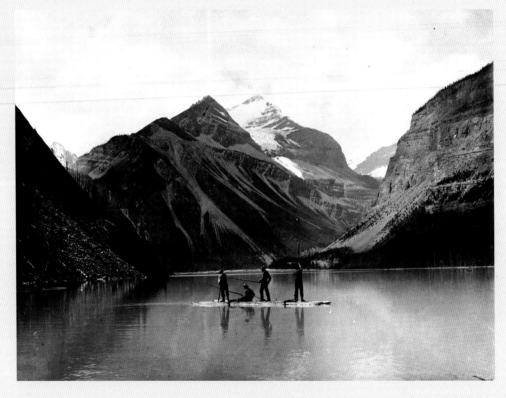

Mount Robson and Lake Helena [Kinney Lake], [c. 1910]
Image F-02062 courtesy of Royal BC Museum, BC archives

KINNEY LAKE

All around the lake and its delta the scenery is extremely picturesque. Towering precipices and leaping waterfalls are on every side, except the valley opening to the south. Over to the west, across the delta, one specially fine fall comes down in a number of white leaps.

—A.O. WHEELER, "The Alpine Club of Canada's Expedition to Jasper Park, Yellowhead Pass and Mount Robson Region," *Canadian Alpine Journal* IV (1912), 57.

DONNA JO MASSIE

Trail to Mount Robson, 2006

WATERCOLOUR ON PAPER, 147.3 × 99.1 CM
COLLECTION OF THERESA MAXWELL

In September 2005 Donna Jo Massie accompanied the renowned guide Lloyd "Kiwi" Gallagher to Mount Robson as part of a project to celebrate the Alpine Club of Canada's centennial. The idea was to create works of art, in two and three dimensions, that portrayed places in the Rockies of special significance for well-known mountaineers. In 2006 the Whyte Museum exhibited this unique collection of art in honour of the Alpine Club of Canada. A book, *The Mountaineer and the Artist*, provided photographs of the participants and the works of art, as well as explaining the thoughts and feelings about these special places from the mountaineers' and the artists' perspectives. Donna Jo remembers a day that started with light rain and thick cloud as she hiked with Gallagher toward Kinney Lake. The chance of even seeing Mount Robson, let alone painting it, seemed remote when, miraculously, the clouds lifted and sunshine illuminated Robson's immense precipices covered in ice and snow. Donna Jo's watercolour expresses the excitement of this sudden revelation, looking up thousands of feet to the sparkling white summit against the blue sky. She has chosen a very large vertical format to portray Robson's imposing shape. Fresh snow delineates intricate patterns on ledges and sheer cliffs. The hiker on the shadowed trail below appears to be walking toward Robson's southwest face with its immense couloir falling from the peak to Kinney Lake. Golden leaves of the poplars frame the magnificent mountain, and the sunshine brings out the warm colours of the autumn foliage along the trail through the rainforest, a world apart from the realm of the mountaineer on the precipitous cliffs above.

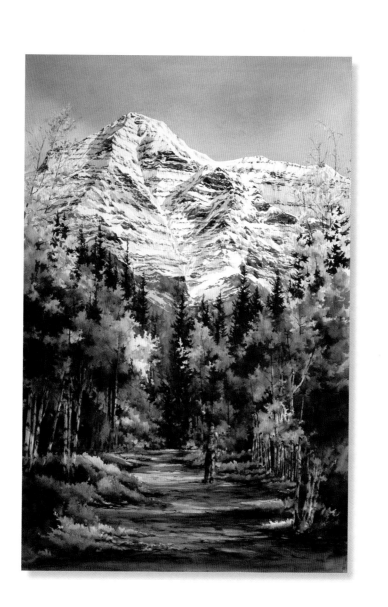

A.P. Coleman

Lake Kinney near Mount Robson, n.d.

WATERCOLOUR ON PAPER, 17.4 × 25.4 CM
WITH PERMISSION OF THE ROYAL ONTARIO MUSEUM © ROM

On his first trip to Mount Robson, in 1907, A.P. Coleman camped with his companions on the Grand Forks (Robson) River, and the next day, Coleman, along with his brother Lucius and George Kinney, struggled through the dense undergrowth along the river toward Robson's looming southwest face. One of their important discoveries was Kinney Lake, recorded in Coleman's small watercolour, painted from a vantage point above the lake and to the southeast, on the side of Campion Mountain. Cinnamon Peak is on the left, in the foreground, facing the massive shape of Mount Robson across the lake. In the background, Whitehorn Mountain towers over the alluvial plain where the Robson River flows out of the Valley of a Thousand Falls toward Kinney Lake. Coleman's realistic image of this glacial lake surrounded by high cliffs reveals his geologist's eye in his sensitivity to the different colours of the rock faces, in various shades of brown and gray, and to the precise shapes of the mountains. This tantalizing glimpse of distant, glaciated peaks – with Mount Phillips between Whitehorn and Robson, and Mount Longstaff beyond – and the river flowing into the far end of Kinney Lake enticed Coleman to travel farther. His watercolour, however, also records the gathering cloud in the blue sky, a sign of a coming change in the weather that would put an end to their explorations at Mount Robson that year.

WILLIAM JOHNSTONE

Lake Kinney, 1913?

WATERCOLOUR ON PAPER ON BOARD, 34.9 × 46 CM
ART GALLERY OF ALBERTA COLLECTION
GIFT OF THE JAEGER FAMILY

William Johnstone's realistic image of Kinney Lake reveals his training in a nineteenth-century watercolour style similar to that of A.P. Coleman. From a vantage point at the end of the lake, possibly near the camp he shared with H.E. Bulyea in August 1918, Johnstone has created a dramatic focus for his sketch with the imposing presence of Whitehorn Mountain in the distance, its ascending pyramids leading to the glacier flowing from its peak. This upward thrust is balanced by the framing diagonals of Mount Robson on the right and Cinnamon Peak on the opposite shore. Johnstone is a careful observer of the subtle variations in colour, from the stronger tones on the slope closest to the viewer with its individual trees to the delicate washes indicating the forest reaching up the sides of Whitehorn. The sky is overcast, and peaks beyond Whitehorn seem to blend into the clouds. Despite the distant haze, Whitehorn is painted in gentle but warm colours. The glacial green lake is still, reflecting the light on a peaceful day in the remote mountains.

ROGER D. ARNDT

Whitehorn and Kinney, 2008

OIL ON PREPARED PANEL, 61 × 40.6 CM
COLLECTION OF THE ARTIST

Kinney Lake, with the glaciated peak of Whitehorn at the far end, is one of the wonders of Mount Robson Provincial Park. Roger Arndt portrays the calm water like a beautiful jewel, its reflections of sky and cloud intermingled with deep emerald greens. A few ripples sparkle near the shore, and the shallow pool closest to the viewer is so clear that rocks are visible beneath the surface. This luminous quality is the result of Roger Arndt's technique of preparing his panels with an absolutely smooth white surface, ideal for reflecting light. From the tiny wildflowers on the shoreline and across the expanse of water to the symmetrical peaks towering in the distance, the painting is filled with the light of a summer's day. Ephemeral clouds drift overhead as mist floats over the Robson River, just beyond the immense buttress of Mount Robson rising sharply on the right. This painting of Kinney Lake, surrounded by high mountains, epitomizes a tranquil beauty in the alpine wilderness.

CAMERON BIRD

Kinney Lake — September, 2010

OIL ON CANVAS, 55.9 × 71.1 CM
PRIVATE COLLECTION

The Robson valley is a favourite place for Cameron Bird to sketch. His vantage point for this painting is near the shoreline of Kinney Lake about halfway toward the northwest end. Mount Robson's sheer cliff rises on the right, just beyond the rocky knoll in the foreground, and in the background the sparkling peak of Whitehorn Mountain soars into the blue sky. With vibrant colours and simplified shapes, Cameron Bird creates a landscape painting that is full of energy. The intense orange in the foreground bushes is repeated in the trees and the higher rock faces, all complemented by shades of blue and green in the alpine firs and the glacial lake. The balancing of colour is consistent with the interplay of curves and angles, with the rounded rock formations in the foreground and the three triangular summits in the background leading up to Whitehorn. Vertical shapes of the trees are balanced by horizontal lines in the water. Wide brush strokes create a distinctive style and help to delineate form, giving the painting a sculptural quality. This image of Kinney Lake on a glorious fall day has a feeling of exhilaration.

GEORGE WEBER

Kinney Lake, Mt. Robson Park, B.C., 1970

SERIGRAPH ON PAPER, 15.2 × 22.9 CM
COURTESY OF DONNA TINGLEY AND WILLOCK & SAX GALLERY

In this striking silkscreen of Kinney Lake, George Weber's perspective is from the shoreline, looking across the expanse of calm water to Whitehorn Mountain dominating the distant skyline. The middle of the image shows the Robson River flowing into the northwest end of the lake, framed by the forested shoulder of Cinnamon Peak on the left and the immense, rounded cliff of Mount Robson on the right. In the shallow water closest to the viewer, two weathered tree trunks lie partly submerged, their tapered shapes emphasizing the horizontal lines of the water and providing a balance to the steep slopes that enclose the lake. George Weber's careful composition is supported by a superb use of colour. He chooses soft, natural tones and applies them with subtle variations in intensity. The lake, for example, changes colour from gentle brown tones in the shallows to stronger greens as the depth increases. Intricate shapes of the forests reaching up the cliffs and the delicate patterns of snow interspersed with rock reveal his skillful handling of the medium. George Weber's image presents the peaceful beauty of Kinney Lake in the midst of magnificent mountains.

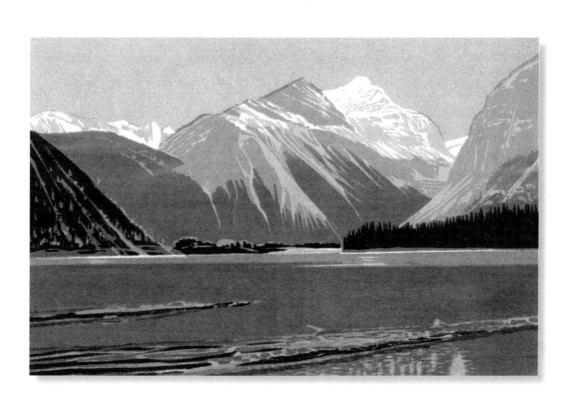

MEL HEATH

Route to High Camp from Kinney Lake, 2011

WATERCOLOUR ON PAPER, 27.9 × 38.1 CM
COLLECTION OF THE ARTIST

This watercolour shows a mountaineer's perspective from a vantage point far above Kinney Lake on the approach to Forster Hut, constructed in 1970 by members of the Alpine Club of Canada. Mel Heath painted his watercolour from a photograph taken by one of the climbers who built the hut. This high camp is located between the two rocky pyramids in the centre of the image, to the left of the lower ice fall in a spot protected from avalanches. Climbers can spend the night in Forster Hut before setting out early the next morning for Robson's summit. This close view of Robson's upper cliffs reveals the immense scale of the mountain, with ledges like enormous steps leading relentlessly upward. The upper ice fall, where the glacier flowing from the summit is broken into two parts, is extremely hazardous because of the frequency of falling ice blocks. The standard route, however, from the hut and up Robson's south face, requires climbers to negotiate this massive wall of ice in order to ascend the glacier above. Mel Heath's watercolour portrays a dangerous, forbidding landscape, but one that also has a rugged beauty with the glacier sparkling in the sunshine and the warm colours of the rock revealing a distinctly lighter tone in some of Robson's sedimentary layers.

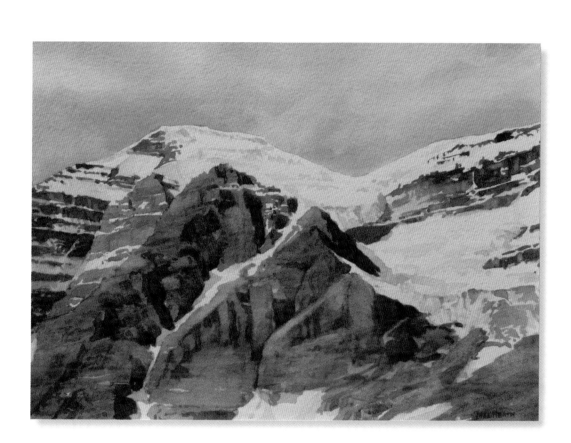

A.P. COLEMAN

Falls on Grand Forks River near Foot of Mt. Robson, n.d.

WATERCOLOUR ON PAPER, 25.4 × 17.8 CM
WITH PERMISSION OF THE ROYAL ONTARIO MUSEUM © ROM

A.P. Coleman's initial plan to approach Mount Robson in 1907 was to follow the Grand Forks River to its source. The river entered Kinney Lake over a broad alluvial plain, but Coleman soon discovered that higher up the water plunged over cliffs into a narrow gorge with walls so steep that they were impossible to climb. He and his companions, Lucius Coleman and George Kinney, did manage to ascend the river valley as far as the highest waterfall, later named Emperor Falls by A.O. Wheeler. Coleman decided to paint the lowest waterfall, which Wheeler called White Falls because the large volume of water shooting over the precipice and hitting the rocks below creates so much foam. Coleman chose a dramatic perspective for his *plein air* sketch by positioning himself beside the waterfall and not, as we do today on the Berg Lake trail, viewing the front of White Falls. The vertical format of his watercolour emphasizes the precipitous nature of the terrain. The cliff closest to the viewer is almost perpendicular, but bushes and a single tree still manage to cling to its ledges. Sunshine illuminates the spectacular waterfall, with its delicate cloud of water vapour. The river then winds its way in a much calmer fashion between the steep shoulders of Mount Robson, to the left, and Whitehorn Mountain. Above the distant alluvial plain, the blue shapes of Cinnamon Peak, in the background on the right, and Campion Mountain, on the left, are not quite high enough to obscure a tantalizing white pyramid to the south. Coleman's observant eye records the mountain landscape with its delicate beauty in the rising mist and its tremendous power in the great volume of falling water.

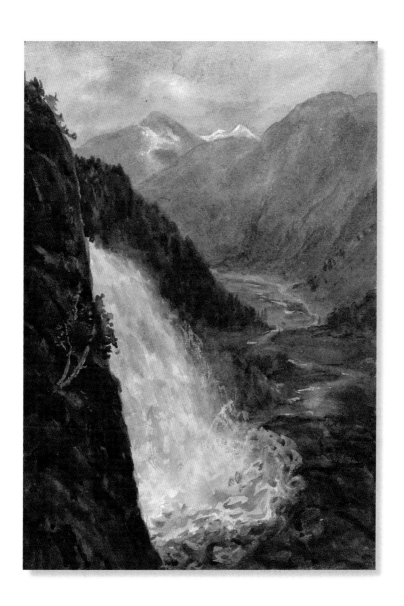

A.P. COLEMAN

Mount Robson from North West, 1908

WATERCOLOUR OVER PENCIL, 25.4 × 17.8 CM
WITH PERMISSION OF THE ROYAL ONTARIO MUSEUM © ROM

This unusual view of Mount Robson from the vicinity of Emperor Falls emphasizes its pyramidal shape. Coleman's sketch is dated 1908, when he made a second expedition to Robson. During many days of inclement weather, he had a chance to explore, including the area around Berg Lake and the top of the valley with the waterfalls that had defeated him the year before. His watercolour shows Robson's summit rising sharply out of the clouds into a rare blue sky. The North Face reflects the morning sunshine, while the Emperor Face is still in shadow. A wreath of cloud divides the painting into two parts, with the warm, forested slopes below and the glorious peak in its fresh mantle of snow floating above. Coleman's sketch catches the fleeting moments when the clouds part, revealing Robson's magnificent summit.

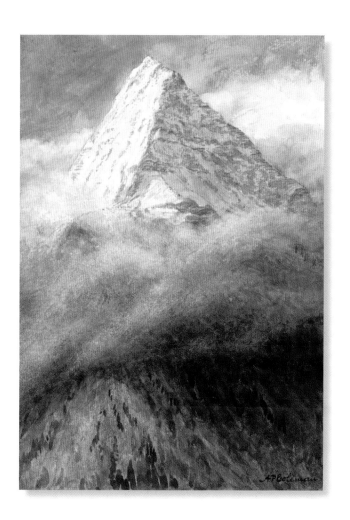

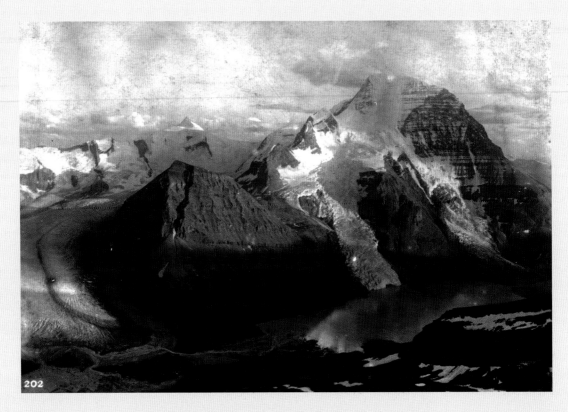

Canadian Alpine Club Mount Robson Climb, 1913
Image G-01548 courtesy of Royal BC Museum, BC Archives

MOUNT ROBSON AND BERG LAKE

We looked to the northwest face of the Massif, which rose supreme in the centre of the view. If one is lucky the hoary crest is free of clouds, which is not often the case. On this side, the whole face seems to fall, sheer, thousands of feet in tremendous rock walls and tiers of precipitous cliffs, far too steep for snow to lie. On the north shoulder rests a mighty ice-field, crevassed and broken in every direction, and frequently changing its form owing to the ice avalanches that come crashing down from the giant cornices lining the supreme crest of the mountain From this elevated ice-field, fed by avalanching snows from the sides of Robson, a gigantic ice cascade tumbles down rock precipices and buries its nose in the blue waters of Berg Lake. Often, great chunks of ice break off with reports like cannon and go leaping down the steep incline to plunge into the placid waters of the lake. Sometimes, the chunk is so large and falls from so great a height that it sends a spout of water twenty to thirty feet into the air and the waves caused by the upheaval wash to the further shore.

—A.O. WHEELER, "The Alpine Club of Canada's Expedition to Jasper Park, Yellowhead Pass and Mount Robson Region, 1911," *Canadian Alpine Journal* IV (1912), 42.

MARGARET LOUGHEED

Mount Robson and Berg Lake, B.C., Canada, c. 1930

OIL ON CANVAS, 77.5 × 92 CM
COLLECTION OF PARKS CANADA

As an artist for Parks Canada from 1930 to 1932, Margaret Lougheed painted in many locations in the Rockies. Her perspective in this Mount Robson painting is from the alpine meadow in the Mumm Basin, looking down past the treeline to Berg Lake. The sun rising in the northeast illuminates the great river of ice falling from Robson's magnificent North Face to the water's edge. Above the North Face the summit rises gloriously into the blue sky of a perfect summer morning. The sunlight catches the top of The Helmet, just below Robson's peak, and brings out the warm colour of the immense buttresses sloping toward the lake. Robson's massive shape takes up most of the painting, framed by the ancient trees in the foreground. Margaret Lougheed's bold use of colour, in the interplay of tones of blue, white and pink, and her strong lines create a cheerful, vibrant image of Mount Robson.

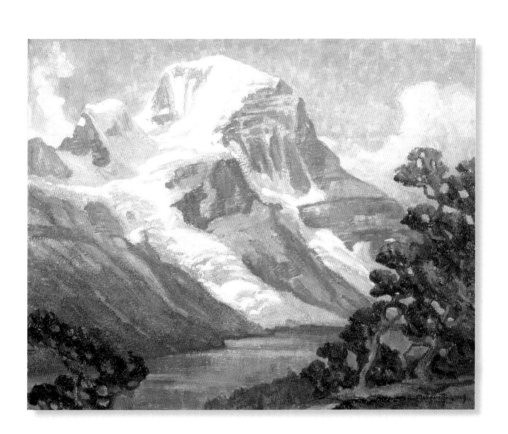

A.P. Coleman

Mount Robson from across Berg Lake, n.d.

WATERCOLOUR OVER PENCIL, 27.3 × 17.8 CM
WITH PERMISSION OF THE ROYAL ONTARIO MUSEUM © ROM

In A.P. Coleman's watercolour, Mount Robson's summit makes a dramatic appearance above a thick layer of cloud. This painting probably dates from his 1908 expedition, when the sun shone infrequently in the midst of weeks of rain and snow. Coleman's vantage point is on a slope above Berg Lake looking down on the reflection of the glacier he called Blue Glacier because of the colour of the jumbled blocks of ice. A.O. Wheeler changed the name to Tumbling Glacier to describe the massive chunks that break off and splash into the water. Today this spectacular ice flow is known as Berg Glacier. Coleman effectively portrays Robson's changeable weather with brief periods of sunshine threatened by masses of dark clouds. The immense summit, with the afternoon sun shining directly on the Emperor Face, seems to be detached from its base by the ring of ephemeral cloud. Below the mist, the sunshine brings vibrant colour to the glacier bordered by reddish-brown rock and to the green slopes at the water's edge. Coleman's image conveys the wonder of seeing Mount Robson emerge from a cloak of enveloping cloud.

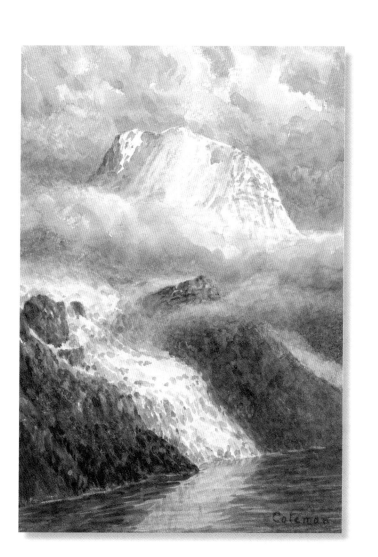

A.Y. JACKSON

Mount Robson, 1914

GRAPHITE ON PAPER, 27.8 × 42.2 CM
FIRESTONE COLLECTION OF CANADIAN ART, OTTAWA ART GALLERY

One of the remarkable qualities of this drawing by A.Y. Jackson is that it has survived, given his propensity for destroying images from his first trip to the Rockies in 1914. Despite its fragile condition and the evidence of the two pages from his sketch book having been taped together, this drawing proves that Jackson did not stay in the Yellowhead valley sketching along the Canadian Northern Railway line. He hiked up from Kinney Lake over the newly constructed trail in the Valley of a Thousand Falls to discover Berg Lake at the foot of Mount Robson. In order to sketch this panorama, he must have climbed up into Mumm Basin, where he could see not only Robson's North Face and the lesser peaks of Helmet and Waffl, but also Rearguard Mountain with the Robson glacier sweeping around its base in the direction of Berg Lake. Beyond the great river of ice is the triangular rock formation known as Extinguisher Tower, tucked into the base of a distant ridge. Jackson's freely flowing pencil in this drawing reveals his keen powers of observation as he delineates different textures, angular rock faces and undulating lines of glaciers. He signed both pages of his drawing, perhaps an indication that he was pleased with the result.

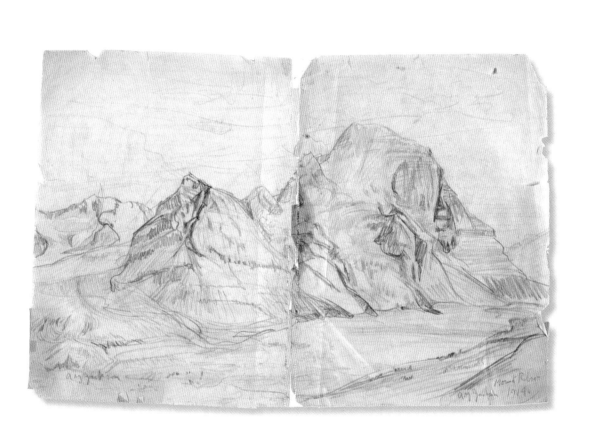

LAWREN HARRIS

Mount Robson, c. 1924–25

GRAPHITE ON WOVE PAPER, 18.9 × 25.4 CM
NATIONAL GALLERY OF CANADA

In his drawing done from the opposite shore of Berg Lake, Lawren Harris portrays the imposing shape of Mount Robson's summit with the immense icefall from the peak to the lake. The approximate date of 1924–25 suggests the possibility that Harris may have been accompanied by A.Y. Jackson on their trip together to the Rockies in 1924. In any case, Mount Robson had a profound impact on Harris, and he was inspired by this landscape at least until 1941. This drawing shows Harris worked quickly with a practised eye, recording shapes, textures, rhythms and colours in preparation for a painting. The "x" notation may indicate lighter values where the sunlight strikes the top of The Helmet, Robson's North Face and Berg Glacier. This drawing seems to represent this amazing landscape without too much simplification and abstraction.

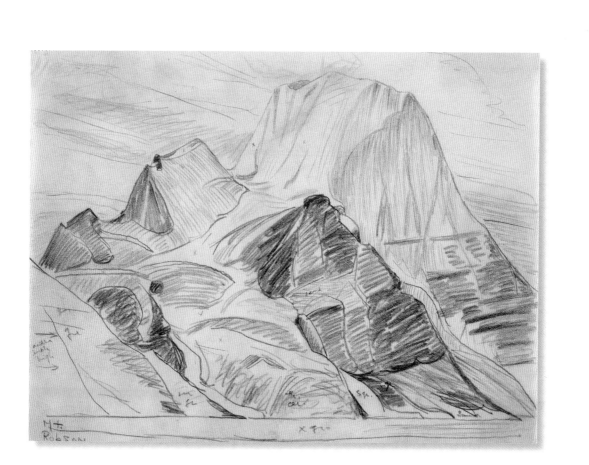

Mt.
Robson

LAWREN HARRIS

Mount Robson from the Northeast, n.d.

OIL ON PAPERBOARD, 30.2 × 38 CM
ART GALLERY OF ONTARIO
THE THOMSON COLLECTION © ART GALLERY OF ONTARIO

Lawren Harris had a high vantage point for this painting, possibly near the present trail that leads up from Robson Pass into Mumm Basin. The title seems somewhat puzzling, but a compass reading taken after the steep ascent, just before the trail turns left toward the meadows, does indicate a position slightly to the northeast. Harris limits his focus to the mountains rising above Berg Lake, with Rearguard Mountain's dark shoulder on the left and the two lesser peaks, Mount Waffl and The Helmet, leading up to Mount Robson's magnificent summit. A comparison with his earlier (1924–25) drawing shows that he has simplified shapes and removed much of the detail. Robson's North Face is narrower and taller, and the gullies on either side have been smoothed over with a glistening white that reflects the morning sun. The Emperor Face, still in shadow, looks even more challenging with its elongated shape and nearly smooth surface, with just a suggestion of the vertical ribs of rock. Harris emphasizes the triangular shapes below the sunlit peaks of Mount Waffl and The Helmet by painting them dark blue in contrast to the sparkling white presence of Mount Robson. The breathtaking vertical rise of Robson's summit into the rich blue sky is inspiring in its austere beauty.

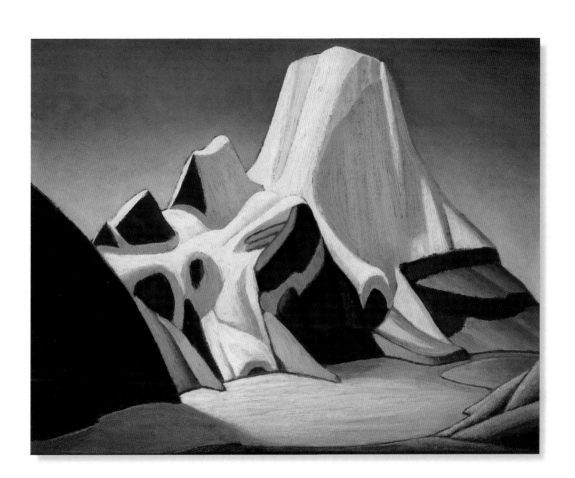

JENNIFER ANNESLEY

Berg Lake, 2008

CHARCOAL AND GOUACHE, 63.5 × 86.4 CM
PRIVATE COLLECTION

This stunning view of Mount Robson towering over Berg Lake is from the Mumm Basin route near the Hargreaves Glacier. Jennifer Annesley's perspective brings the rugged beauty of the Emperor Face into prominence, with all its intricate detail accentuated by sunlight and snow clinging to its cliffs. Directly below, the surface of the Mist Glacier catches the light, revealing the amazing texture of this frozen river stretching down to Berg Lake. On the other side of the great rock buttress in the middle of the image, Berg Glacier is in full sunlight, its sinuous piles of ice flowing inexorably toward the water. From this angle, Mount Waffl and The Helmet, above Berg Glacier, seem flattened, and Robson's North Face, in shadow, does not exhibit its true character as an immensely challenging route to the summit. The wonder of Jennifer Annesley's painting is in the use of light and contrasting values. Her medium of charcoal and gouache is admirably suited to portray the whole range of values from the sparkling snow to the deep shadows around the shore of Berg Lake. This marvellous interplay of light and dark is caused by the great rift in the storm clouds, allowing sunshine to illuminate the landscape and create a dappled pool of light on the surface of Berg Lake.

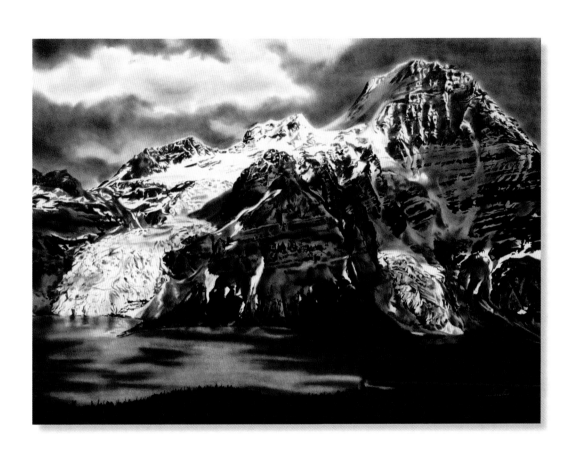

TREVOR LLOYD JONES

Glacier below Mt. Robson, 1990

ACRYLIC ON CANVAS, 71.1 × 55.9 CM
COLLECTION OF THE ARTIST

Trevor Lloyd Jones' wonderful painting of Mist Glacier reveals that this apparently static river of ice has great vitality and beauty. His perspective is from the terminal moraine below Robson's Emperor Face, looking over a small lake, hidden from view, to the ice flowing over and between the immense boulders. The tremendous power of the glacier as it scours the rock is evident in the pile of accumulated debris in the foreground. However, this forbidding landscape of rock and ice also has a richness in colour and line. At close range we can see the complex patterns created by the enormous pressure of the slowly moving glacier. The fractured ice becomes a natural mosaic of angular shapes in different shades of blue, all pressed together in sweeping curves and diagonals. Glistening snow on the glacier's smooth surface provides a distinct contrast. The painting shows an enormous rift in the thick layer of ice where great blocks have broken off above as the glacier was forced over a huge rock outcropping. The great struggle between the opposing forces of rock and glacier is certainly apparent in this portrait of Mist Glacier.

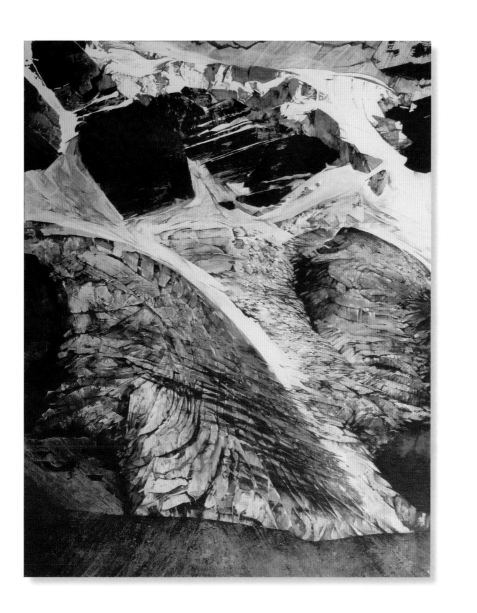

HUBERT NANZER

Mount Robson, 2011

OIL ON CANVAS, 152.4 × 121.9 CM
COLLECTION OF THE ARTIST

Hubert Nanzer captures Mount Robson's majestic beauty in the few moments before the sun sets and the colours fade. From a perspective high up in Mumm Basin, the icebergs appear as tiny specks as they float into Berg Lake, now in shadow except for the reflection of the glacier above. The last rays of sunshine bring out the intricate lines and intense colours in the reddish-brown rock and the luminous snow tinged with pink. Like a spotlight, the setting sun shines past the rocky ribs on the vast Emperor Face and comes to rest on The Helmet and Mount Waffl, the natural focus for this painting. Blue shadows on the North Face above are cold and forbidding, but Robson's peak against the deep blue sky is still catching the sunlight, emphasizing its eminent position as the highest point in the landscape for hundreds of kilometres. Hubert Nanzer's painting is a stunning portrait of Mount Robson, a natural wonder.

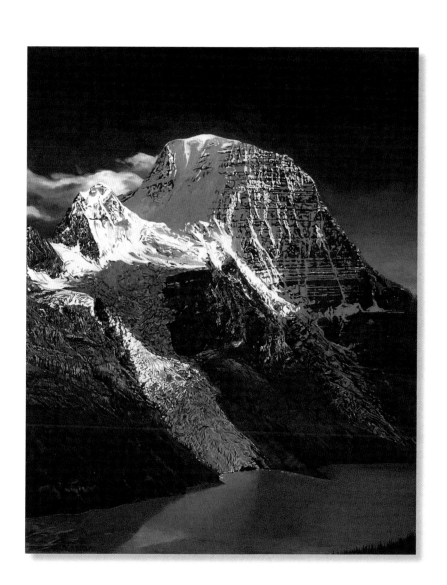

HUBERT NANZER

Berg Glacier, 2011
OIL ON CANVAS, 152.4 × 101.6 CM
COLLECTION OF THE ARTIST

From his perspective on the opposite shore of Berg Lake, Hubert Nanzer allows us to see at close range the incredible power and beauty of Berg Glacier. His focus is almost completely on the tumbling mass of ice in its steep descent between Robson's enormous buttress on the right and Rearguard's shoulder on the left. The low viewpoint, looking past the foreground trees, dramatically emphasizes the high wall of ice across the lake. Above this wall, tremendous pressure is exerted by the glacier flowing inexorably toward the lake, occasionally causing great ice blocks to crash into the water. Nanzer's image of the glacier's size and strength is combined with a wonderful portrayal of light. The intense white of the ice in direct sunlight is contrasted with the exquisite tones of blue, turquoise and jade in the shadows. The darker values also reveal the glacier's textured surface, a myriad of intricate forms. This fascinating image allows us to appreciate the breathtaking natural beauty of Berg Glacier, in all its glorious colours and fantastic shapes.

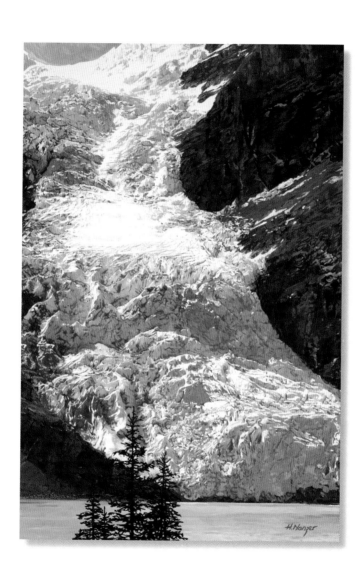

ROGER D. ARNDT

Robson Alpine, 2009

OIL ON PREPARED PANEL, 71.1 × 40.6 CM
PRIVATE COLLECTION

In his painting, Roger Arndt encapsulates a glorious summer morning in the alpine meadows near Hargreaves Lake. Beyond the trees, Berg Lake is just visible below the magnificent presence of Mount Robson. The hiking trail bending toward the lake is bordered by exquisite flowers and golden foliage, spreading like a luxuriant carpet beneath the tall trees. These warm, vibrant colours in the foreground are in contrast to the cooler tones of the distant peaks, mainly in shadow except for a ribbon of light falling from Robson's summit to the bottom of Berg Glacier. The snow and ice sparkle in the sunlight, and the enormous cloud hovering overhead takes on a pink glow. An atmospheric haze seems to fall over the mountains across the lake, softening their outlines under the fresh snow. Roger Arndt's image portrays a rare day at Mount Robson, one filled with sunshine bringing vitality to the tiny flowers and the awe-inspiring peaks.

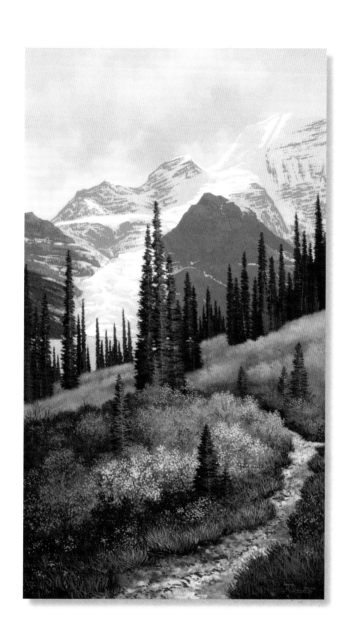

GLENN PAYAN

Mt. Robson (Above Berg Lake), 2007

OIL ON CANVAS, 101.6 × 76.2 CM
PRIVATE COLLECTION

When Glenn Payan tried to see Mount Robson in 1987 from the shoreline of Berg Lake, low cloud and drizzle obscured the mountain. Years later he used a photograph to paint Robson's image as he hoped he might have seen it. Rather than concentrating on precise details, he chose to portray the transcendent feeling of looking up at Robson's summit, its white triangle in the morning sunlight etched against a pattern of overhanging blue clouds. Shapes of the cliffs and glaciers are simplified and elongated to increase the sense of Robson's great height. A path of light draws the viewer's eye up past Berg Glacier and illuminated buttresses to the North Face and the summit ridge. With rich colours and strong lines, Glenn Payan gives his painting great vitality as Robson's glorious summit is revealed despite the high cloud.

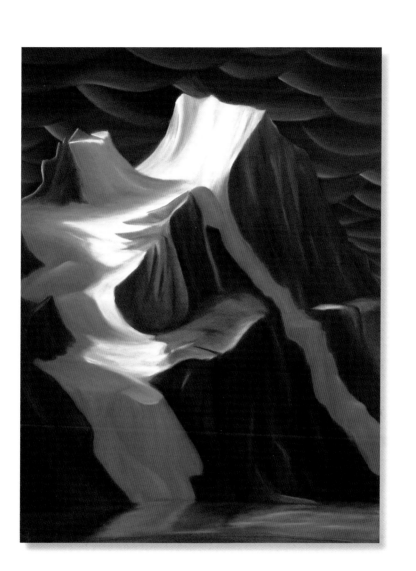

Mel Heath

Berg Lake, Mt. Robson, c. 2010

Oil on canvas, 61 × 76.2 cm
Private Collection

Although mist still lingers below the Emperor Face in Mel Heath's painting, the clouds have parted to reveal Robson's magnificent summit shimmering against patches of blue sky. Fresh snow at higher elevations softens the appearance of the rugged cliffs, and Berg Glacier, its fractured surface depicted in a delicate contrast of light and shadow, bends gracefully toward the lake. Cool blue tones in the snow, ice and rock are balanced by warmer colours in the trees and bushes on the foreground shore. With a sensitivity to natural colours and forms, Mel Heath expresses the spirit of this austere but inspiring landscape.

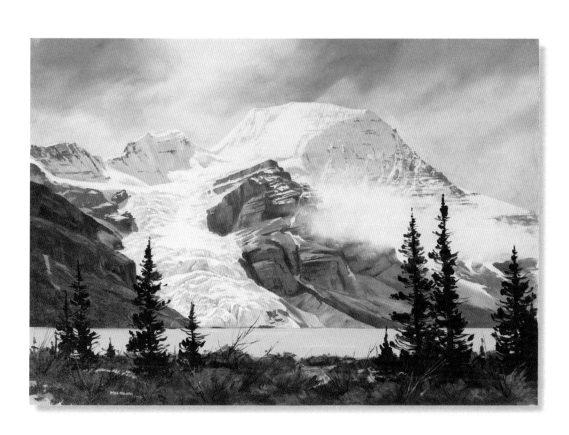

GREGG JOHNSON

Mt. Robson, Backing Berg Lake and Toboggan Creek, c. 2005

WATERCOLOUR ON PAPER, 55.9 × 76.2 CM
PRIVATE COLLECTION OF HENRY BECKMANN

Gregg Johnson's vibrant watercolour depicts Mount Robson towering over Berg Lake on a perfect summer's day. With a group of photographers and artists, Johnson had taken advantage of some fine weather by flying in to Robson Pass to spend the day near Berg Lake before hiking out in the evening. A photograph taken on this trip from the mouth of Toboggan Creek, near the day shelter at Berg Lake campground, became the inspiration for this watercolour. Sunshine and a cloudless sky are rare at Mount Robson, even in summer, and Gregg Johnson captures the exhilaration of experiencing such magnificent scenery in ideal conditions. The sunlight sparkles on Robson's summit and on the great river of ice falling from the North Face, bending between indigo cliffs on its way down to the lake. In the foreground, on either side of the bubbling creek, the light brings out the striking colours in the trees, set against the darker greens of the forest in shadow. Even the boulders beside the creek have taken on warm tones in the direct sunlight. This watercolour has a great sense of immediacy, portraying the freshness and vitality of one of Robson's spectacular days.

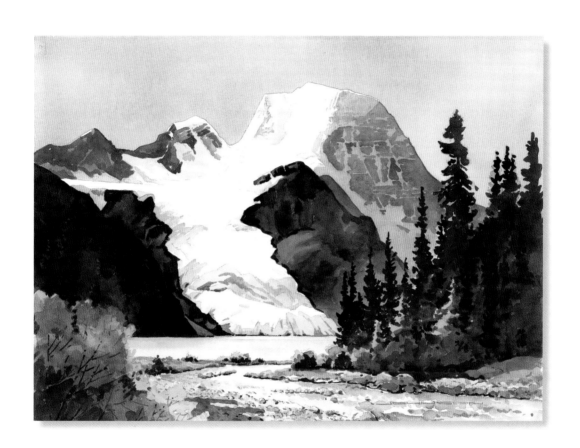

GLEN BOLES

Mt. Robson, 2008

ACRYLIC ON CANVAS, 45.7 × 61 CM
PRIVATE COLLECTION OF IAN OPELIK

In Glen Boles' painting, the viewer's eye follows the shallow stream flowing out of Robson Pass toward the northeast end of Berg Lake. The stream takes a gentle course over a lengthy alluvial plain dotted with islands of cotton grass. Once past the lake, the focus shifts to the mountaineer's realm as the eye travels up the fractured surface of Berg Glacier and over the snowfield below The Helmet to Mount Robson's formidable North Face, radiant in the morning sunlight. The Emperor Face, also a tremendous challenge for climbers, is still partly in shadow. The long summit ridge is outlined against a deep blue sky, and one of the few clouds appears to float above Robson's peak. By restricting his view of the landscape primarily to Mount Robson and using a dramatic contrast in value between the dark slopes below and the lighted precipices above, Boles puts great emphasis on the magnificent but treacherous approaches to Robson's peak. His awareness of the dangers is evident in details such as the cornices overhanging the North Face and the bergschrund extending across its base. His painting presents Mount Robson with its challenge and grandeur on a promising summer morning.

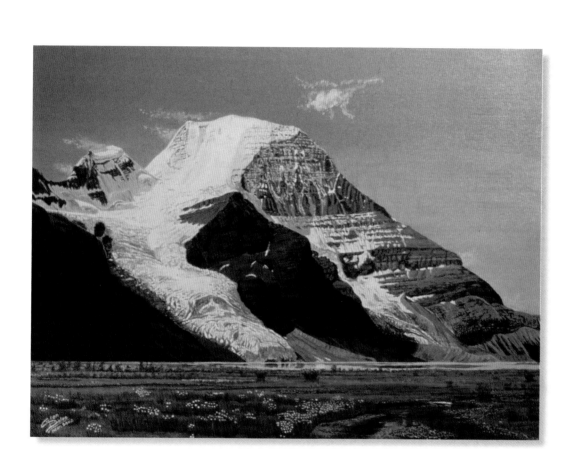

NORENE CARR

North Face, Mt. Robson, Berg Lake, 1988

OIL ON CANVAS, 55.9 × 71.1 CM
MOUNT ROBSON PROVINCIAL PARK VISITOR CENTRE

Norene Carr donated this painting to the Mount Robson Visitor Centre in 1988 to commemorate the park's 75th anniversary. She portrays a scene that A.O. Wheeler had predicted would bring many tourists to Berg Lake. Her perspective from the lakeshore, near the day shelter and the mouth of Toboggan Creek, shows ice floes that have tumbled from the glacier on the opposite shore and floated across the lake, their fanciful shapes doubled by reflections in the calm water. As the icebergs weather and melt into the green lake, they reach another stage in a long cycle that started as snow that was frozen, compressed into glacial ice and moved ever so slowly down the steep cliffs. Above the lake's magical reflections, Mount Robson's majestic presence dominates the landscape in the morning sunshine. Gleaming expanses of snow and ice are in stark contrast to grey rock showing beneath the snow and, especially, the dark buttresses separating the two glaciers. Mauve shadows add a softer beauty to the ice. Snow on the ledges accentuates the upward tilt of Robson's sedimentary layers, the origin of the idea of the spiral road leading to the summit. Norene Carr's painting combines the ephemeral beauty of the icebergs' reflections with the great strength of Robson's glaciers and massive precipices.

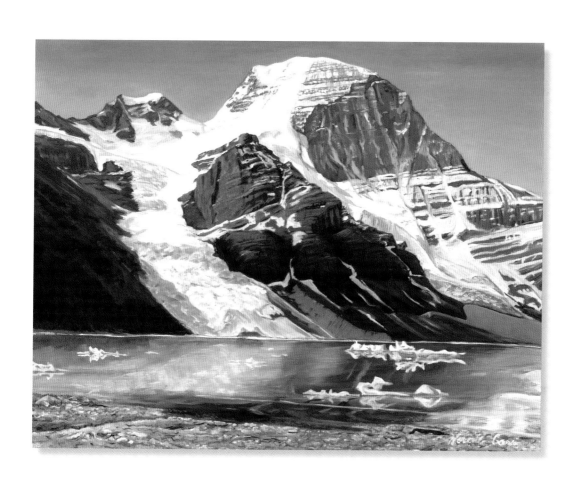

GLEN BOLES

Mt. Robson North Face, 2009

ACRYLIC ON CANVAS, 61 × 45.7 CM
PRIVATE COLLECTION OF RON SIGURDSON

From a vantage point high on the side of Rearguard Mountain, Glen Boles presents a wonderful, mountaineer's view of Mount Robson's North Face. The vertical format of his image emphasizes the steepness of the snowfield as the viewer's gaze travels up past Mount Waffl and The Helmet, on the left, to the formidable North Face, overhung with cornices and streaked with avalanches. Boles' experienced eye sees the dangers of crossing the snowfield with its jumbled ice blocks and the huge crevasse stretching across the base of the North Face. On the eastern end of the summit ridge, a triangular cliff face is visible from this angle, and on the west, the immense Emperor Face comes to a point at Emperor Ridge, the realm of gargoyles and a formidable challenge to climbers attempting to reach Robson's peak. Streaks of cloud appear to be flying over the summit, an indication of the strong winds so high up. The wind's energy and the bright morning sunshine that brings out the warmth in the scintillating snow and ice give this painting great vitality.

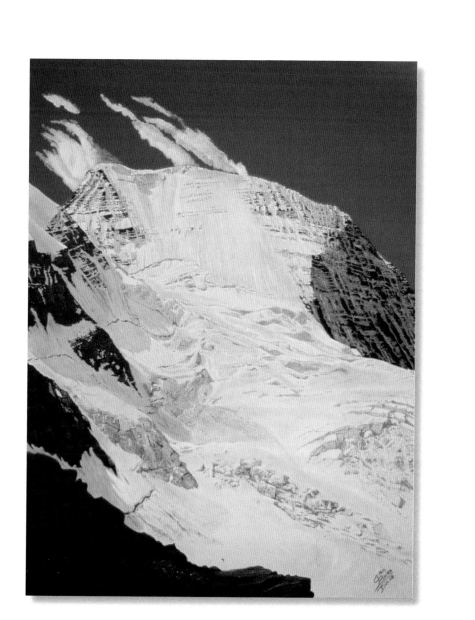

JENNIFER ANNESLEY

Mt. Robson, North Face, 2008
WATERCOLOUR ON PAPER, 35.6 × 53.3 CM
PRIVATE COLLECTION

While staying at the Rearguard campsite on the north side of Berg Lake, Jennifer Annesley was very fortunate on two nights in succession to see Mount Waffl, The Helmet and Mount Robson reflecting the setting sun. Her watercolour portrays the wonder of light creating such warm colours in an austere landscape of snow, ice and nearly vertical cliffs. The angular rock faces, too steep for snow to accumulate, have become a deep red in the sunset. The North Face is a beautiful combination of light and shade, warm and cool colours, with the summit ridge leading to Robson's peak glowing orange against the blue sky. Shadows are encroaching as the sun sinks lower, but Berg Glacier, below The Helmet, still reflects a fascinating array of colours that helps to define the fractured nature of the ice. On both sides of the glacier, the very dark rocks, their shapes accentuated by patches of snow, provide a dramatic contrast to the amazing spectacle of the peaks above. This stunning watercolour captures the marvellous textures and colours of the high alpine landscape in the fleeting moments before the sun goes down.

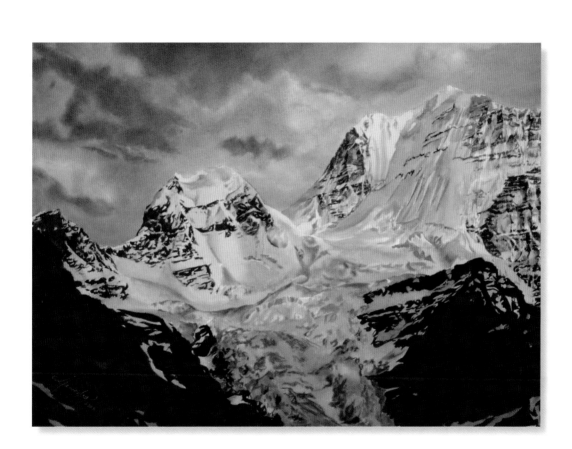

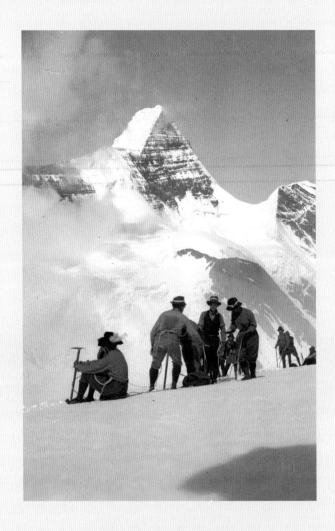

Byron Harmon

ROBSON GLACIER, ROBSON AMPHITHEATRE AND MOUNT ROBSON

The entire amphitheatre was filled with snow and ice, rising clear to the summit of Mt. Resplendent and piled in great masses high up on the sides of Mt. Robson. Sheer ice-cliffs, broken ice-falls and enormous mounds of snow were seen everywhere on the east face, in fact snow covered the entire east and north faces except where the perpendicular rock walls made it impossible for it to lie. At one particular spot the snow masses seemed to culminate in a great rounded shoulder, behind which lay a more nearly level snowfield. It led by a comparatively easy incline to the bergschrund, which separated it from the long southeastern arête of the mountain, and showed like an irregular black line on the surface.

—A.O. WHEELER, "The Alpine Club of Canada's Expedition to Jasper Park, Yellowhead Pass and Mount Robson Region, 1911," *Canadian Alpine Journal* IV (1912), 27.

JENNIFER ANNESLEY

Snowbird Pass, 2008

WATERCOLOUR ON PAPER, 26.7 × 73.7 CM
PRIVATE COLLECTION

Jennifer Annesley saw this spectacular panorama from the trail leading to Snowbird Pass. The sun setting in the southwest casts a brilliant shaft of light across the landscape, creating a dramatic contrast between the illuminated ridges and snowfields in the background and the darker foreground. The viewer looks from the somber shadows engulfing a gigantic rock hummock, or nunatak, and the great buttress of Rearguard Mountain, on the right, to a landscape of vibrant colour. The long, diagonal slope of Titkana Peak in the middle of the painting, on the left, is divided between shadows and splashes of colour in the sunlight. In the background, sun and clouds create fascinating patterns of light and shadow on the snow and rock faces. Lynx Mountain's snowy peak, on the left, is at one end of the magnificent ridge leading southwest all the way to Resplendent Mountain, hidden at this angle by the dark shoulder of Rearguard. The drama also extends to the sky as the clouds reveal their intricate shapes changing colour in the setting sun. This wild, forbidding landscape is filled with an exhilarating light and warmth in Jennifer Annesley's watercolour.

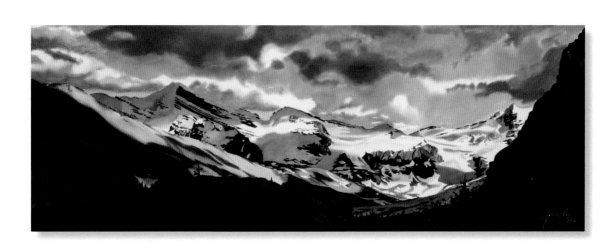

A.Y. JACKSON

Five Mile Glacier, Mt. Robson, 1924

OIL ON BOARD, 21.2 × 26.9 CM
KAMLOOPS ART GALLERY

The date of A.Y. Jackson's oil sketch is particularly interesting because it shows that he did return to Mount Robson in 1924, probably in the company of Lawren Harris. Jackson's title suggests that Robson Glacier extended much farther in the direction of Robson Pass than it does today. His painting depicts a huge mound of ice between the terminal moraine protecting the foreground trees and the shoulder of Titkana Peak, sloping from the left in front of Lynx Mountain, rising magnificently in the background. Jackson's vantage point, probably in the Mumm Basin, allowed him to look over the trees and line up the highest point of the glacier with the peak of Lynx Mountain directly behind. Sunlight breaking through the leaden clouds creates the focus of the image on the shining ice cap in the centre. His sketch has a sense of immediacy as he appears to have worked quickly to establish colours and rhythms. Broad brush strokes shape the undulating lines of Robson Glacier and the snowfields on Lynx Mountain. In his painting, Jackson presents the grandeur of this immense, remote landscape.

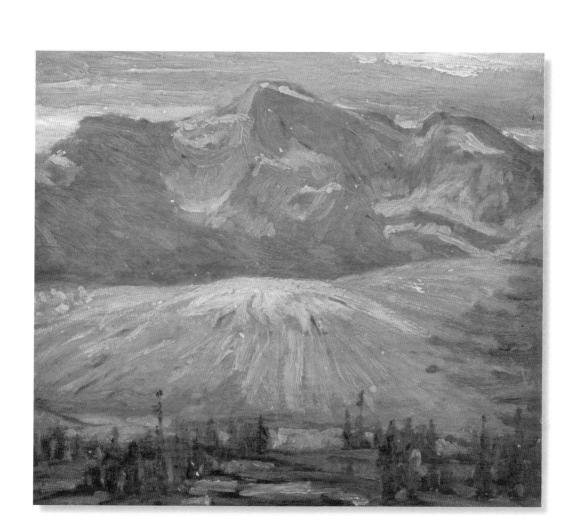

Lawren Harris

Glacier, Rocky Mountains, c. 1929

GRAPHITE ON PAPER, 18.4 × 24.8 CM
PRIVATE COLLECTION OF MARY FUS AND CHRIS CLEAVELEY

This pencil drawing by Lawren Harris, complete with notes on colours and values, appears to be the preparation for his oil sketch *Glacier, Mt. Robson District*, completed in 1924–25. The later date for the drawing is puzzling because a comparison of the graphite and oil sketches shows greater simplification in the painting, particularly in the foreground. As Harris tended to progress in the direction of simplification and abstraction, the date for this pencil drawing could perhaps be four or five years earlier. The subject is the Robson Amphitheatre at the upper end of Robson Glacier, surrounded by The Dome, Mount Robson and The Helmet to the west and Resplendent and Lynx Mountains to the east. The focus in Harris' drawing is not the spectacular peaks, but the Robson col, a narrow gap in the background leading the eye to the clear air beyond. From his vantage point on the side of Lynx, Harris appears to be looking past a steep snow slope and over the vast expanse of ice, enclosed by a number of vertical rock formations. The prominent rocky towers on the left are above Extinguisher Tower, which is hidden from view as is the imposing summit of Resplendent Mountain. Harris creates a pattern of descending peaks in the west through simplification and foreshortening. Rock has been shaded to provide a contrast with the snow and ice, and the numbering system indicates a progression from the darkest value in the foreground, 4, to the lightest, 1, at the col. Harris notes beautiful colours in this rugged landscape and a symmetry in mountain shapes, all supporting a feeling of transcendence as the eye moves from the spectacular glacier and mountains to the heavens.

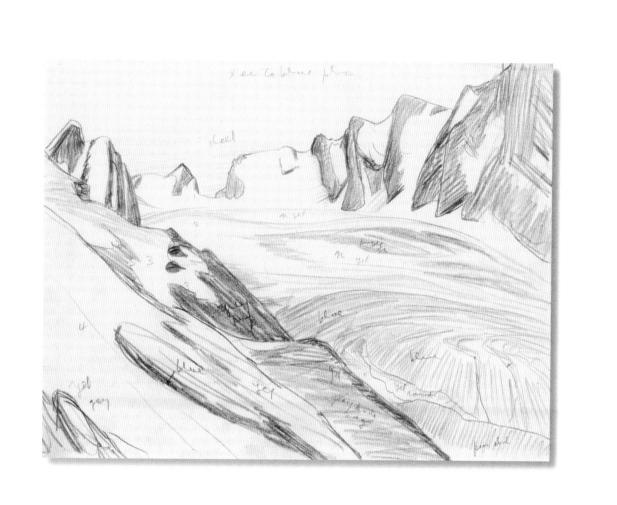

LAWREN HARRIS

Glacier, Mt. Robson District, 1924–1925

OIL ON BOARD, 30.5 × 38 CM
PRIVATE COLLECTION OF MARY FUS AND CHRIS CLEAVELY

This small oil sketch by Lawren Harris is similar to his pencil drawing of the Robson Amphitheatre except that he has altered the foreground and simplified even more the shapes of the triangular towers surrounding the glacier. Apart from the snow slope just visible on the left, the foreground now consists of rounded, angular and pyramidal rock in rich shades of deep red and mauve. These warm colours are in contrast to the cool blues and whites of the glacier, with touches of pink to harmonize with the surrounding rock. The undulating lines on the glacier include an arch across the top of the ice that is repeated in the arch of blue sky over the Robson col. Towers around the glacier are more abstract, pointing emphatically to the heavens. Even the buttresses supporting the snowy ramps on either side of the col have become more definitely pyramidal. The grandeur of the immense arches and magnificent peaks is uplifting as our eyes and thoughts are moved toward the col and the firmament.

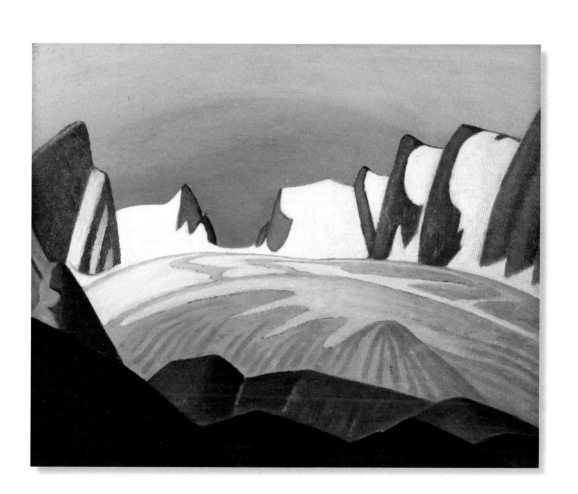

A.P. Coleman

Mount Robson from North East, n.d.

WATERCOLOUR OVER PENCIL, 17.8 × 25.1 CM
WITH PERMISSION OF THE ROYAL ONTARIO MUSEUM © ROM

This unusual perspective on Mount Robson is from A.P. Coleman's camp near Extinguisher Tower, the black triangular rock beside Robson Glacier that is just showing on the left of his watercolour. On one of the few days of good climbing weather during his 1908 expedition, Coleman set out from this high camp with his brother Lucius and George Kinney to climb Mount Robson from the east side. In his small sketch, possibly completed on site, Coleman portrays the shadowed glacier with its treacherous crevasses in striking contrast to the brilliant peaks in the distance, covered in fresh snow that reflects the morning sunshine. This spectacular landscape shows the three mountains all leaning in the same direction like gigantic waves on a frozen sea. The peak closest to the viewer, in the centre of the painting, is The Helmet, with the smaller Mount Waffl to the right. Looming behind The Helmet, and presenting a remarkably similar outline, is Mount Robson, its north and east faces almost completely covered in snow. Robson's summit is seen against a blue sky, but clouds are building in the west, a sign of approaching bad weather. Coleman's party did manage to climb up the glacier and over The Dome, just to the left of The Helmet, to reach the base of Robson's east face late in the afternoon, but time was too short to climb any higher.

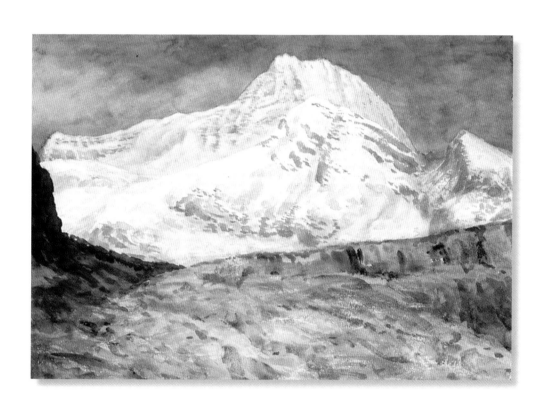

TREVOR LLOYD JONES

Mt. Robson, from Robson Glacier, 1979

ACRYLIC ON PAPER, 30 × 46 CM
COLLECTION OF THE ARTIST

Trevor Lloyd Jones' fascinating perspective on Robson Glacier and the northeast side of Mount Robson is a mountaineer's view from the base of Rearguard, looking across the glacier to the dark triangle of Extinguisher Tower. Soaring overhead, under the enormous cloud, is Mount Robson's North Face, with the southeast ridge extending down to the left of The Roof. Between the glacier and Robson's summit, we have the unusual sight of the east side of The Helmet in the centre and Mount Waffl to the right. On the left of The Helmet, The Dome lies below the Kain Face on Robson's southeast ridge. In contrast to the prominent triangular shapes of Mount Robson and Extinguisher Tower, the glacier extends in a sweeping curve across most of the width of the painting, revealing fractures in the windswept ice as it is slowly forced over an underlying cliff. Treacherous crevasses have cut deep diagonal lines, but the many shades of brown and grey in the ice below the surface have a subtle beauty. An otherwise stark landscape of snow, ice and rock shows some warmth in the pale colour of the meltwater on the glacier's surface, a complement to the deep blue sky. Despite the danger, this forbidding landscape is inspiring in its monumental power.

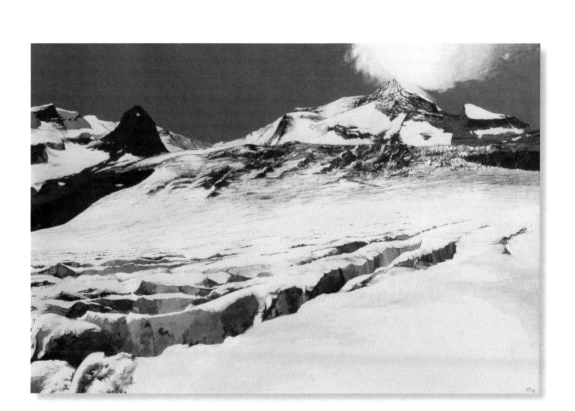

GLENN PAYAN

Kain Face, Mt. Robson, 2010

OIL ON CANVAS, 50.8 × 40.6 CM
PRIVATE COLLECTION

Glenn Payan's painting provides a striking view of Mount Robson from Resplendent Mountain. The high vantage point allows the viewer's eye to travel over The Dome in the foreground, across the snowfield and up the nearly vertical cliff to Robson's south-east ridge. Once on this knife-edge, the eye effortlessly follows the illuminated south face to Robson's peak. Conrad Kain took this extremely arduous route when he guided Albert MacCarthy and William Foster to the summit in 1913. Glenn Payan's perspective on the Kain Face includes an inspiring image of The Roof, the last thousand feet of Robson soaring above the southeast ridge into a rich indigo sky. The distant peaks of Whitehorn, just showing beyond the ridge, and Mount Phillips and Mount Anne-Alice, beyond The Helmet on the right, give a sense of Robson's dominance in the landscape. Its great height is emphasized by the dramatic lighting on the south face and the elongated summit pyramid. In contrast to the tremendous vertical drop from Robson's peak, the sweeping lines of Robson Glacier, bathed in sunlight, provide a spectacular setting for the monarch of the Rockies.

LAWREN HARRIS

Mount Robson from the South East, 1929

OIL ON PAPERBOARD, 30.3 × 37.9 CM
ART GALLERY OF ONTARIO
THE THOMSON COLLECTION © ART GALLERY OF ONTARIO

Lawren Harris included this wonderful oil sketch in the group of six paintings he exhibited in the 1930 Little Pictures Show at the Ontario Society of Artists, and Bess Harris was so fond of the painting that she kept it in her collection until she died.[171] This small sketch seems to be the preparation for a famous canvas by Harris titled *Mount Robson* in the McMichael Canadian Art Collection. Although the larger canvas has warmer tones of brown in the exposed rock faces, in contrast to much blue and grey in the sketch, both images have the same composition and simplified shapes. From a high vantage point on Resplendent Mountain, Harris looked across a chasm to Robson Glacier flowing around The Dome and to the striking southeast ridge of Mount Robson leading to the magnificent summit pyramid. Almost all the shapes have this tremendous upward energy, for example in the exaggerated peaks running, on the left, to the end of Robson's southeast ridge. Curved lines across The Dome and on the snowfield provide some balance to this pronounced upward movement. The texture of the snow, often with vertical grooves suggesting avalanche paths, is not entirely smooth, as Harris includes a pattern of fractured ice blocks in the foreground just below The Dome, and high up on Robson's south face he indicates the treacherous mounds of loose snow, a formidable barrier for climbers. Despite the simplification in shapes, this painting has a great deal of resemblance to the actual landscape. Harris sees patterns of form, line and colour that can be emphasized to convey the uplifting feeling of looking at Robson's peak reaching into a blue sky.

HORACE CHAMPAGNE

A River of Ice, the Robson Glacier from the Snowbird Pass trail, 2012

PASTEL ON PAPER, 30.5 × 45.7 CM
COLLECTION OF THE ARTIST

Horace Champagne captures the vitality of Robson Glacier on a warm August afternoon from a vantage point high on the Snowbird Pass trail, looking over the treetops and up into Robson cirque. His painting reflects a great sense of movement with the immense cloud stretching across the sky to the left, its tip hovering over the peak of Resplendent Mountain and casting shadows on the landscape underneath. This ephemeral shape is balanced by the upward thrust of the snow-covered cliffs of The Dome and Mount Robson's southeast ridge, leading to The Roof and the summit soaring out of the picture in the upper right corner. Below these magnificent mountains, the massive glacier flows out of the cirque and down through a gateway formed by the indigo rock of Extinguisher Tower on the left and the sloping shoulder of Rearguard Mountain directly opposite. Here the ice makes a dramatic bend to the north toward Robson Pass. Patterns of colour and texture on the glacier's surface enhance the feeling of downward flow despite the solidity of the ice. Sunlight on the lateral moraines below Extinguisher Tower and Rearguard Mountain brings out a warmth of colour beside the cooler tones of the glacier, and closest to the viewer the composition is anchored by the cheerful hues of the tree in the lower left corner. The energy of this painting is apparent in the wonderful use of light and colour and in the inexorable power of the flowing glacier.

LAWREN HARRIS

Isolated Peak, c. 1929

GRAPHITE ON WOVE PAPER, 19.2 × 25.4 CM
NATIONAL GALLERY OF CANADA © FAMILY OF LAWREN S. HARRIS

Lawren Harris sketched this image of Resplendent Mountain from an elevated vantage point just east of Robson Glacier, possibly near the present trail to Snowbird Pass. His observant eye and deft hand enable him to reproduce precise shapes as he looks over the mounds of ice to Resplendent's snow-covered summit with its double triangle, a natural phenomenon caused by shadow below the peak in the afternoon light. The dark shoulder of Rearguard Mountain is to the right of the glacier, opposite the black triangular shape of Extinguisher Tower, and above the Tower Harris uses dark shading for the exposed rock faces on the ridge leading to Resplendent Mountain. Radiating lines on the glacier are derived from its heavily crevassed surface, but they also suggest the expansive shape of this huge mass of ice. This magnificent landscape with its great glacier, dark tower and shining peak fascinated Harris. In his Rocky Mountain Sketchbook, a collection of pencil drawings now in the collection of the Vancouver Art Gallery, he made preliminary sketches of the double triangle on Resplendent's summit and the contrasting dark triangle of Extinguisher Tower, with the interesting shapes of the surrounding rock formations. His larger drawing *Isolated Peak* incorporates these earlier pencil sketches, and all lead to *Mountain Sketch LXV* and the canvas *Mountains in Snow: Rocky Mountain Paintings VII*.

LAWREN HARRIS

Mountains in Snow: Rocky Mountain Paintings VII, c. 1929

OIL ON CANVAS, 131.3 × 147.4 CM
ART GALLERY OF ONTARIO
THE THOMSON COLLECTION © ART GALLERY OF ONTARIO

In this remarkable image of Resplendent Mountain, Lawren Harris has arranged the elements of the actual landscape, portrayed in his drawings and an oil sketch of the same scene, to create a spiritual aura around the splendid peak soaring into the heavens. The light is carefully controlled so that the viewer looks from a darker foreground toward Resplendent's radiant presence. The rounded ice of the glacier, in beautiful shades of blue and mauve, is enclosed on three sides by brown rock, exhibiting the few horizontal lines in the painting. The triangular Extinguisher Tower, opposite Rearguard Mountain, is no longer black as it actually appears, but a dark brown with warm tones where the light strikes it. This natural triangle sits below a series of elongated pyramids, their abstract shapes lined up in a progression along the ridge toward Resplendent's amazing double triangle projecting from high, snow-draped cliffs into radiating circles of light in the rich blue sky. Immediately in front of Resplendent, Harris accentuates the sweeping lines of the natural landscape to emphasize Resplendent's tall shape rising dramatically behind. With much thought, Lawren Harris has created an inspirational image, one in which the earthly representation is not as significant as the spiritual effect of the mountain.

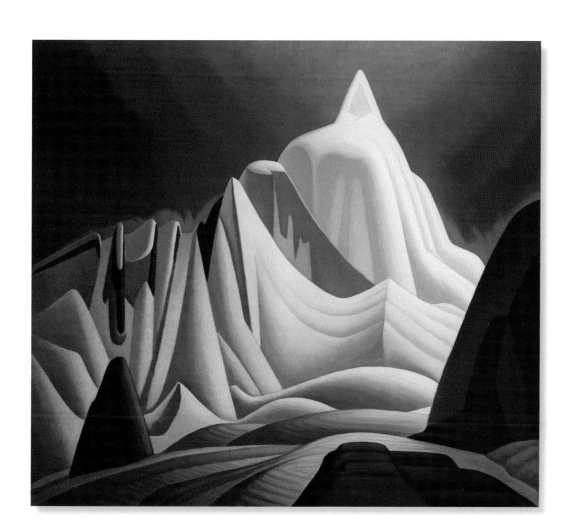

Notes

1 A.P. Coleman, *The Canadian Rockies[:] New and Old Trails* (Calgary: Rocky Mountain Books, 2006), 196.

2 Coleman, *New and Old Trails*, 142–143.

3 Coleman, *New and Old Trails*, 199–200.

4 Coleman, *New and Old Trails*, 145.

5 See T. Gardiner, "The Name 'Mt. Robson,'" *Canadian Alpine Journal* LIII (1970), 27–30 for a thorough discussion of possible sources.

6 J.G. MacGregor, *Overland by the Yellowhead* (Saskatoon: Western Producer, 1974), 71.

7 A.O. Wheeler, "National Parks As an Asset," *Canadian Alpine Journal* VI (1914–1915), 117.

8 J.G. MacGregor, "Who Was Yellowhead?" *Alberta Historical Review* XVII, 4 (1969), 12–13.

9 G.P.V. Akrigg and Helen B. Akrigg, *1001 British Columbia Place Names* (Vancouver: Discovery Press, 1969), 148–149.

10 J.M. Thorington, "A Note on the Naming of Mt. Robson," *The Alpine Journal* XLVIII (1936), 323.

11 Berenice Gilmore, *Artists Overland* (Burnaby: Burnaby Art Gallery, 1980), 55.

12 Gilmore, *Artists Overland*, 54.

13 See MacGregor, *Overland*, 79–85, for an account of the journey from Edmonton to Tête Jaune Cache.

14 Quoted by A.G. Harvey, "The Mystery of Mt. Robson," *British Columbia Historical Quarterly* I (1937), 207.

15 Walter B. Cheadle, *Cheadle's Journal of a Trip across Canada 1862–1863*, with Introduction and Notes by A.G. Doughty and Gustave Lanctôt (Edmonton: M.G. Hurtig Ltd., 1971), 3.

16 MacGregor, *Overland*, 98.

17 Cheadle, *Journal*, 177.

18 Cheadle, *Journal*, 5.

19 William Fitzwilliam, Viscount Milton, and Dr. Walter B. Cheadle, *The North-West Passage By Land* (London: Cassell, Petter & Galpin, 1865), 257.

20 See Coleman, *New and Old Trails*, 116, for the passage from Douglas' journal in which he estimates the height of Mounts Hooker and Brown.

21 Coleman, *New and Old Trails*, 128.

22 James McEvoy, *Report on the Geology and Natural Resources of the Country Traversed by the Yellow Head Pass Route from Edmonton to Tête Jaune Cache* , Annual Report for 1898, Vol. II, Sec. D (Ottawa: Geological Survey of Canada, 1900), 16D.

23 G.M. Dawson, "Notes on the Shuswap People of British Columbia," *Transactions of the Royal Society of Canada* IX (1891), Section II, 37.

24 Coleman, *New and Old Trails*, 129.

25 MacGregor, *Overland*, 111.

26 David P. Silcox, "On the Art of A.P. Coleman," in *A.P Coleman, Geologist, 1852–1939: Science, Art and Discovery*, edited by Lila M. Laakso and Raymond Laakso, E.J. Pratt Library, Victoria University (Toronto), catalogue to an exhibition June 13–October 13, 1994. See also the online exhibition *A.P. Coleman: Geologist, Explorer (1852–1939) – Science, Art & Discovery* » Artist » Amateur artist" (Victoria University Library (Toronto) and ROM) for excerpts in which Silcox discusses Coleman's artistic achievements, accompanied by numerous illustrations of his work, accessed August 31, 2012, http://is.gd/RmdSNC.

27 Roger Boulet, *Vistas[:] Artists on the Canadian Pacific Railway* (Calgary: Glenbow Museum, 2009), 50.

28 Evelyn de R. McMann, *Royal Canadian Academy, Exhibitions and Members, 1880–1979.* (Toronto: University of Toronto Press, 1981).

29 Mary Allodi, *Canadian Watercolours and Drawings in the Royal Ontario Museum*, I (Toronto: Royal Ontario Museum, 1974).

30 Gilmore, *Artists Overland*, 12.

31 Gilmore, *Artists Overland*, 13.

32 Coleman, *New and Old Trails*, 204.

33 Coleman, *New and Old Trails*, 126.

34 Coleman, *New and Old Trails*, 118.

35 Coleman, *New and Old Trails*, 126.

36 William Colgate, *Canadian Art[:] Its Origin and Development* (Toronto: Ryerson Press, 1943), 33.

37 Colgate, *Canadian Art*, 39–40.

38 Gilmore, *Artists Overland*, 23.

39 Coleman, *New and Old Trails*, 154.

40 Coleman, *New and Old Trails*, 143.

41 Coleman, *New and Old Trails*, 145.

42 Coleman, *New and Old Trails*, 145.

43 Coleman, *New and Old Trails*, 198.

44 Coleman, *New and Old Trails*, 157.

45 Coleman, *New and Old Trails*, 175.

46 Coleman, *New and Old Trails*, 177.

47 A.P. Coleman, "On a Mountain Glacier; Chapter II, Spitzbergen" in *Reminiscence of Arctic Travels*, ms c. 1930, 43. Quoted in online exhibition *A.P. Coleman: Geologist, Explorer (1852–1939) – Science, Art & Discovery* » Rockies Exploration » Mount Robson » 4 (Toronto: Victoria University and ROM), accessed August 31, 2012, http://is.gd/TAi1n1.

48 Coleman, *New and Old Trails*, 180.

49 Coleman, *New and Old Trails*, 182.

50 Coleman, *New and Old Trails*, 182.

51 George Kinney, "Mount Robson," *Canadian Alpine Journal* II, 1 (1909), 12–14.

52 Coleman, *New and Old Trails*, 183.

53 Coleman, *New and Old Trails*, 185.

54 Coleman, *New and Old Trails*, 185.

55 Rev. G. Kinney and Curly Phillips, "To the Top of Mount Robson. Told by Kinney and Phillips," *Canadian Alpine* Journal II, 2 (1910), 21–32.

56 Mary T.S. Schäffer, *Old Indian Trails of the Canadian Rockies*, edited by E.J. Hart (Banff: Whyte Museum of the Canadian Rockies, 1980), 118–127.

57 Schäffer, *Old Indian Trails*, 122.

58 Schäffer, *Old Indian Trails*, 122–123.

59 Chic Scott, "Mountain Mysteries," *Canadian Alpine Journal* LXXXIV (2001), 102. See also Chic Scott, *Pushing the Limits[:] The Story of Canadian Mountaineering* (Calgary: Rocky Mountain Books, 2000), 70–82.

60 Kinney to Wheeler, September 23, 1909, Archives of the Whyte Museum of the Canadian Rockies, Banff, AC 00 120.

61 Kinney to Wheeler, September 23, 1909.

62 Kinney and Phillips, "To the Top of Mount Robson," *Canadian Alpine Journal* II, 2 (1910), 30.

63 Kinney and Phillips, "To the Top of Mount Robson," 30.

64 Rev. G.R.B. Kinney, "Mount Stephen," *Canadian Alpine Journal* I, 1 (1907), 91–93.

65 Kinney to Wheeler, September 23, 1909.

66 Wheeler to Kinney, March 11, 1910, Archives of the Whyte Museum of the Canadian Rockies, Banff, AC 00 120.

67 Kinney to Wheeler, March 21, 1910, Archives of the Whyte Museum of the Canadian Rockies, Banff, AC 00 120.

68 Arthur O. Wheeler, "The Alpine Club of Canada's Expedition to Jasper Park, Yellowhead Pass and Mount Robson Region, 1911," *Canadian Alpine Journal* IV (1912), 8–80.

69 A.L. Mumm, "An Expedition to Mount Robson," *Canadian Alpine Journal* II, 2 (1910), 10–20.

70 James G. MacGregor, *Pack Saddles to Tête Jaune Cache* (Edmonton: Hurtig Publishers, 1973), 134.

71 Mumm, "An Expedition to Mount Robson," 18.

72 See E.J. Hart, *Diamond Hitch[:] The Pioneer Guides and Outfitters of Banff and Jasper* (Banff: EJH Literary Enterprises Ltd., 2001), 200–202, for an account of the explorations of Mumm and Collie in 1910 and 1911.

73 William L. Putnam, Glen W. Boles and Roger W. Laurilla, *Place Names of the Canadian Alps* (Revelstoke: Footprint Publishing, 1990), 28.

74 A.O. Wheeler, "The Alpine Club of Canada's Expedition to Jasper Park, Yellowhead Pass and Mount Robson Region, 1911," *Canadian Alpine Journal* IV (1912), 10.

75 See William R. Watson, "G. Horne Russell Biography" (c. 1959), at Galerie Walter Klinkhoff, Montreal, accessed August 31, 2012, www.klinkhoff.com/canadian-artist/G-Horne-Russell.

76 See Boulet, *Vistas[:] Artists on the Canadian Pacific Railway* (Calgary: Glenbow Museum, 2009).

77 N. Hollister, "Mammals of the Alpine Club Expedition to the Mount Robson Region," *Canadian Alpine Journal* Special Number (1912), 6–44.

78 Wheeler, "The Alpine Club of Canada's Expedition to Jasper Park, Yellowhead Pass and Mount Robson Region, 1911," 8–80.

79 Jenny Crompton, A.O. Wheeler's great-granddaughter, kindly gave me access to the 1911 Diary.

80 Wheeler, "The Alpine Club of Canada's Expedition to Jasper Park, Yellowhead Pass and Mount Robson Region, 1911," 20.

81 Wheeler, "The Alpine Club of Canada's Expedition to Jasper Park, Yellowhead Pass and Mount Robson Region, 1911," 24.

82 Wheeler, "The Alpine Club of Canada's Expedition to Jasper Park, Yellowhead Pass and Mount Robson Region, 1911," 25.

83 Wheeler, "The Alpine Club of Canada's Expedition to Jasper Park, Yellowhead Pass and Mount Robson Region, 1911," 28.

84 Conrad Kain, "First Ascent of Mt. Whitehorn (August 12, 1911)," translated by P.A.W. Wallace, *Canadian Alpine Journal* VI (1914–1915), 42.

85 Wheeler, "The Alpine Club of Canada's Expedition to Jasper Park, Yellowhead Pass and Mount Robson Region, 1911," 55.

86 Wheeler, "The Alpine Club of Canada's Expedition to Jasper Park, Yellowhead Pass and Mount Robson Region, 1911," 64. Wheeler's enthusiasm for the recreational opportunities of Mount Robson may have influenced the Grand Trunk Pacific Railway to ask P.M. Rattenbury to create architectural drawings for a Chateau Mount Robson. The drawings were completed in December 1912. Samples can be viewed at Valemount & Area Museum » Roots » Explore the Overlanders' Journey » Thumbnail Gallery page 4, images 71, 72, accessed August 31, 2012, http://is.gd/8YiYvS.

87 Arthur O. Wheeler, "Report of Mt. Robson Camp (1913)," *Canadian Alpine Journal* VI (1914–1915), 179.

88 W.W. Foster, "Mount Robson (1913)," *Canadian Alpine Journal* VI (1914–1915), 17.

89 Conrad Kain, "The First Ascent of Mt. Robson, the Highest Peak of the Rockies (1913)," trans. P.A.W. Wallace, *Canadian Alpine Journal* VI (1914–1915), 22.

90 Foster, "Mount Robson (1913)," 17.

91 Kain, "The First Ascent of Mt. Robson," 22.

92 Foster, "Mount Robson (1913)," 19.

93 Kain, "The First Ascent of Mt. Robson," 27.

94 Conrad Kain, "Reminiscences of Seven Summers in Canada," *American Alpine Journal* I (1929/32), 291.

95 Hickson to Thorington, May 28, 1938, Archives of the Whyte Museum of the Canadian Rockies, Banff, M106/147.

96 Wheeler to J.M.T. [J.M. Thorington], 6-9-38 [June 9, 1938], Archives of the Whyte Museum of the Canadian Rockies, Banff, M106/147.

97 Basil S. Darling, "First Attempt on Robson by the West Arête (1913)," *Canadian Alpine Journal* VI (1914–1915), 29–34.

98 Albert H. MacCarthy and Basil S. Darling, "An Ascent of Mt. Robson from the Southwest (1913)," *Canadian Alpine Journal* VI (1914–1915), 34–42.

99 MacCarthy and Darling, "An Ascent of Mt. Robson from the Southwest," 39.

100 MacGregor, *Overland*, 186.

101 Colgate, *Canadian Art*, 78–79.

102 Leslie Dawn, *Towards the Group of Seven and Beyond: Canadian Art in the First Five Decades of the Twentieth Century* (Kamloops: Kamloops Art Gallery, 1998), 12.

103 Colgate, *Canadian Art*, 80.

104 McMann, "John William Beatty," *Royal Canadian Academy Exhibitions and Members.*

105 A.Y. Jackson, *A Painter's Country[:] The Autobiography of A.Y. Jackson* (Toronto, Vancouver: Clarke, Irwin, 1964), 30.

106 Jackson describes his adventures in *A Painter's Country*, 35–37.

107 Naomi Jackson Groves, *A.Y.'s Canada* (Toronto: Clark, Irwin, 1968), 96, 148.

108 Jackson, *A Painter's Country*, 37.

109 The postcard was sent to Jackson's friend and patron Dr. James MacCallum. See Groves, *A.Y.'s Canada*, 148.

110 Jackson, *A Painter's Country*, 37.

111 McMann, "A.Y. Jackson," *Royal Canadian Academy Exhibitions and Members.*

112 Groves, *A.Y.'s Canada*, 148.

113 Jackson's *Mount Robson* and *Mount Resplendent* are in private collections in Alberta. *White Horne [sic] under Cloud* was up for auction c. 2000 and is probably now in a private collection. See Lisa Christensen, *A Hiker's Guide to the Rocky Mountain Art of Lawren Harris* (Calgary: Fifth House, 2000), 21, 26, 32.

114 Groves, *A.Y.'s Canada*, 148.

115 Jackson's drawing *Mount Resplendent* in the Whyte Museum is reproduced in Christensen, *A Hiker's Guide to the Rocky Mountain Art of Lawren Harris*, 28.

116 Groves, *A.Y.'s Canada*, 148.

117 Patricia Ainslie and Mary-Beth Laviolette, *Alberta Art and Artists[:] An Overview* (Calgary: Fifth House, 2007), 127.

118 H.E. Bulyea, "A Trip to Mount Robson," *Canadian Alpine Journal* X (1919), 26–31.

119 Bulyea, "A Trip to Mount Robson," 30.

120 Jackson, *A Painter's Country*, 56–57.

121 Jackson describes his adventures in Jasper National Park in *A Painter's Country*, 106–109.

122 A.Y. Jackson, "Artists in the Mountains," *Canadian Forum* V, 52 (January 1925), 114.

123 Jackson, "Artists in the Mountains," 114.

124 Jackson, *A Painter's Country*, 107.

125 Jackson, "Artists in the Mountains." 114.

126 Jackson, *A Painter's Country*, 108.

127 See Groves, *A Y's Canada*, Plate 71, 150.

128 Canadian National Railways, *Jasper National Park* (Montreal: Canadian National Railways, 1927), 30.

129 Wayne Larsen, *A.Y. Jackson[:] The Life of a Landscape Painter* (Toronto: Dundurn Press, 2009), 173.

130 Jackson, *A Painter's Country*, 146.

131 Larsen, *A.Y. Jackson*, 185.

132 See Plate 8 in P.B. Baird, "A.Y. Jackson: A Portfolio of Arctic Sketches," *The Beaver* (Spring 1967), 14, and Baird's description of the expedition, 6.

133 Arthur Lismer, "A.Y. Jackson," in *A.Y. Jackson[:] Paintings 1902–1953* (Toronto: Art Gallery of Ontario, 1953), 4–7.

134 Bess Harris and R.G.P. Colgrove, eds., *Lawren Harris* (Toronto: Macmillan of Canada, 1969), 62.

135 A.Y. Jackson, "Lawren Harris: A Biographical Sketch," in *Lawren Harris: Paintings 1910–1948* (Toronto: Art Gallery of Toronto, 1948), 11.

136 Denis Reid, *Atma-Buddhi-Manas: The Later Work of Lawren S. Harris* (Toronto: Art Gallery of Ontario, 1985), 10.

137 Jackson, *A Painter's Country*, 107.

138 Wayne Larsen, *A.Y. Jackson[:] The Life of a Landscape Painter* (Toronto: Dundurn Press, 2009), 125.

139 Jackson, *A Painter's Country*, 63.

140 Jeremy Adamson, "Lawren Stewart Harris: Towards an Art of the Spiritual," in *Canadian Art: the Thomson Collection at the Art Gallery of Ontario* (Toronto: Art Gallery of Ontario and Skylet Publishing, 2008), 71.

141 Harris and Colgrove, eds., *Lawren Harris*, 7.

142 Lawren Harris, "Revelation of Art in Canada," *The Canadian Theosophist* VII, 5 (July 15, 1926), 86.

143 Harris and Colgrove, eds., *Lawren Harris*, 10.

144 Jeremy Adamson, *Lawren S. Harris[:] Urban Scenes and Wilderness Landscapes 1906–1930* (Toronto: Art Gallery of Ontario: 1978), 133.

145 Ann Davis, *The Logic of Ecstasy[:] Canadian Mystical Painting, 1920–1940* (Toronto: University of Toronto Press, 1992), 62.

146 Annie Besant and C.W. Leadbeater, *Thought-forms* (London: Theosophical Publishing House, 1901), 46.

147 Adamson, *Lawren S. Harris: Urban Scenes and Wilderness Landscapes*, 132–133.

148 Lawren Harris, "Creative Art and Canada," in *Yearbook of the Arts in Canada 1928–1929*, ed. Bertram Brooker (Toronto: Macmillan of Canada, 1929), 185.

149 Catharine M. Mastin, "East Views West: Group Artists in the Rocky Mountains," in *The Group of Seven in Western Canada*, ed. Catherine M. Mastin (Toronto: Key Porter Books and Glenbow Museum, Calgary, 2002), 39.

150 Reid, *Atma-Buddhi-Manas*, 15–16; see also Plate 37 for a reproduction of the painting *Mt. Ann[e]-Alice*. Harris and Colgrove, *Lawren Harris*, 90, include a colour reproduction of the same canvas.

151 James L. Swanson, *Place Names in the Canadian Rockies*, s.v. "Hargreaves Glacier," accessed August 31, 2012, www.spiralroad.com/sr/pn/h/hargreaves_glacier.html.

152 See Dolly Connelly, "Berg Lake Chalet," *The Beaver* (Winter 1981), 22–30, for an account of Alice Wright's association with Berg Lake Chalet and Mount Robson Provincial Park.

153 Connelly, "Berg Lake Chalet," 22.

154 Suzanne White, "Banff Culture Weekend opens doors," *Rocky Mountain Outlook*, August 5, 2010. The collection in the Banff Administration Building includes, for example, several paintings from Waterton Glacier International Peace Park (*South Kootenay Pass, Cameron Mountain* and *Upper Waterton Lake*), Banff National Park (*Mt. Coleman from Sunset Pass*) and Yoho National Park (*Emerald Lake, Takakkaw Falls, Twin Falls, Yoho Valley–The President and Vice-President, Glacier, MacArthur Lake* and *Lake O'Hara, Looking towards Wiwaxy*).

155 For information about Margaret Lougheed's artistic career, see "Excursions: Sings on Canvas" (Toronto: Edward P. Taylor Research Library & Archives, Art Gallery of Ontario, n.d.).

156 Vancouver Art Gallery files, made available to me by Cheryl Siegel, give details of the works Margaret Lougheed contributed to group exhibitions of the B.C. Society of Fine Arts and the Vancouver Art Gallery.

157 R.W. Sandford, *King of the Spiral Road[:] A Celebration of the Life of Hans Schwarz* (Calgary: Alpine Club of Canada and McAra Printing, 2001), 4–5.

158 Phyllis Munday, "First Ascent of Mt. Robson by Lady Members," *Canadian Alpine Journal* XIV (1924), 69.

159 Frank N. Waterman, "The Tragedy on Mt. Robson," *Canadian Alpine Journal* XIX (1931), 69–71.

160 Sarka Spinkova, "Mount Robson, 1957," *Canadian Alpine Journal* XLI (1958), 56.

161 Spinkova, "Mount Robson, 1957," 56.

162 Robert Kruszyna, "Robson's SSW Arête," *Canadian Alpine Journal* XLV (1962), 89.

163 Jo Kato, "Ralph Forster Mt. Robson Hut," *Canadian Alpine Journal* LIV (1971), 122–123.

164 Simona Škarja, "In the Sign of Mt. Robson," trans. Simona Pihler, *Canadian Alpine Journal* LXXIV (1991), 45.

165 Škarja, "In the Sign of Mt. Robson," 46.

166 Robert L.M. Underhill, "An Attempt on Mt. Robson by the NW (Emperor Falls) Ridge," *Canadian Alpine Journal* XIX (1931), 67.

167 T.M. Spencer, "Robson by Emperor Ridge," *Canadian Alpine Journal* XLV (1962), 87.

168 Barry Blanchard, "The King and I," *Canadian Alpine Journal* LXXXVI (2003), 30–37.

169 See Glen Boles, *My Mountain Album[:] Art & Photography of the Canadian Rockies & Columbia Mountains* (Calgary: Rocky Mountain Books, 2006), 102–103, for a wonderful pen and ink drawing of Mt. Robson and Berg Lake. See also Boles' spectacular photographs of Mt. Robson with afternoon cloud (114), the Emperor Face (95) and Robson's east arête (83).

170 R.W. Sandford, *Once Upon a Mountain[:] The Legend of the Grizzly Group* (Calgary: Alpine Club of Canada and McAra Printing, 1998), 10, 16.

171 Adamson, "Lawren Stewart Harris: Towards an Art of the Spiritual," 82.

List of Artists

JENNIFER ANNESLEY (1967–)
Berg Lake, 2008
Charcoal and gouache, 63.5 × 86.4 cm
Private collection
Photograph: Jennifer Annesley

Mt. Robson, North Face, 2008
Watercolour on paper, 35.6 × 53.3 cm
Private collection
Photograph: Jennifer Annesley

Snowbird Pass, 2008
Watercolour on paper, 26.7 × 73.7 cm
Private collection
Photograph: Jennifer Annesley

ROGER D. ARNDT (1959–)
Robson Alpine, 2009
Oil on prepared panel, 71.1 × 40.6 cm
Private collection
Photograph: Allen Arndt

Whitehorn and Kinney, 2008
Oil on prepared panel, 61 × 40.6 cm
Collection of the artist
Photograph: Allen Arndt

CAMERON BIRD (1971–)
Kinney Lake – September, 2010
Oil on canvas, 55.9 × 71.1 cm
Private collection
Photograph: Stephen Lowe Art Gallery

GLEN W. BOLES (1935–)
Mt. Robson, 2008
Acrylic on canvas, 45.7 × 61 cm
Private collection of Ian Opelik
Photograph: Glen Boles

Mt. Robson in the Clouds, 1984
Oil on canvas, 61 × 89 cm
Private collection of Jan Opelik
Photograph: Glen Boles

Mt. Robson North Face, 2009
Acrylic on canvas, 61 × 45.7 cm
Private collection of Ron Sigurdson
Photograph: Glen Boles

NORENE CARR (1937–)
North Face, Mt. Robson, Berg Lake, 1988
Oil on canvas, 55.9 × 71.1 cm
Collection of Mount Robson Provincial
Park Visitor Centre
Donated by Norene Carr in honour of
the 75th anniversary

HORACE CHAMPAGNE (1937–)
*A River of Ice, the Robson Glacier from the
Snowbird Pass trail*, 2012
Pastel on paper, 30.5 × 45.7 cm
Collection of the artist
Photograph: Horace Champagne

**ARTHUR PHILEMON COLEMAN
(1852-1939)**
Camp on Moraine, Mount Robson, no date
Watercolour over pencil, touches of
gouache, 17.8 × 25.4 cm
With permission of the Royal Ontario
Museum © ROM
932.39.13

Cutting Steps, Robson Glacier, 1908?
Watercolour on cardboard, 26 × 18 cm
Arthur P. Coleman Collection and
Arthur P. Coleman Online Exhibit,
Victoria University Library (Toronto)

*Falls on Grand Forks River near Foot of
Mount Robson*, no date
Watercolour over pencil, 25.4 × 17.8 cm
With permission of the Royal Ontario
Museum © ROM
932.39.28

Lake Kinney near Mount Robson, no date
Watercolour over pencil, 17.4 × 25.4 cm
With permission of the Royal Ontario
Museum © ROM
932.39.26

Main Glacier, Mount Robson, B.C., no
date
Watercolour over pencil, 47.6 × 65.4 cm
With permission of the Royal Ontario
Museum © ROM
932.39.17

Mount Robson from across Berg Lake, no
date
Watercolour over pencil, 27.3 × 17.8 cm
With permission of the Royal Ontario
Museum © ROM
932.39.24

Mount Robson from Grand Forks River, no
date
Watercolour over pencil, 14.9 × 22.5 cm
With permission of the Royal Ontario
Museum © ROM
932.39.27

*Mount Robson from Moraine at Dawn: Sun
from Northeast*, no date
Watercolour over pencil, 17.8 × 25.4 cm
With permission of the Royal Ontario
Museum © ROM
932.39.12

Mount Robson from North East, no date
Watercolour over pencil, 17.8 × 25.1 cm
With permission of the Royal Ontario
Museum © ROM
932.39.21

Mount Robson from North West, 1908
Watercolour over pencil, 25.4 × 17.8 cm
With permission of the Royal Ontario
Museum © ROM
932.39.23

Sunrise on Mount Robson, B.C., no date
Watercolour over pencil, 67.9 × 99.7 cm
With permission of the Royal Ontario
Museum © ROM
932.39.8

DAVID DAASE (1960–)
Sunset on Mount Robson, 2006
Oil on canvas, 38.1 × 76.2 cm
Private collection
Photograph: David Daase

**LAWREN S. HARRIS, CANADIAN
(1885-1970)**
Glacier, Mt. Robson District, 1924–1925
Oil on board, 30.5 × 38 cm
Private collection of Mary Fus and Chris
Cleaveley
Photograph: Kent Wong

Glacier, Rocky Mountains, c. 1929
Graphite on paper, 18.4 × 24.8 cm
Private collection of Mary Fus and Chris Cleaveley
Photograph: Kent Wong

Isolated Peak, c. 1929
Graphite on wove paper, 19.2 × 25.4 cm
National Gallery of Canada, purchased 1976
© family of Lawren S. Harris
Acc. no. 18713

Mountains in Snow: Rocky Mountain Paintings VII, c. 1929
Oil on canvas, 131.3 × 147.4 cm
Art Gallery of Ontario
The Thomson Collection © Art Gallery of Ontario

Mount Robson, c. 1924–25
Graphite on wove paper, 18.9 × 25.4 cm
National Gallery of Canada
Gift of Lawren P. and Anne Harris, Ottawa, 1977,
in memory of Kathleen M. Fenwick
Acc. no. 18774

Mount Robson from the Northeast, no date
Oil on paperboard, 30.2 × 38.0 cm
Art Gallery of Ontario
The Thomson Collection © Art Gallery of Ontario

Mount Robson from the South East, 1929
Oil on paperboard, 30.3 × 37.9 cm
Art Gallery of Ontario
The Thomson Collection © Art Gallery of Ontario

MEL HEATH (1930-)
Berg Lake, Mt. Robson, c. 2010
Oil on canvas, 61 × 76.2 cm
Private collection
Photograph: Graham Twomey

Mount Robson, Summit Clouds, c. 2010
Watercolour on paper, 38.1 × 55.9 cm
Private collection
Photograph: Graham Twomey

Ralph Forster Hut (Alpine Club of Canada), Mount Robson 1970, 1970
Photo engraving on zinc plate, 24 × 20 cm
Private collection of Robi Fierz
Photograph: Robert Fierz

Route to High Camp from Kinney Lake, 2011
Watercolour on paper, 27.9 × 38.1 cm
Collection of the artist
Photograph: Mel Heath

A.Y. (ALEXANDER YOUNG) JACKSON (1882-1974)
A Vista from Yellowhead, 1924
Pen and ink with white gouache on illustration board, 26.4 × 34.3 cm
National Gallery of Canada, purchased 1925
Courtesy of the estate of Dr. Naomi Jackson Groves
Acc. no. 3171

Five Mile Glacier, Mt. Robson, 1924
Oil on board, 21.2 × 26.9 cm
Kamloops Art Gallery, 1995–35

Moose Lake, Mile 25, B.C., 1914
Oil on board, 21.5 × 26.9 cm
Kamloops Art Gallery, 1994–10

Mount Robson, 1914
Graphite on paper, 27.8 × 42.4 cm
Firestone Collection of Canadian Art, Ottawa Art Gallery;
donated to the City of Ottawa by the Ontario Heritage Foundation
Courtesy of the estate of Dr. Naomi Jackson Groves
Photograph: Tim Wickens
FAC 0505

Mount Robson, Resplendent and Kain, 1914
Oil on wood panel, 21.4 × 26.8 cm
Gift of Mr. S. Walter Stewart
McMichael Canadian Art Collection
1968.8.23

South of Razor Mountain, B.C., 1914
Oil on board, 21.7 × 27 cm
Kamloops Art Gallery, 1998–001

GREGG JOHNSON (1935-)
Mt. Robson Backing Berg Lake and Toboggan Creek, c. 2005
Watercolour on paper, 55.9 × 76.2 cm
Private collection of Henry Beckmann
Photograph: Gregg Johnson

Mt. Robson from Carr's Pond, 2010
Watercolour on paper, 55.9 × 76.2 cm
Collection of the artist
Photograph: Gregg Johnson

Wild Lupines in the Robson Valley, c. 2002
Watercolour on paper, 55.9 × 76.2 cm
Private collection
Photograph: Gregg Johnson

WILLIAM JOHNSTONE (1868-1927)
Lake Kinney, 1913?
Watercolour on paper on board, 34.9 × 46 cm
Art Gallery of Alberta Collection,
Gift of the Jaeger family
Acc. no. 2010.5
Photograph © Art Gallery of Alberta

TREVOR LLOYD JONES (1946-)
Glacier below Mt. Robson, 1990
Acrylic on canvas, 71.1 × 55.9 cm
Collection of the artist
Photograph: Norma Stromberg-Jones

Mt. Robson, from Robson Glacier, 1979
Acrylic on paper, 30 × 46 cm
Collection of the artist
Photograph: Norma Stromberg-Jones

MARGARET HANNAH LOUGHEED (1897-1989)
Mount Robson and Berg Lake, B.C., Canada, c. 1930
Oil on canvas, 77.5 × 92 cm
Collection of Parks Canada
Photograph provided by Parks Canada

DONNA JO MASSIE (1948-)
Trail to Mount Robson, 2006
Watercolour on paper, 147.3 × 99.1 cm
Collection of Theresa Maxwell
Photograph courtesy of the Alpine Club of Canada and the Whyte Museum of the Canadian Rockies

DAVID McEOWN (1963-)
Mt. Robson, 2004
Watercolour on paper, 38.1 × 55.9 cm
Private collection
Photograph: David McEown

LINDA McKENNY (1949-)
Moose Lake, B.C., 2006
Oil on board, 50.8 × 76.2 cm
Private collection
Photograph: Linda McKenny

Winter, Mount Robson, 2011
Oil on canvas board, 61 × 91.4 cm
Collection of the artist
Photograph: Linda McKenny

HERBERT NANZER (1948-)
Berg Glacier, 2011
Oil on canvas, 152.4 × 101.6 cm
Collection of the artist
Photograph: Ivan Karabobaliev

Mount Robson, 2011
Oil on canvas, 152.4 × 121.9 cm
Collection of the artist
Photograph: Ivan Karabobaliev

GLENN PAYAN (1962-)
Kain Face, Mt. Robson, 2010
Oil on canvas, 50.8 × 40.6 cm
Private collection
Photograph: Glenn Payan

Mt. Robson (Above Berg Lake), 2007
Oil on canvas, 101.6 × 76.2 cm
Private collection
Photograph: Glenn Payan

CATHERINE ROBERTSON (1941-)
Mt. Robson, Fall Colours, 2011
Acrylic on canvas, 20.3 × 25.4 cm
Collection of the artist
Photograph: Nathalie Davidson,
White Rock Design & Print

GEORGE WEBER (1907-2002)
Kinney Lake, Mt. Robson Park, B.C., 1970
Serigraph on paper, 15.2 × 22.9 cm
Courtesy of Donna Tingley and Willock
& Sax Gallery, Banff
Photograph: Willock & Sax Gallery

GEORGE HARLOW WHITE (1817-1887)
Mount Robson, Rocky Mountains, 1876?
Pencil sketch, 7.9 × 11.8 cm
Courtesy of Toronto Public Library
Acc. no. JRR 3060

Bibliography

Adamson, Jeremy. "Lawren Stewart Harris: Towards an Art of the Spiritual." In *Canadian Art: The Thomson Collection at the Art Gallery of Ontario*, 69–88. Toronto: Art Gallery of Ontario and Skylet Publishing, 2008.

————. *Lawren S. Harris: Urban Scenes and Wilderness Landscapes, 1906–1930*. Toronto: Art Gallery of Ontario, 1978.

Ainslie, Patricia, and Mary-Beth Laviolette. *Alberta Art and Artists[:] An Overview*. Calgary: Fifth House, 2007.

Akrigg, G.P.V., and H.B. Akrigg. *1001 British Columbia Place Names*. Vancouver: Discovery Press, 1969.

Allodi, Mary. *Canadian Watercolours and Drawings in the Royal Ontario Museum*. 2 vols. Toronto: Royal Ontario Museum, 1974.

Alpine Club of Canada. *The Mountaineer and the Artist[:] the Alpine Club of Canada Centennial*. Calgary: McAra Printing, 2006.

Amery, L.S. "An Attempt on Mount Robson." *The Alpine Journal* XXV (1910), 293–305.

A.P. Coleman: Geologist, Explorer (1852–1939) – Science, Art & Discovery An online exhibition by Victoria University Library (Toronto) and Royal Ontario Museum. Accessed August 31, 2012, http://is.gd/RmdSNC.

A.Y. Jackson: Paintings 1902–1953. Toronto: Art Gallery of Toronto, 1953.

Baird, P.B. "A.Y. Jackson: A Portfolio of Arctic Sketches." *The Beaver* (Spring 1967), 6–14.

Beers, Don. *Jasper–Robson: A Taste of Heaven*. Calgary: Highline Publishing, 1996.

Besant, Annie, and C.W. Leadbeater. *Thought-forms*. London: Theosophical Publishing House, 1901.

Birney, Earle. "Conrad Kain." *Canadian Alpine Journal* XXXIV (1951), 85–88.

Birrell, A.J. *Benjamin Baltzly: Photographs and Journals of an Expedition through British Columbia, 1871*. Toronto: Coach House Press, 1978.

Blanchard, Barry. "The King and I." *Canadian Alpine Journal* LXXXVI (2003), 30–37.

Boles, Glen. "The Grizzly Group at Longstaff." *Canadian Alpine Journal* LXXVI (1993), 85–87.

———— *My Mountain Album[:] Art & Photography of the Canadian Rockies & Columbia Mountains*. Calgary: Rocky Mountain Books, 2006.

Boulet, Roger. *Vistas[:] Artists on the Canadian Pacific Railway*. With an essay by Terry Fenton. Companion to an exhibition organized by The Glenbow Museum. Calgary: Glenbow Museum, 2009.

Brown, Elizabeth. *A Wilderness for All: Landscapes of Canada's Mountain Parks, 1885–1960*. Banff: Whyte Museum of the Canadian Rockies, 1985.

Buckingham, William. "Kain Ridge on Robson." *Canadian Alpine Journal* XLV (1962), 88.

Bulyea, H.E. "A Trip to Mount Robson." *Canadian Alpine Journal* X (1919), 26–31.

Canadian National Exhibition. *Catalogue of Paintings and Sculpture by British, Russian and Canadian Artists; Graphic Art and Photography*. Toronto: Canadian National Exhibition, August 29–September 12, 1925.

————. *Catalogue of Paintings and Sculpture by British, American, Italian and Canadian Artists; Graphic Art, Applied Art and Salon of Photography*. Toronto: Canadian National Exhibition, August 28–September 11, 1926.

————. *Catalogue[:] British, Belgian, French and Canadian Paintings, British and Canadian Sculpture, International Graphic and Applied Art and Salon of Photography*. Toronto: Canadian National Exhibition, Aug. 27–Sept. 10, 1927.

Canadian National Railways. *Jasper National Park*. Montreal: Canadian National Railways, 1927.

Canadian Northern Railway. *Catalogue of Paintings of Scenes along the line of the Canadian Northern Railway*. Toronto: Canadian National Exhibition, 1915.

Carlson, Howard. "Mt. Robson Traverse." *Canadian Alpine Journal* XXVI (1938), 15–20.

C.B.S. "In Memoriam Arthur Philemon Coleman." *Canadian Alpine Journal* XXVI (1938), 125–129.

Cheadle, Walter B. *Cheadle's Journal of a Trip across Canada 1862–1863*.

With introduction and notes by A.G. Doughty and Gustave Lanctôt. Edmonton: Hurtig Publishers, 1971. The first Canadian edition, including the introduction by Doughty and Lanctôt, was published in 1931 by Graphic Publishers.

Cheesmond, David. "Mt. Robson Emperor Face." *Canadian Alpine Journal* LXVI (1983), 131.

Christensen, Lisa. *A Hiker's Guide to Art of the Canadian Rockies*. Calgary: Glenbow Museum, 1996.

———. *A Hiker's Guide to the Rocky Mountain Art of Lawren Harris*. Calgary: Fifth House, 2000.

Claunch, Don. "First 1953 Ascent of Mount Robson." *Canadian Alpine Journal* XXXVII (1954), 72–74.

Coleman, A.P. *The Canadian Rockies[:] New and Old Trails*. Reprinted with a new foreword by Chic Scott. Calgary: Rocky Mountain Books, 2006. First published 1911 by T.F. Unwin.

———. "Geology and Glacial Features of Mt. Robson." *Canadian Alpine Journal* II, 2 (1910), 73–78.

———. *Glaciers of the Rockies & Selkirks*.

Ottawa: Department of the Interior, Dominion Parks Branch, 1921.

———. "On a Mountain Glacier; Chapter II, Spitzbergen." In *Reminiscence of Arctic Travels*, ms, c. 1930.

Coleman, John T. "Magnificent Failure." *B.C. Magazine* in *The [Vancouver] Province*, March 30, 1957, 3.

Colgate, William. *Canadian Art[:] Its Origin and Development*. Toronto: Ryerson Press, 1943.

Colgrove, Pete. "Mount Robson Summer Camp." *Canadian Alpine Journal* XXXIX (1956), 115–119.

Collie, J. Norman. "The Canadian Rocky Mountains a Quarter of a Century Ago." *Canadian Alpine Journal* XIV (1924), 80–87.

———. "On the Canadian Rocky Mountains North of the Yellowhead Pass." *The Alpine Journal* XXVI (1912), 5–17.

Connelly, Dolly. "Berg Lake Chalet." *The Beaver* (Winter 1981), 22–30.

Darling, Basil S. "First Attempt on Robson by the West Arête (1913)." *Canadian Alpine Journal* VI (1914–1915), 29–34.

Davis, Ann. *The Logic of Ecstasy[:] Canadian Mystical Painting, 1920–1940*. Toronto: University of Toronto Press, 1992.

Dawn, Leslie. *Towards the Group of Seven and Beyond: Canadian Art in the First Five Decades of the Twentieth Century*. Kamloops: Kamloops Art Gallery, 1998.

Dawson, George M. "Notes on the Shuswap People of British Columbia." *Transactions of the Royal Society of Canada* IX (1891), Section II, 37.

Delesalle, Marco. "Remembrances: Bob Enagonio." *Canadian Alpine Journal* LXXXVIII (2005), 162–163.

Dougherty, Sean M. *Selected Alpine Climbs in the Canadian Rockies*. Calgary: Rocky Mountain Books, 1991.

Duval, Paul. *Canadian Impressionism*. Toronto: McClelland & Stewart, 1990.

Ever Upward[:] A Century of Canadian Alpine Journals 1907–2007. DVD. Alpine Club of Canada, 2008.

Fairley, Bruce. "George Kinney, Mount Robson and a Little Question of Hearsay." *Canadian*

Alpine Journal LXXXII (1999), 66–70.

Firestone, O.J. *The Other A.Y. Jackson*. Toronto: McClelland & Stewart, 1979.

Fitzwilliam, William, Viscount Milton; and Dr. Walter B. Cheadle. *The North-West Passage By Land*. London: Cassell, Petter & Galpin, 1865.

Foster, W.W. "Mount Robson (1913)." *Canadian Alpine Journal* VI (1914–1915), 16–21.

Fuhrmann, Peter. "Scipio Merler." *Canadian Alpine Journal* LXXXVIII (2005), 162.

Gardiner, T. "The Name 'Mt. Robson.'" *Canadian Alpine Journal* LIII (1970), 27–30.

Geological Survey of Canada. *Geology of Mount Robson Provincial Park*. Map by E.W. Mountjoy and D.C. Murphy. Pamphlet's content, design and illustrations mostly by L. Iredale, digital cartography by Paul Wozniak of the Geological Survey of Canada and photography mainly by G.M. Ross. Calgary: Geological Survey of Canada, n.d.

Gibson, Rex. "The Mount Robson Ski Camp."

Canadian Alpine Journal XXXIV (1951), 63–65.

Gilmore, Berenice. *Artists Overland: A Visual Record of British Columbia 1793 1886*. Burnaby: Burnaby Art Gallery, 1980.

Grant, George Monro. *Ocean to Ocean: Sandford Fleming's Expedition through Canada in 1872*. Toronto: Belford Brothers Publishers, 1877. First published in 1873.

———, ed. *Picturesque Canada: The Country as It Was and Is*. Illustrated under supervision of L.R. O'Brien. Toronto: Belden Brothers, 1882–1884.

Groves, Naomi Jackson. *A.Y.'s Canada*. Toronto: Clarke, Irwin, 1968.

———. "A Profile of A.Y. Jackson." *The Beaver* (Spring 1967), 15–19.

Hallowes, K.B. "Mount Robson Camp (1913)." *Canadian Alpine Journal* VI (1914–1915), 149–152.

Harmon, Carole. *The Rainbow Mountains[:] A Centennial Exhibition of Photographs by Byron Harmon, 1911*. Banff: Harmon Gallery, August 6 through Fall 2011.

Harmon, Carole, and Bart Robinson. *Byron Harmon: Mountain Photographer*.

Canmore: Altitude Publishing, 1992.

Harris, Bess, and R.G.P. Colgrove, eds. *Lawren Harris*. With an introduction by Northrop Frye. Toronto: Macmillan of Canada, 1969.

Harris, Lawren. *Contrasts[:] A Book of Verse*. Toronto: McClelland & Stewart, 1992.

———. "Creative Art and Canada." In *Yearbook of the Arts in Canada, 1928–1929*, edited by Bertram Brooker. Toronto: Macmillan of Canada, 1929.

———. "Revelation of Art in Canada." *The Canadian Theosophist* VII, 5 (July 15, 1926), 85–88.

———. "Theosophy and Art." *The Canadian Theosophist* XIV, 6 (1933), 161–166.

———. "Winning a Canadian Background." *The Canadian Bookman* V, 2 (February 1923), 37.

Hart, E.J. *Diamond Hitch[:] The Pioneer Guides and Outfitters of Banff and Jasper*. Banff: EJH Literary Enterprises Ltd., 2001. Originally published 1979 by Summerthought.

Harvey, A.G. "The Mystery of Mt. Robson." *British*

Columbia Historical Quarterly I (1937), 207–226.

Hickson, J.W.A., Letter to J.M. Thorington, May 28, 1938. Archives of the Whyte Museum of the Canadian Rockies, Banff. M106/147.

Hill, Charles C. *The Group of Seven, Art for a Nation*. Ottawa: National Gallery of Canada, 1995.

Hollister, N. "Mammals of the Alpine Club Expedition to the Mount Robson Region." *Canadian Alpine Journal* Special Number (1912), 6–44.

Horne, Greg. "Mount Robson New Approach Line." *Canadian Alpine Journal* LXXVIII (1995), 85–86.

House, Steve. "The Emperor's New Route." *Canadian Alpine Journal* XCI (2008), 127–128.

Housser, Frederick Broughton. *A Canadian Art Movement: The Story of the Group of Seven*. Toronto: Macmillan of Canada, 1926.

Hunter, Andrew. *Lawren Stewart Harris: A Painter's Progress*. New York: Americas Society, 2000.

"In Memoriam Caroline B. Hinman 1884–1966." *Canadian Alpine Journal* L (1967), 134–136.

Isaac, Sean. "Where the Crowds Can Go." *Canadian Alpine Journal* LXXXIX (2006), 19–21.

Jackson, A.Y. "Artists in the Mountains." *The Canadian Forum* V, 52 (January 1925), 112–114.

———. "Banff School of Fine Arts." *Canadian Art* III, 4 (July 1946), 160–161.

———. "Lawren Harris: A Biographical Sketch." In *Lawren Harris[:] Paintings, 1910–1948*. Toronto: Art Gallery of Toronto, 1948.

———. *A Painter's Country: The Autobiography of A.Y. Jackson*. Toronto, Vancouver: Clarke, Irwin, 1964. First published 1958.

Kain, Conrad. "The Ascent of Mt. Robson." *The Alpine Journal* XXVIII, 203 (February 1914), 35–38.

———. "The First Ascent of Mt. Robson, the Highest Peak of the Rockies (1913)." Translated by P.A.W. Wallace. *Canadian Alpine Journal* VI (1914–1915), 21–27.

———. "First Ascent of Mt. Whitehorn (August 12, 1911)." Translated by P.A.W. Wallace. *Canadian Alpine Journal* VI (1914–1915), 42–43.

———. "Reminiscences of Seven Summers in Canada." *American Alpine Journal* I (1929/32), 290.

Kato, Jo. "Note re Robson Hut." *Canadian Alpine Journal* L (1967), 128.

———. "Ralph Forster Mt. Robson Hut." *Canadian Alpine Journal* LIV (1971), 122–123.

King, James. *Inward Journey[.] The Life of Lawren Harris.* Toronto: Thomas Allen Publishers, 2012.

Kinney, Rev. George R.B. Letters to A.O. Wheeler, September 23, 1909, and March 21, 1910. Archives of Whyte Museum of the Canadian Rockies, Banff. AC 00 120.

———. "Mount Robson." *Canadian Alpine Journal* II, 1 (1909), 10–17.

———. "Mount Stephen." *Canadian Alpine Journal* I, 1 (1907), 91–93.

Kinney, Rev. George, and Curly Phillips, "To the Top of Mount Robson. Told by Kinney and Phillips." *Canadian Alpine Journal* II, 2 (1910), 21–32.

Kruszyna, Robert. "Robson's SSW Arête." *Canadian Alpine Journal* XLV (1962), 89.

Lang, Michale. *An Adventurous Woman Abroad[:] The Selected Lantern Slides of Mary T.S. Schäffer.* Calgary: Rocky Mountain Books, 2011.

Larisey, Peter. *Light for a Cold Land[:] Lawren Harris's Work and Life – An Interpretation.* Toronto and Oxford: Dundurn Press, 1993.

Larsen, Wayne. *A.Y. Jackson[:] The Life of a Landscape Painter.* Toronto: Dundurn Press, 2009.

Lawren Harris: Retrospective Exhibition, 1963. Ottawa: National Gallery of Canada, 1963.

Laviolette, Mary-Beth, and Patricia Ainslie. *Alberta Art and Artists: An Overview.* Calgary: Fifth House, 2007.

Lismer, Arthur. "A.Y. Jackson." In *A.Y. Jackson[:] Paintings 1902–1953.* Toronto: Art Gallery of Toronto, 1953.

Linke, Don G. "New (Canadian) Ascents and Various Expeditions." *Canadian Alpine Journal* LI (1968), 213–217.

Long, William E. "Californians on Mount Robson." *Canadian Alpine Journal* XXXVII (1954), 79–81.

Lower, J.A. "The Construction of the Grand Trunk Pacific Railway in British Columbia." *B.C. Historical Quarterly* IV, 3 (1940), 163–181.

MacCarthy, Albert H. "William Wasborough Foster. In Memoriam." *Canadian Alpine Journal* XXXVIII (1955), 58.

MacCarthy, Albert H., and Basil S. Darling. "An Ascent of Mt. Robson from the Southwest (1913)." *Canadian Alpine Journal* VI (1914–1915), 34–42.

MacGregor, James G. *Overland by the Yellowhead.* Saskatoon: Western Producer, 1974.

———. *Pack Saddles to Tête Jaune Cache.* Edmonton: Hurtig Publishers, 1973. Originally published c. 1962 by McClelland & Stewart.

———. "Who Was Yellowhead?" *Alberta Historical Review* XVII, 4 (1969), 12–13.

Mastin, Catharine M. "East Views West: Group Artists in the Rocky Mountains." In *The Group of Seven in Western Canada*, edited by Catherine M. Mastin. Toronto: Key Porter Books and Glenbow Museum, Calgary, 2002.

McDougall, Anne. *Anne Savage: The Story of a Canadian Painter.* Montreal: Harvest House, 1977.

McEvoy, James. *Report on the Geology and Natural Resources of the Country Traversed by the Yellow Head Pass Route from Edmonton to Tête Jaune Cache… .* Annual Report for 1898, Vol. II, Sec. D. Ottawa: Geological Survey of Canada, 1900.

McMann, Evelyn de R. *Royal Canadian Academy, Exhibitions and Members, 1880–1979.* Toronto: University of Toronto Press, 1981.

Mellen, Peter. *The Group of Seven.* Edmonton: Hurtig Publishers Ltd., 1984.

Mitchell, C.H. "Mount Resplendent and the Routes of Ascent (1913)." *Canadian Alpine Journal* VI (1914–1915), 50–58.

Mohling, Franz. "Mount Robson – North Face." *Canadian Alpine Journal* LIII (1970), 101.

"Mt. Robson Camp, 1924." *Canadian Alpine Journal* XIV (1924), 133–143.

Mumm, Arnold L. "An Expedition to Mount Robson." *Canadian Alpine Journal* II, 2 (1910), 10–20.

Munday, Phyllis. "First Ascent of Mt. Robson by Lady Members." *Canadian Alpine Journal* XIV (1924), 68–74.

Murray, Joan, and Robert Fulford. *The Beginning of Vision[:] The Drawings of Lawren Stewart Harris.* Vancouver and Toronto: Douglas & McIntyre in association with Mira Godard Editions, 1982.

Newell, George R. "To the Top of Mt. Robson." *Pioneer Days in B.C.* Vol. 3. Edited by Art Downs. Surrey, B.C.: Heritage House, 1977.

Odell, N.E. "The Ascent of Mount Robson and Other Climbs in 1930." *Canadian Alpine Journal* XIX (1931), 10–22.

O'Hooligan, Seamus. Review of online article by James L. Swanson titled "George Kinney and the First Ascent of Mount Robson." *Canadian Alpine Journal* LXXIX (1996), 130.

Parker, Elizabeth. "Early Explorers of the West: Milton and Cheadle." *Canadian Alpine Journal* XXXIII (1950), 74–78.

Phillips, Donald. "Winter Conditions North and West of Mt. Robson." *Canadian Alpine Journal* VI (1914–1915), 128–135.

Pole, Graeme. *The Canadian Rockies[:] A History in Photographs.* Banff: Altitude Publishing, 1991.

Putnam, William Lowell *Climbers Guide to the Rocky Mountains of Canada–North.* New York: American Alpine Club, 1974.

Putnam, William L., Glen W. Boles and Roger W. Laurilla. *Place Names of the Canadian Alps.* Revelstoke: Footprint Publishing, 1990.

Putnam, Windsor B. "Mount Robson–1922." *Canadian Alpine Journal* XIII (1923), 39–47.

Reid, Dennis. *Alberta Rhythm: The Later Work of A.Y. Jackson.* Toronto: Art Gallery of Ontario, 1982. Exhibition catalogue.

———. *Atma-Buddhi-Manas: The Later Work of Lawren S. Harris.* Toronto: Art Gallery of Ontario, 1985. Exhibition catalogue.

———. *The Group of Seven.* Ottawa: National Gallery, 1970. Exhibition catalogue.

———. *Our Own Country Canada, Being the Account of the National Aspirations of the Principal Landscape Artists in Montreal and Toronto 1860–1890.* Ottawa: National Gallery of Canada, 1979.

Reisenhofer, Glen. "Re-examining the First Ascent of Mount Robson's Southwest Ridge." *Canadian Alpine Journal* XCI (2008), 72–73.

Reiss, Margaret. "Robson Ski Camp." *Canadian Alpine Journal* XXXVII (1954), 136–138.

Sacks, Ronald. "Mt. Robson North Face." *Canadian Alpine Journal* LXII (1979), 155–157.

Saltiel-Marshall, Alice. "Somewhere to Nowhere." *Canadian Alpine Journal* XXVIII (1995), 24–25.

Sandford, Robert William. *Ecology & Wonder in the Canadian Rocky Mountain Parks World Heritage Site.* Edmonton: AU Press, 2010.

———. "Following Wheeler Home." *Canadian Alpine Journal* XC (2007), 22–25.

———. *King of the Spiral Road[:] A Celebration of the Life of Hans Schwarz.* Calgary: Alpine Club of Canada and McAra Printing, 2001.

———. *Once Upon a Mountain[:] The Legend of the Grizzly Group.* Calgary: Alpine Club of Canada and McAra Printing, 1998.

———. "This Serious Sport of Climbing – Reflections on the Birth of the Alpine Club of Canada on the Occasion of Its 90th Anniversary," *Canadian Alpine Journal* LXXX (1997), 51–53.

Schäffer, Mary T.S. *Old Indian Trails of the Canadian Rockies.* In *A Hunter of Peace: Mary T.S. Schäffer's Old Indian Trails of the Canadian Rockies with Photographs by the Author* [et al.]. Edited by E.J. Hart. Banff: Whyte Museum of the Canadian Rockies, 1980. Originally published in 1911 by G.P. Putnam's Sons. (Reprinted Calgary: Rocky Mountain Books, 2007 and 100th Anniversary Limited Edition 2011.)

Schauffelberger, Walter. "Whitehorn (1913)." Translated by P.A.W. Wallace, *Canadian Alpine Journal* VI (1914–1915), 43–45.

Scott, Chic. "Alpine Update." *Canadian Alpine Journal* LXXII (1989), 85.

———. "Mountain Mysteries." *Canadian Alpine Journal* LXXXIV (2001), 100–101.

———. *Pushing the Limits: The Story of Canadian Mountaineering.* Calgary: Rocky Mountain Books, 2000.

Secor, Deborah. "Joie de Vivre." *Pastel Journal* 60 (February 2009), 32–39.

Sherman, Paddy. *Cloud Walkers: Six Climbs on Major Canadian Peaks*. New York: St. Martin's Press, 1965.

Sibbald, A.S. "North of Mount Robson." *Canadian Alpine Journal* XVI (1927), 147–153.

Silcox, David P. "On the Art of A.P. Coleman." In *A.P. Coleman, Geologist, 1852–1939: Science, Art and Discovery*. Edited by Lila M. Laakso and Raymond Laakso. Toronto: Victoria University Library, 1994. Exhibition catalogue.

Škarja, Simona. "In the Sign of Mt. Robson." Translated by Simona Pihler. *Canadian Alpine Journal* LXXIV (1991), 45–47.

Sisler, Rebecca. *Passionate Spirits: A History of the Royal Canadian Academy of Arts, 1880–1980*. Toronto: Clarke, Irwin, 1980.

Smith, Cyndi. *Off the Beaten Track[:] Women Adventurers and Mountaineers in Western Canada*. Canmore, Alta.: Coyote Books, 1989.

Smythe, Frank S. *Climbs in the Canadian Rockies*. London: Hodder & Stoughton, 1950.

Sparling, Walt. "Mt. Phillips." *Canadian Alpine Journal* XXXIX (1956), 120–121.

Spencer, T.M. "Robson by Emperor Ridge." *Canadian Alpine Journal* XLV (1962), 84–88.

Spinkova, Sarka. "Mount Robson, 1957." *Canadian Alpine Journal* XLI (1958), 55–57.

Stone, W.E. "A Day and Night on Whitehorn (1913)." *Canadian Alpine Journal* VI (1914–1915), 45–50.

Swanson, James L. *British Columbia Place Names in the Vicinity of Mount Robson*. Prince George: Fraser–Fort George Museum Society, 1987.

———. "George Kinney and the First Ascent of Mount Robson." In *Spiral Road[:] Documents Relating to the Canadian Rocky Mountains*. Banff: 1999. Accessed September 6, 2012, www.spiralroad.com/sr/kinney/index.html.

———. "Hargreaves Glacier." In *Place Names in the Canadian Rockies*. Banff: 2002. Accessed August 31, 2012, www.spiralroad.com/sr/pn/h/hargreaves_glacier.html.

———. "The Three Mountaineers." *Canadian Alpine Journal* LXXIII (1990), 107–108.

Taylor, William C. *Tracks Across My Trail: Donald "Curly" Phillips, Guide and Outfitter*. Jasper: Jasper-Yellowhead Historical Society, 1984.

Thorington, James Monroe. *The Glittering Mountains of Canada[:] A Record of Exploration and Pioneer Ascents in the Canadian Rockies, 1914–1924*. Reprinted with a new foreword by Robert William Sandford. Calgary: Rocky Mountain Books, 2012. First published 1925 by John W. Lea.

———. "In Memoriam Conrad Kain 1883–1934." *Canadian Alpine Journal* XXII (1933), 184–187.

———. "A Mountaineering Journey through Jasper Park." *Canadian Alpine Journal* XVI (1926–1927), 71–85.

———. "A Note on the Naming of Mt. Robson." *The Alpine Journal* XLVIII (1936), 322–323.

Underhill, Robert L.M. "An Attempt on Mt. Robson by the NW (Emperor Falls) Ridge." *Canadian Alpine Journal* XIX (1931), 66–68.

Victoria University Library and Royal Ontario Museum. *A.P. Coleman: Geologist, Explorer (1852–1939) – Science, Art & Discovery*. Accessed September 6, 2012, http://library2.vicu.utoronto.ca/apcoleman.

Waterman, Frank N. "From Field to Mt. Robson – Summer 1923." *Canadian Alpine Journal* XIV (1924), 100–109.

———. "In Memoriam: Newman D. Waffl, 1879–1930." *Canadian Alpine Journal* XIX (1931), 117–118.

———. "The Tragedy on Mt. Robson," *Canadian Alpine Journal* XIX (1931), 69–71.

Wates, Cyril G. "Men, Mountains and Motives." *Canadian Alpine Journal* XXVIII, 1 (1941), 11–19.

Watson, William R. "G. Horne Russell Biography" (c. 1959). Galerie Walter Klinkhoff, Montreal. Accessed August 31, 2012, www.klinkhoff.com/canadian-artist/G-Horne-Russell.

Wessel, Dave. "The Second 1953 Ascent." *Canadian Alpine Journal* XXXVII (1954), 75–78.

Wheeler, Arthur O. "The Alpine Club of Canada's Expedition to Jasper Park, Yellowhead Pass and Mount Robson Region, 1911." *Canadian Alpine Journal* IV (1912), 8–80.

———. Letter to George Kinney, March 11, 1910. Archives of the Whyte Museum of the Canadian Rockies, Banff. AC 00 120.

———. Letter to J.M.T. [J.M. Thorington], 6-9-38 [June 9, 1938]. Archives of the Whyte Museum of the Canadian Rockies, Banff. M106/147.

———. "The Mount Robson Camp of the Alpine Club of Canada." *The Alpine Journal* XXVII (1913), 329–331.

———. "National Parks As an Asset." *Canadian Alpine Journal* VI (1914–1915), 117.

———. "Origin and Founding of the Alpine Club of Canada." *Canadian Alpine Journal* XXVI (1938), 79–98.

———. "Passes of the Great Divide." *Canadian Alpine Journal* XVI (1926–1927), 117–135.

———. "Report of Mt. Robson Camp (1913)." *Canadian Alpine Journal* VI (1914–1915), 179–181.

———. "Robson Glacier." *Canadian Alpine Journal* VI (1914–1915), 104–107.

Wheeler, Marilyn. *The Robson Valley Story*. McBride, B.C.: Robson Valley Story Group, 1979.

White, James. "Cheadle's 'Journal' – Across the Mountains, June 25 to August 28, 1863." *Canadian Alpine Journal* XIV (1924), 87–99.

———. "Place Names in Vicinity of Yellowhead Pass." *Canadian Alpine Journal* VI (1914–1915), 107–114.

White, Suzanne. "Banff Culture Weekend opens doors." *Rocky Mountain Outlook*, August 5, 2010.

Index

When Jane Gooch first camped at Lake O'Hara, in 1975, she could not have foreseen how important the Rockies would become in her life. She travelled from her home in Vancouver many times during the summer months to hike in the mountains, and her love of the alpine landscape eventually inspired her to study the artists who have painted in the Rockies. Her great enjoyment of the outdoors and a lifelong interest in art were combined with her academic background in writing and research. Jane has a doctorate in Renaissance Drama from the University of Toronto, and for years she taught in the English Department at the University of British Columbia. Her book on the art of Mount Robson is the fourth in a group that includes *Artists of the Rockies: Inspiration of Lake O'Hara* (The Rockies Network and Alpine Club of Canada, 2003), *Mount Assiniboine: Images in Art* (Rocky Mountain Books, 2007) and *Bow Lake: Wellspring of Art* (Rocky Mountain Books, 2010). The photograph of the author was taken by Jane Whitney in early August 2012, high above Robson Pass on the trail to Mumm Basin.

Those who are inspired by Mount Robson Provincial Park and wish to offer support through donations or gifts in kind can gain more information about making contributions by viewing the partnership opportunities section on the B.C. Parks website, www.bcparks.ca